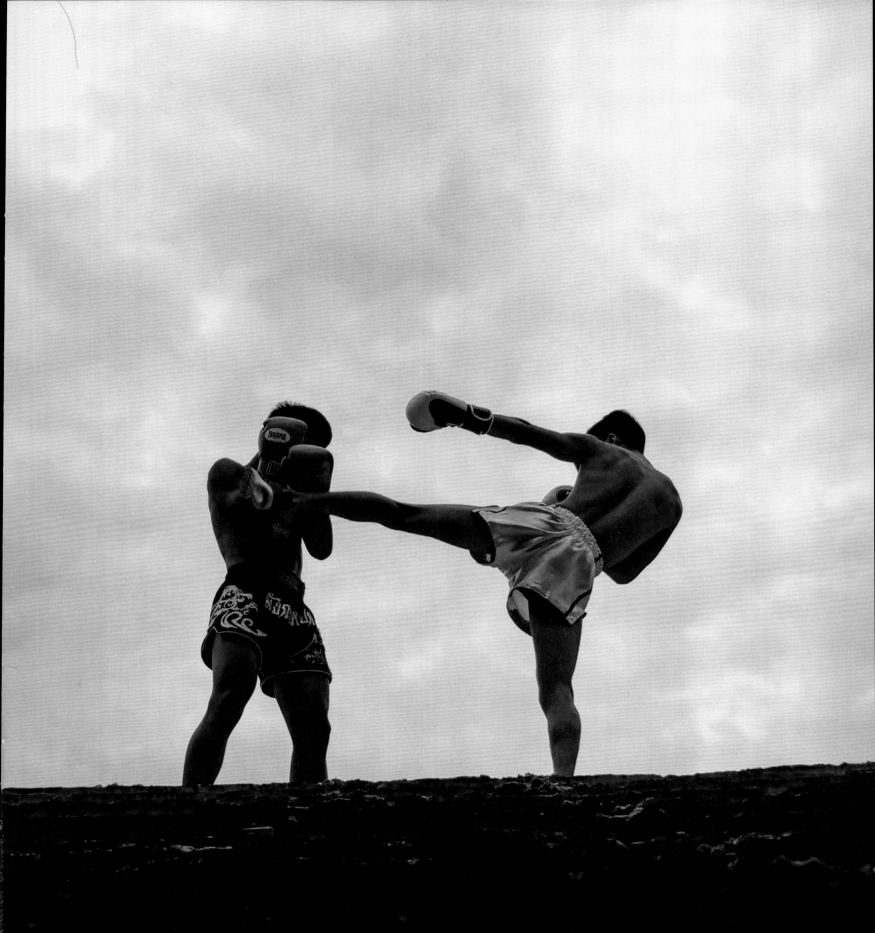

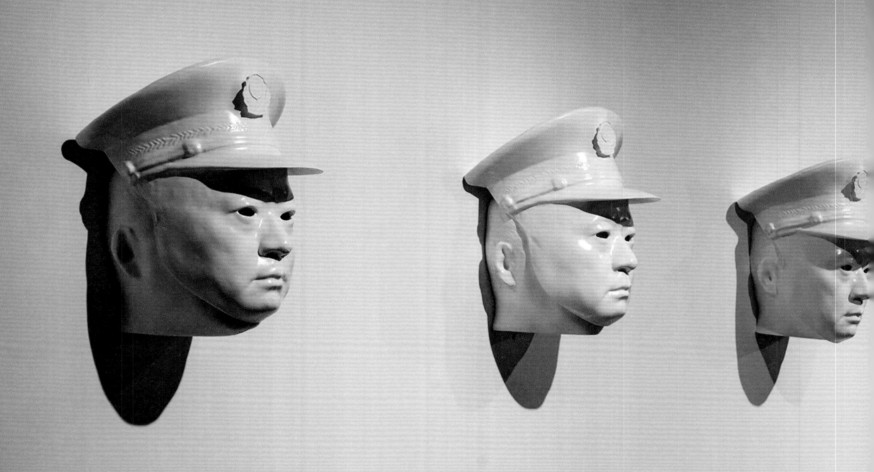

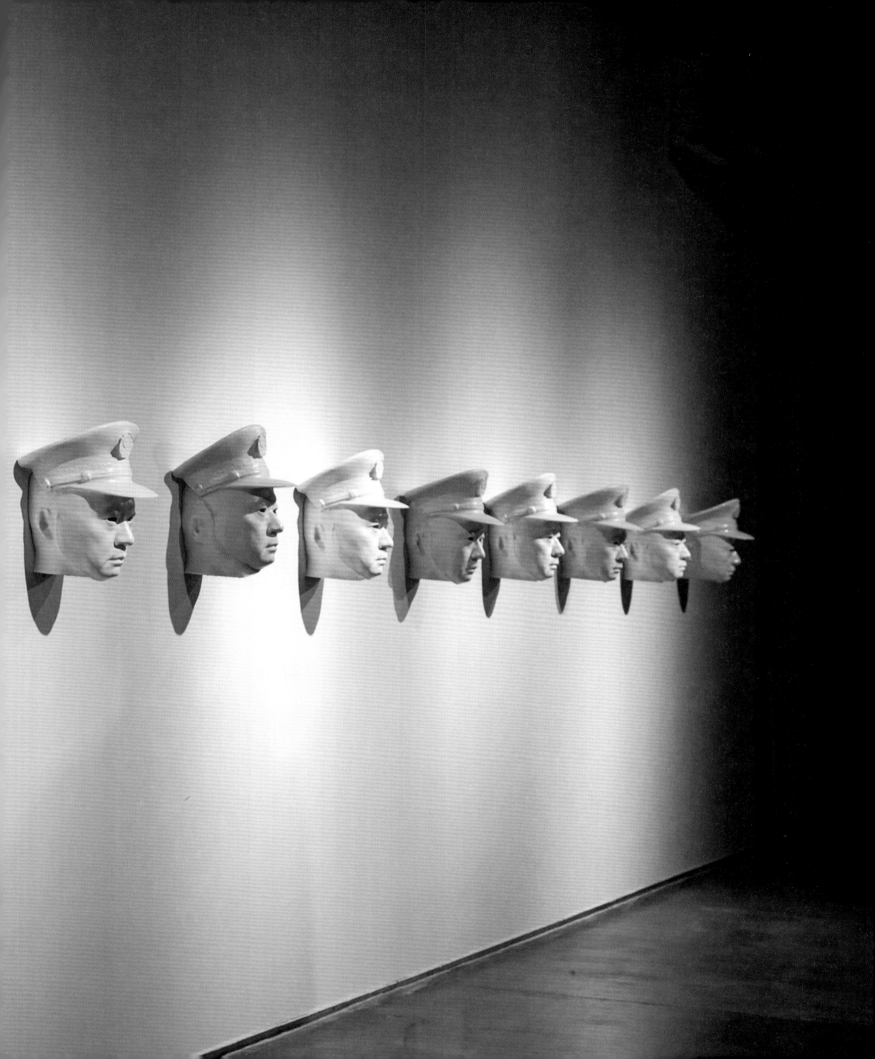

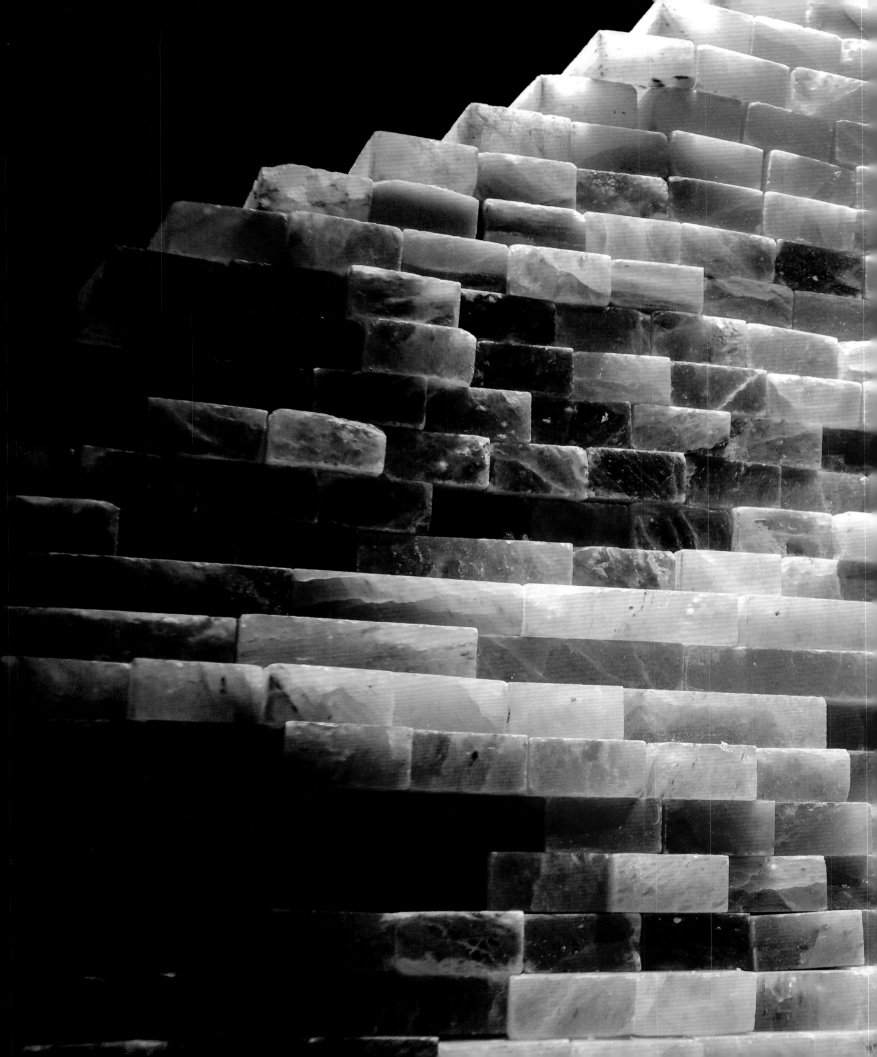

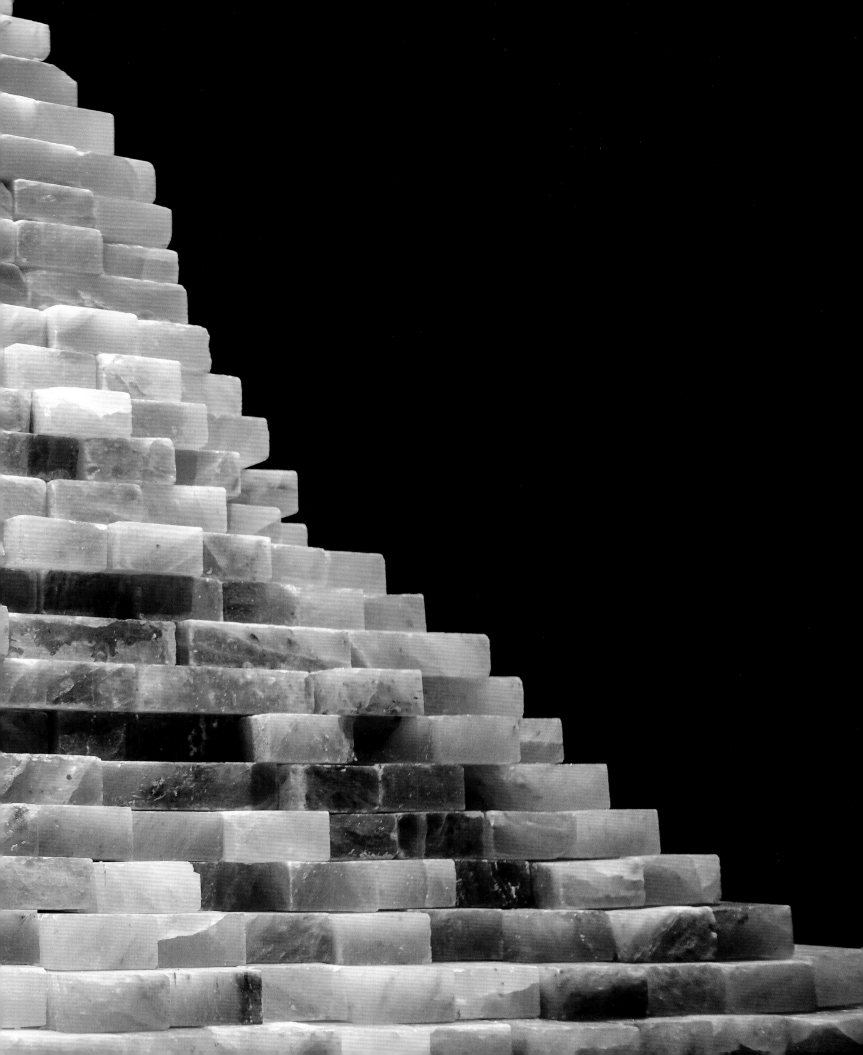

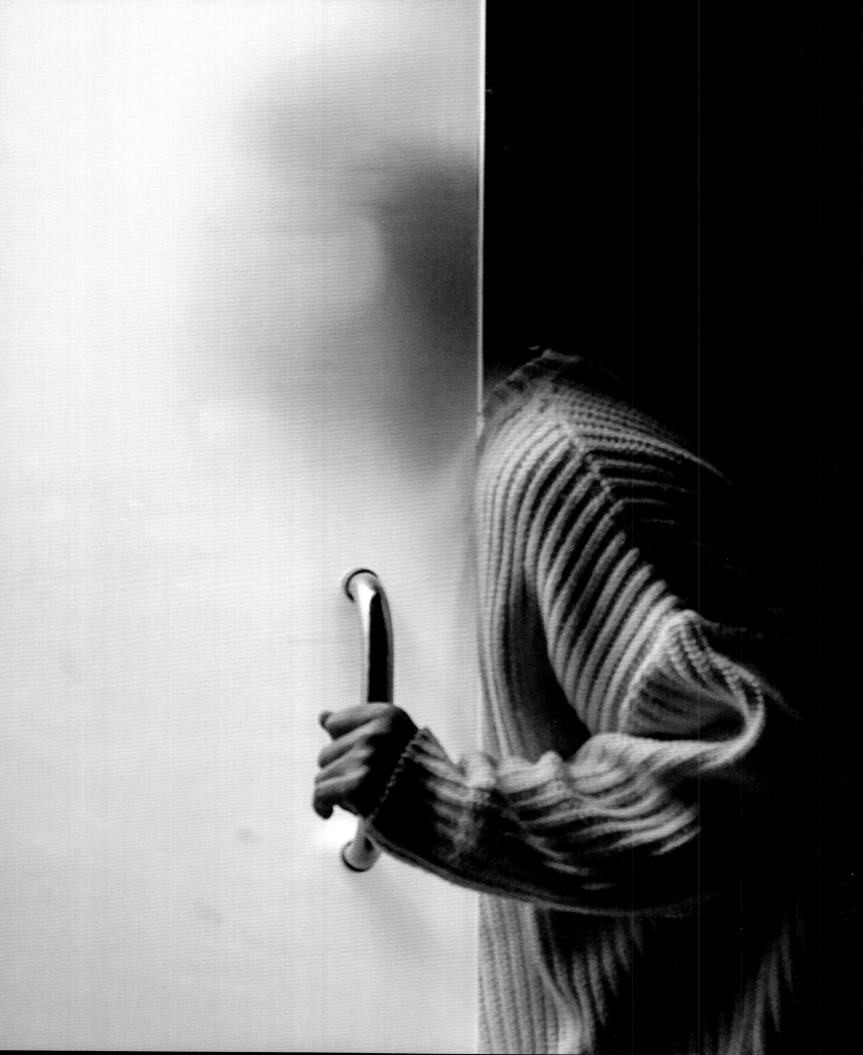

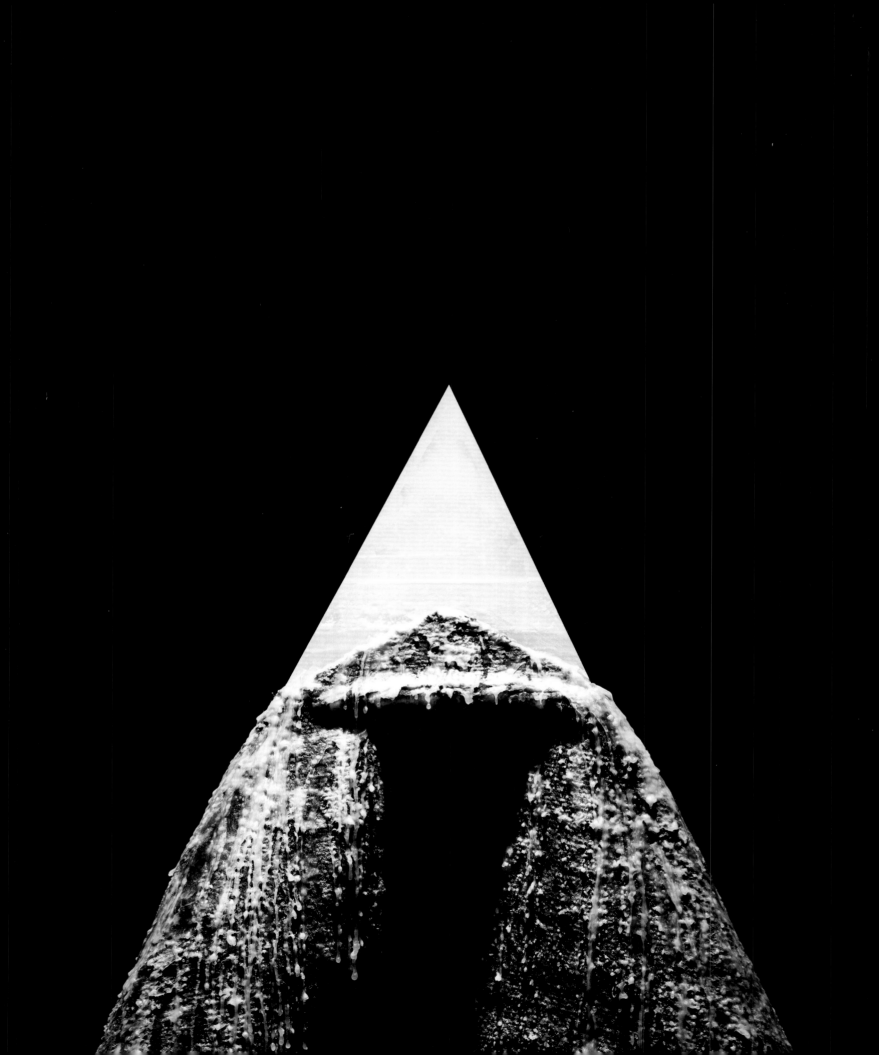

YES, TODAY
ART AS A LIFE PRACTICE
LI YONGZHENG

RIZZOLI
NEW YORK

New York · Paris · London · Milan

TEXTS

ARTWORKS BORDERS SERIES

ARTWORKS

AFTERWORDS

TEXTS

Politics as Sensibility—On Works by Li Yongzheng
by Lü Peng

[...] politics in its strict sense never presupposes a re-ified subject or predefined group of individuals such as the proletariat, the poor, or minorities. On the contrary, the only possible subject of politics is the people or the dēmos, i.e. the supplementary part of every account of the population. Those who have no name, who remain invisible and inaudible, can only penetrate the police order via a mode of subjectivization that transforms the aesthetic coordinates of the community by implement-ing the universal presupposition of politics: we are all equal. Democracy itself is defined by these intermittent acts of political subjectivization that reconfigure the communal distribution of the sensible. However, just as equality is not a goal to be attained but a presup-position in need of constant verification, democracy is neither a form of government nor a style of social life. Democratic emancipation is a random process that re-distributes the system of sensible coordinates without being able to guarantee the absolute elimination of the social inequalities inherent in the police order.[1]

Death . . . I don't believe in it because you're not around to know that it's happened. I can't say anything about it because I'm not prepared for it.[2]

[1] Rockhill G., "Editor's Introduction," in Rancière J., *The Politics of Aesthetics*, edited and translated by Gabriel Rockhill (London: Bloomsbury, 2013), pp. xiii–xiv.

[2] Warhol A., *The Philosophy of Andy Warhol* (New York: Harcourt Brace Jovanovich, 1975), p. 123.

Jacques Rancière uses a soft approach in discussing politics and sensibility, but when reading him, one can't help but look for a point of reference, or a specific sensibility in one specific artwork, as for example in correspondences between Greenberg and Pollock, Baudelaire and Manet, as well as between Nietzsche and Van Gogh; a relationship between thought and artworks continues to raise the question of representation. While perhaps not an antithetical relationship, this is certainly one of mutual arising.

We are not clear about whether Li Zhongzheng has carefully read Rancière or is even familiar with the author. The artist has never insisted on ideas or narrative to drive his practice. Instead, he works in subtler ways to bring the audience deeply into his work. Indeed, there is an overload of Chinese politics in contemporary art, an overemphasis of human rights as artworks are misread. It is as if critics who interpret Li Yongzheng's artworks get lost in politics, unable to speak from outside these ideological boundaries. However, if we carefully look at the facts, perhaps we will find that the old affairs of political ideology cannot touch upon the heart of the matter. Li Yongzheng is acutely aware of this, that things in this world are not either-or. Although Carl Schmitt has urged us time and time again never to forget the difference between ourselves and our enemies, politics still declares its state of continuous emergency. The treachery of globalization is truly laughable, and there's nothing we can do about it.

In contrast, Rancière's discourse is useful to us precisely because of its permeable and changeable nature. It has few political precepts, thereby "thinking" itself more flexibly into the essences of politics and aesthetics. Rancière's strongest distinction is one between politics and control. Schmitt's central tenet also admits to this distinction, though he elides the discussion on control, thereby failing to unmask politics and aesthetics as we encounter in Rancière.

Li Yongzheng is hyper-aware, approaching artwork design through a number of channels. Most important, he surmises the spirit of an artwork's installation site. In the history of Chinese installation art, even in global installation art, there are various degrees of emphasis upon site. Artists generally neglect site, tending instead to passively react to external factors. This is due to the public nature of installation. But Li Yongzheng thinks long and hard on his site of installation, integrating it as a key factor into the artwork, as if to turn our experience of art into one of situation.

Then, in terms of form, the artist makes great effort to think through the material history and cultural sources of his installation artwork. Realism and tactility bring about fruition in the artist's semiotic sphere of production, this latter being a central theme of installation or political art. Li Yongzheng refrains from purposely foregrounding this point, thereby exercising great self-restraint. In other words, he will let the subject of an installation work absorb the atmosphere of the place, so that the audience will not feel abruptness or cut off from the context. In doing so, he shows the internal logic of the subject rather than the simple formal needs. One of the main characteristics of his art is indeed that Li Yongzheng would never think about external concepts, relatively to the context.

Regarding time, Li Yongzheng's installation artworks often address the theme of dissipation. This material annihilation brings with it a certain representational structure. As the material of a work goes through the process of dissipation, it exists at the border between two system-states. One structure dissipates as the other accretes. This is not just the representation of the process itself, but rather the expression of the concept of transformation. In this way, Li Yongzheng brings us into the fold of his semiotic mythos. For example, in his artwork, *Consumed Salt at Gangren Boqi Mountain* (2014), two thousands bricks of Himalayan rock salt were stacked on-site, forming a representational Gangren Boqi Mountain. Through the course of the exhibition, the artist then sold these bricks of salt for 100 Chinese RMB apiece, selling 1,323 bricks in the span of one month. In all, these rock-salt bricks underwent a dual dissipation: firstly, they were taken from Gangren Boqi Mountain and disengaged from their natural locus; secondly, these bricks then

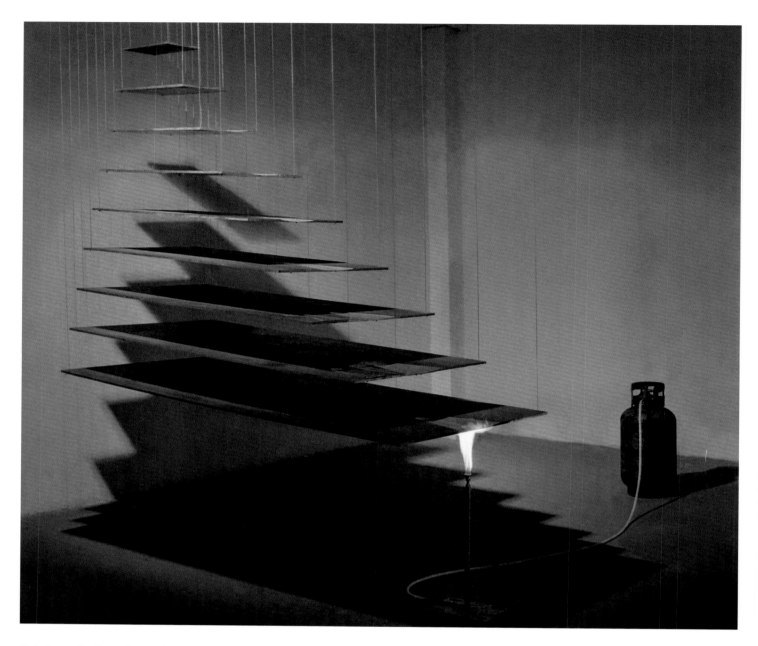

Metal as Medium for Water and Fire, 2011
Installation artwork
300 × 300 × 500 cm & variable dimensions

underwent a second dissipation, disengaged by the artist from the installed artwork, taken apart from their signifying unity comprising Gangren Boqi Mountain, annihilated as the signified mountain ceased to exist. At the same time, however, the artwork was brought doubly into being: it was that which was signified, being Gangren Boqi Mountain and its implied background; and the artwork instituted an economic exchange, hinting at our power as consumers to dissemble a given semiotic system, while at the same time dissembling material nature itself.

However, the artist refrains from explaining Gangren Boqi Mountain as a signifier, leaving his audience to surmise its import. This catapults his artwork into an ambiguous region and returns the artwork to Rancière's structure, wherein we discern what can be perceived in an artwork, and what cannot. Ultimately, dissipation becomes a generative force in the artist's creative process, creating material evidence and historical representation as concepts emerge from a sphere of imagination. In fact, this installation is the complete release of a first version completed by the

artist in 2009, *Salt at Gangren Boqi Mountain*. This first work can be regarded as the artist's inner yearning, but in the 2014 work, the real mountain has been replaced by its symbol, and then truly disintegrated until it could not be found, disappearing into the visitor's hand. In this process, the sacred mountain is interpreted as becoming "nothing." What's interesting is that after many years, people can explore and focus back to the earliest starting point: The Gangren Boqi Mountain.

In another artwork, *Death Has Been My Dream for a Long Time* (2015), Li Yongzheng's Himalayan salt bricks continued their disintegration. These bricks traveled all the way from the Himalayas to Tanggu Harbor along China's seaboard, just east of Tianjin. They were then arranged along the shoreline to form the eight Chinese characters that spell out "Death Has Been My Dream for a Long Time." In the lapping of tidal waters, these bricks then dissolved into the sea. We can read this piece as the artist's attempt to embrace two separate instances of annihilation, fusing them into a single, larger, inter-textual dissipation. The process of rinsing and dissolving is not evident, but what is clear is the artist seeking to link two examples of one process together into a single representative structure, an expression of endless proliferations of what gets lost.

As a variation on annihilation, displacement is then used in another similar artwork. In terms of historical, site-specific or semiotic bricks being displaced, this displacement is actually already visible from the beginning, already gradually dissipating into a renewed sensibility. However, at the same time, the internal structure of a given set of sensibilities is already being destroyed in this sense from the beginning. As soon as this system has been replicated in the process of displacement, it is already changing its sensibilities all over again. This is what Rancière calls the mode of "subjectivization," where one disrupts established settings of sensibilities in this very way. From this we can see that Li Yongzheng has a streak of idealism woven through his sorrow.

The process of displacement in another work, *Defend Our Nation* (2015), further represents the disappearance of a vanishing ambition. China once tested the nuclear bomb in the Lop Nur area, and this was Mao Zedong's extreme attempt to build his nationalist will. Now that everything has passed, time has only left the traces of the political tension linked to the slogan "Defend Our Nation." In this abandoned military area, the artist, through an act that is still risky today, replaced the four words "*Bao wei zu guo* (i.e. *Defend Our Nation*)" with bricks made by soldiers

at that time, with new ones he himself brought from thousands of miles away. The new words were retained, but the replacement caused history to leave, and the relics to become physical evidence, a kind of memorial.

As we come to know this process of subjectivization, we see that displacement occupies an important place in the artist's body of work. One can also see in many of his pieces that the artist is interested in *participation*. This sort of participation has been constructed through displacement on subtle structural levels. For example, the artist may invite participants to exchange one of their secrets for a fragment of one of his painted canvases, or he may invite them to participate in transmitting a specific object. Perhaps Li Yongzheng realizes that the transmission of a material object provides conditions for apperception, coming to know a material object in a new way, one that is oriented around the object's removal. This is displacement in its broadened sense.

Regardless of whether what is transmitted is a material object or a meme of information, Li Yongzheng expresses an inclination toward relational aesthetics. In many instances, installation is not a key component of his installation works but rather merely a single phase along a string of relationships, a segue into a symbolic order as what can be received by the viewer.

Now we approach Li Yongzheng's creative production from another angle. We all know that contemporary art tends to obfuscate conceptual and linguistic practices. In this sort of situation, even Rancière's philosophical points of view can be obscured. Critics and artists can use facts and descriptions of factual objects to form discourse. As such, what emerges from an experimental field of discourse can seem full of vitality, and it has the ability to speak to the reader. In talking about *Free for the taking* – a work completed in 2014 – perhaps plain speaking alone can astonish us. In this artwork, Li Yongzheng uses an old printing machine to reproduce a few back issues of the *Xinhua Daily* newspaper, once broadly distributed throughout China between the years of 1938 and 1947.[3] The news content shocks people, bringing them back to an unthinkable relationship with time and space.

[3] From January 11, 1938 to February 28, 1947, The *Xinhua Daily* was Communist China's official publication in the Guomindang areas and continued to be so until the outbreak of the civil war. The artist set an old monochrome offset press at the exhibition site and printed some *Xinhua Daily* issues that had been published between 1938 and 1947. The audience could freely take the printed newspapers away. It aimed to bring up some historical issues that have not yet been solved, as well as make people think.

This requires historical awareness from the audience members, much as basic knowledge of art would be expected from any audience present at an exhibition. The crux of the matter is that the newspaper in our hand is not a discarded thing of the past. The information on these pages is immediately relevant, even today. One can't pretend to have not seen, nor pretend that this newspaper is an object of the past. It is not, as once semiotic content reaches into its new and contemporary context, its significance is reignited. Quatrains of all eternity may be poetic, but the questions and issues they address are not. What has been sent for you is not an old disused newspaper, but a set of real questions that are posed, and that the audience members are forced to answer. It's fine not to engage with Rancière's discourse in doing so, and one can still choose to run and hide. Is this not what Wittgenstein termed "remaining silent"? Even if one is scared witless, one must acknowledge the astonishing nature of the artwork, *Free for the Taking*. In China, there are too many people, and I'm talking about artists who are afraid of these questions or who lack interest, as if I am interested in protecting their good name. They fiddle with abstractions, as arrogant philosophers who look disdainfully upon a local storyteller who is speaking many truths, giving us insight into crucial issues. We can't say that a given philosophical viewpoint has no value, but if we take many of these viewpoints and stuff them into a single space, they will merely make a spectacle of themselves. In this manner, it is hard for people to enter their own philosophical thinking. It is easier for people to enter through something they see, just as the people everywhere in the city seeing boxes of goods and chicken straw cluttered around are not getting the nourishment they need to feed their inner lives.

An artist's semiotic silence and his "existential map" are inextricably related. We are however able to attain a degree of understanding while being unable to completely grasp the representational nature of Li Yongzheng's artwork. As with another piece of his, an abstract view of life appears to occur in a very concrete and clear manner. His original idea is always manifested in a binary structure, as with a water drop and knife's blade: wet and dry, a soft light beam and hard metal. These perceptions are purified, forming a primal unity. In another more complicated installation work, *Metal as Medium for Water and Fire* (2011) water drips downward level by level, from the topmost and smallest metal plate until it hits the bottommost and largest plate, where it is heated by a flame underneath, and then evaporates into steam. The artist inserts a brief explanation: "Manifest matter undergoes transformation, and in this process, there is a poetic notion of death." This piece quite clearly describes the artist's worldview of cyclical nature where, as one matter is dissipated it comes to form another existence. Matter is never completely annihilated. This is a very Eastern notion, and the artist no doubt uses it to engage with politics as sensibility. It is just this basic mechanism of eternal transformation that shapes Li Yongzheng's own sensibilities about politics.

In an ideal system, politics would be defined as good in relation to the world, in apposition to control and supervision, and yet still exercise control. At an appropriately adjusted level, the political system would be understood as continuously changing for the good; while control would be distinguished from the start as something in the world that assigned sensibilities, dividing the communal body into distinct groups, each with their social position, modes of being, and functions. In the artwork, *Look! Look!* (2013), Li Yongzheng attempts to use meta-philosophy to question the whole of what can and can't be seen. In the system of this artwork, all parts are equal; "The metal box is a fifty by fifty by fifty-centimeter water-holding vessel, a perfect square. As far as I'm concerned, there are no primary or secondary elements in the work. There was no design needed. All sides are equal and compose a simple shape." But on the other hand, the structure of our world intrinsically involves distinction and design, thus, "The edges along the upper part of the metal box are actually thinner, such that when the water completely fills the box, a slight incline can be detected. All four sides and the bottom are ground and buffed to be mirror reflective. Viewers can look into the water and see their reflection. It's the kind of experience they would have every morning as they looked in the mirror."

Just as Rancière pointed out, in an ideal political body, the only primary element would be the people or the *dēmos*. There would be no predetermined concretizations or linguistic mechanisms along the lines of "proletariat," "poor," or "minority." The artist invokes this political ideal within his artwork, creating a mirror image that reflects an image that is still undetermined by the artist. The viewer sees what he or she wants to see.

The artist goes on to say, "The viewer sees him or herself through the water, an everyday experience of self-reflection. Look, stare, reflect...some people see peace or love, while others see horror and hatred.

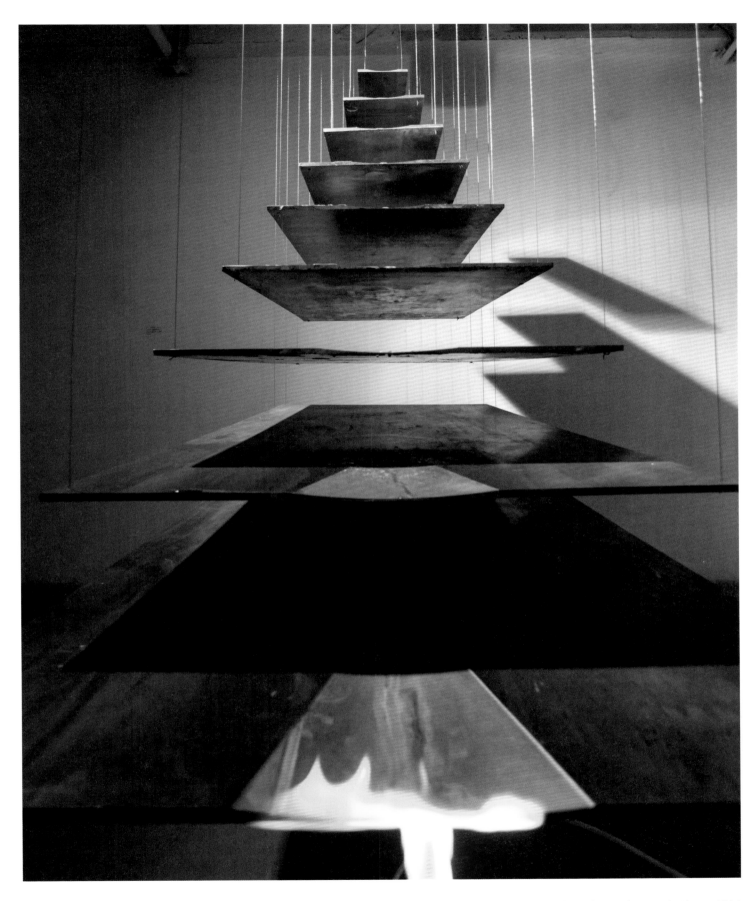

Metal as Medium for Water and Fire, 2011
Installation artwork
300 × 300 × 500 cm & variable dimensions

Some are content, others haunted. Some reach out to dialogue and are rejected, others dwell upon the dalliance of light, and yet still others merely see a material object. But regardless, each and every one of them will see the occasional bubble rise slowly to the water's surface and burst." The onslaught of subjectivization is thus challenged by the popping of occasional bubbles. Politics and the sum of all its perceptions are structured by this mirror image, that image which the artist in his heart institutes as the entire visage of the social order. This social world was perhaps suggested into place by Western political powers, but it has evoked local modes of awareness and perception.

We now resort to sensibility as a mode of discussing an experiential artwork, *Death Has Been My Dream for a Long Time* (2015). This artwork derives from an incident that took place on June 9, 2015 in Bijie, Guizhou, in Qixingguan district's Cizhu village, where four children were found dead in their home. Without immediate family to care for them, these children had ingested fatal amounts of agricultural pesticide. The elder brother, Zhang Qigang, left a simple suicide note saying: "Thank you for your good will, I know you meant well by me, but I have to go. I once swore I would never live beyond 15 years of age. Death has been my dream for a long time. Today is a new beginning!" We can imagine what Rancière or Agamben would have to say if they were privy to this news. How would those unfamiliar with China's living experience or historical context respond to this piece of news? Do we actually believe that words like "particular" and "holism" are useful in this discussion? Coming from a vantage point of common knowledge gleaned from personal experience, do we surmise that we need some strange conceptual rubric to talk about this? Of course, Duchamp would never want to realistically narrate events, nor would any adherent of conceptual thought and logic. It's all really decided by our own inner value system and point of view.

In the work *There Is Salt* (2017), the artist used Himalayan salt blocks to reproduce a map that was found on the internet. The map reported where some people had committed suicide in the regions of Western China. As the audience walked on this representational map, the salt cracked. This was the artist's way of reminding the walker that "it is hard to find a language that is able enough to explain the disappearance of countless lives." In fact, our choice of words comes from unconscious actions, not from the books we read. Rather, we develop our discourse according to our personal needs. This is the difficulty we face when making judgments about conceptual and installation art. Perhaps I can say one more thing: this is especially true in China. The problem that Li Yongzheng raised with this work is not a concept that can be continuously interpreted by critics, and it does not have any limitless poetic meaning. The dream of death is just a fact of death that occurs once and everywhere.

In talking about his artwork *Look! Look!*, the artist cites a phrase from the *Diamond Sutra*: "As a lamp, a cataract, a star in space / an illusion, a dewdrop, a bubble / a dream, a cloud, a flash of lightning / view all created things like this." Sixth Patriarch Huineng once used this phrase to express the impermanence and emptiness of all things. The *Diamond Sutra* is a complex artwork, the meaning of which gives us moments of reflection. Although we can hardly surmise the real meaning of Huineng's words, we can glean from a few lines in his *Platform Sutra* that in the case of most perceptions, we rarely ever see what is there.

Li Yongzheng creations in the Covid-19 post-pandemic era have become more in-depth, focusing directly on social history. It is worth noting the artist's great sensitivity when placing his works in a specific social situation or historical scene, and that he works in a surgical style. When we discuss the way an artist works, by "surgical" we mean cutting, stitching, and opening and closing with precision. It means being calm and having a very limited field of vision. Surgical also means the removal of redundant objects. Analogous to the removal of unnecessary objects from the body's system, Li Yongzheng seems to have spiritually removed something through his symbolic rituals. For example, during the pandemic of the new Corona virus, the artist set off from southern China to Xinjiang to invite local Uighurs to have a dinner in the desert. The venue for this dinner was in a remote canyon. Li placed a long Western-style table very poetically, and viewers who are familiar with the artist's work will not think this has been done randomly. In his works, every detail is composed of a tight structure, like a scale. Using the long Western-style table instead of the Chinese round table just touched upon a certain ideological and socio-cultural approach. Some images were left after people ate together. It is worth noting that the final form of this work did not remain; after the dinner, the long table and everything left on it were burned. The artist is telling us that there is no such permanent banquet in the world and that rather everything is destined to sink, as asserted by the philosopher Schopenhauer.

However, what he is even more likely to tell us is the diffusive but inseparable relationship between this work and the horrific memories of the global social ban imposed during the Black Death in Florence and the Spanish flu. What did people eat and talk about during the epidemics? This has symbolically become the beginning of a new *Decameron*. However, all this was annihilated in the fire. This kind of annihilation makes this work more intriguing, and it once again returns to the artist's Zen view: the illusion of the image and the truth of immortality. The long table also brings us back to the idea in Plato's *The Ideal State*: What is true goodness? This question adds to the philosophical confusion in 2021.

A Family from Ding'er is closer to Joseph Beuys's social sculpture and war aesthetics. When we see carpets presented in an "unnatural" way, such as the carpet wrapping a piano, the political sensibility and meaning of the work become very strong. The political sensibility of two kinds of everyday objects is immediately stimulated, epitomizing how in the semantics of social history what is certain can be transformed into something uncertain. Before seeing Beuys's work, we were aware of what a carpet and a piano were, but when they are used to wrap and form strange configurations, we suddenly feel the appeal behind the symbols: the wild and reverberating calls of those who have been there.

Li Yongzheng's inheritance of Beuys's legacy was carried out in an ingenious way. He is not so heavy, and tries to support the narrative of the grand history with two symbols, but in a daily "tea and rice-style," i.e. microscopic approach. In his calm and slightly humorous narrative, through the internet, he purchased all the carpets from a young Uighur man whose family was from Ding'er, in Xinjiang. His family had moved into a new residence and these carpets were left unused. The artist re-decorated the carpets with wax and displayed them in the exhibition hall to form the Chinese characters standing for "heart," "word," and "mountain peak."

The everyday thing, the carpet, is placed in a new dimension to be observed. As a consequence, the carpet is distorted into the image of the artist or the public. And the initial idleness of this object is also very interesting. Idleness means that the carpet is a useless thing, a forgotten and abandoned item that slips from sensible to insensible. Now, the artist makes it unexpectedly regain its meaning and presents a certain sanctified and solemn intention in the exhibition. This is a very large-scale transformation, pushing everyday things into the overall structure of social history at an unexpected pace.

If a single work is not clear enough for us to grasp the artist's intention, then the *Xinjiang Carpets* series further clarified this intention. He cut out the flower sections of the Xinjiang carpet with a circular die and placed them on the two sides of the exhibition hall. The damaged parts of the flower and grass patterns that once decorated the carpet were supplemented by hand-painted gray paintings installed in the exhibition hall.

The cut Xinjiang carpet became a structure full of holes, and in its negative form, just like negative film in photography, all the patterns are concentrated together. As a part of a cultural meme, the patterns were therefore separated from their original framework. The hollowed-out structure filled with holes reminds us of what Henry Moore did with stone, penetrating every volume of his sculptures. We really admire Moore's idea, which was originally born in Michelangelo: sculpture is originally contained in marble, and I just throw away the unimportant parts. The problem is that we have never thought about the fate of the parts that are thrown away, where they are, and what they mean.

The rich meaning of Li Yongzheng's carpet series lies in that he distinguishes the schema from the framework to which it belongs. He distinguishes the different understandings and uses of the same material object with different sensibilities and distinguishes the transformable boundary between meaningful and meaningless. What is the existence that is valuable to the viewer? The carpet as the carrier or the pattern of decorative motifs? Before confirming this fact, human history has experienced a long and endless Brownian motion, and this state of affairs continues to this day.

Starting from the minutiae, developing surprisingly subversive concepts, and insisting on a certain roughness and rigidity in form is the charm of Li Yongzheng's art. In the *Gangren Boqi Mountain* series, for example, he has been using salt bricks; therefore, the smallest segment in these works is represented by salt. Salt is a necessity, but at the same time it is a sacred site, like the salt rocks of the Gangren Boqi Mountain. In Li's work, the process of melting the salt mountain continues. As a moving and changing social sculpture, a symbol of Hinduism, Tibetan Buddhism, Bon religion, and ancient Jainism, the salt mountain has been recognized as the center of the world, thus bearing a perceptible burden. The structure of this work is not only related to the signified-signifier

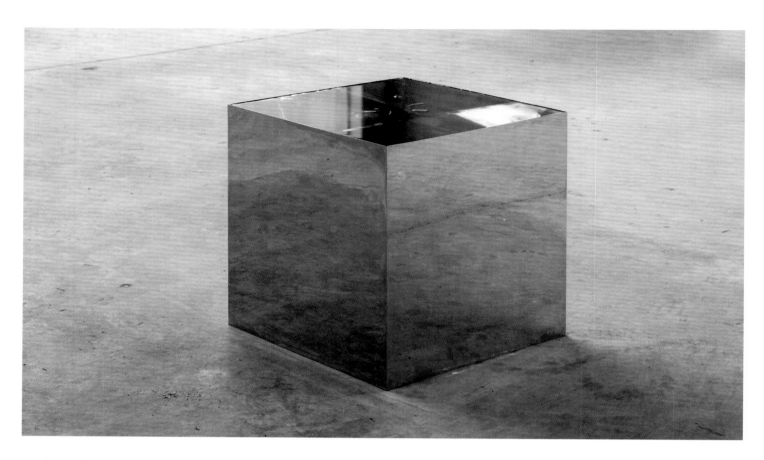

Look! Look!, 2013
Installation artwork
50 x 50 x 50 cm

senses of the mountain, but it is also connected to the function of the humidifier: a destructive element that deviates from the construction of the salt mountain. Humidifiers continuously increase the entropy value, disintegrating the shaping of certain beliefs. Does this social historical process have a counterpart in the real world? Obviously, the artist did not tell us the answer. Through his art, and only in an implicit, unobtrusive, subtle, and meaningful way does he reveal the relationship between sensibility and insensibility: a relationship of mutual obscuration. The action performed by the public that was asked to purchase salt bricks from the salt pyramid and then take them away may be defined as "spectacle," epitomizing Guy Debord's concept of spectacle, i.e the consumerist society. The artist is therefore dismantling spectacles in a way that even Guy Debord never talked about. On the surface, the spectacles that seem to rise in popularity exist only in the constantly increasing entropy system, and what determines this system is a humidifier that is not the object of viewing and gazing. This can only make people wonder where

the humidifier in our lives is. *Dasein* (i.e. existence) is where to find some solace in the face of doomed survivals and deaths.

In the 1980s, Chinese artists realized that they had various media at their creative disposal. However, looking at this age of experimentation from an art-historical point of view, we must treat these questions as they occur contextually. By the end of the 1970s, a very small piece of wood made into a ready-made artwork could grow into an emblematic representation (Wang Keping's *Silent*); Huang Yongping and the Xiamen Dada group burned personal objects (often their own artworks) in a bonfire to express their casting away of traditional notions of art. Gu Wenda and Wu Shanzhuan's multimedia practice then re-invigorated tradition and historicity as new starting points. Their artworks challenged both traditional modes of ink and wash painting, as well as the logic of Chinese characters. This was a time when artists sought to break with the past as they braved the future. In 1988, Xu Bing's exhibition exposed the question arising after rapid modernism: Exactly

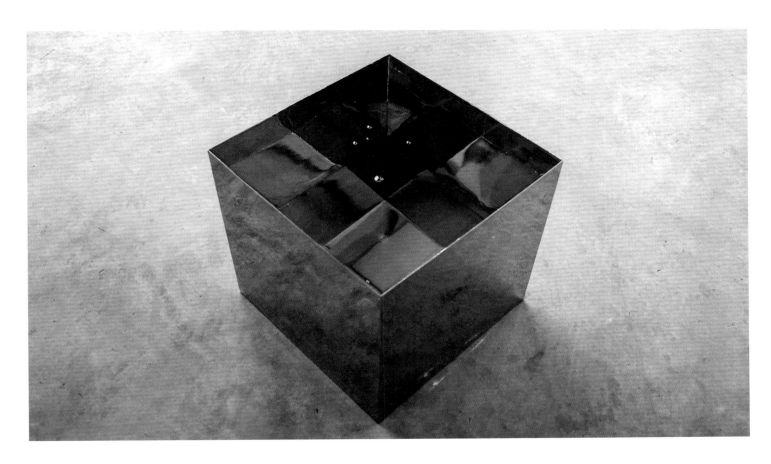

Look! Look!, 2013
Installation artwork
50 x 50 x 50 cm

what is the history of language and culture? This is really something we should think about today. Zhang Peili used repetition in his artworks to erode time, minimalizing to the greatest extent the obscuring pretension that language embodies. Of the early years, the most direct and conceptual performance artwork was the "gunshot" (Xiao Lu's *Dialogue*, 1989) performed at the China Avant-Garde Exhibition. An installation artwork expressing great wisdom was Huang Yongping's *The History of Chinese Art and A Concise History of Modern Painting Washed in a Washing Machine for Two Minutes.* He took print works he had washed in a washing machine and piled them up as an installation artwork, using two historical modes of painting history to strongly foreground cultural precepts and prejudices. Yin Xiuzhen followed the traces of her own movements through a city as she then fabricated the city, telling us the story of how to "see" one's life in urban spaces.

Cai Guo-Qiang's *Using Straw Boats to Borrow Arrows* is an apt metaphor for East-West relations. After 2000, China's conceptual art took a turn toward the popular,

as philosophy and allusion were used to confuse and obscure, demonstrating that the structure of China's social space is highly changeable. Regardless of what the artist wished to express, as long as the medium and visual language were vague enough, the whole of society would be able to view it, as artworks passed under the censors' radar. But how can we view the resulting exhibitions of these works? What were the artists seeking to achieve? Exhibitions these days are a wholly commercial enterprise, like small-town art fairs, merely an array of individual egos on display.

Li Yongzheng is not here to discuss philosophy. He is more interested in experience. This is not to say that experience has nothing to do with philosophical method. For example, through the space or the physical experience of the works on borders, what he gains is not a simple record of actions, but rather an understanding of human existence and the conditions of the existence itself. Through his work, the artist is telling us that experience itself is a form of contemplation. Experience is a value system, a conceptual rubric. When one drives a land rover out

into the wastelands of China's western region, one takes knowledge, experience, and determination alongside. Indeed, this is a historical undertaking, a driving inquiry. God tells us that the meaning of life is the pursuit of truth. In actuality, scholars who stick with what's popular are similar to young girls who enjoy trying on many outfits. From Derrida, Foucault, and Habermas to Deleuze, Rancière, and Agamben, how will our artists and critics contextualize French, German, and English notions into Chinese discourse? This is certainly something that few artists and critics have achieved.

Li Yongzheng's value as an artist lies in his willingness to engage with the vantage point of Western art-politics, striking through the heart of contemporary Chinese sensibilities. As a whole, these sensibilities comprise the most basic level of an existential map. When we laugh casually with one another, lightly discussing the differences and similarities between China and the West, we then take these intrinsically independent social worlds and cast them together. But if we are willing to cease our posturing and admit to the special nature of different experiences, of perceptions and linguistic expressions of people in Chinese society, we must then persist in making great effort to embrace the full implications of specific yet subtle perception and revealing. Only then are we ready to realize what Li Yongzheng has to offer, as he questions and redefines the practical spaces and specific structures of Western art-political notions, creating an inter-textuality with an ideal nationhood. Thereby, Li Yongzheng's artworks are interesting insofar as they are structurally and linguistically unutterable, as when we face his creative sentiment in the salt mountain at the end of a long narrow road. When we understand where the artist is coming from, we can read his creative process, but we are still startled by his artworks and ready-mades. Perhaps Rancière did not originally intend to stun us,

but rather to produce and structure the social world. He stuns us by saying things could not be any other way as he resets the structures that stand before us. Perhaps we are engulfed by this lonely aesthetic paradigm, with these complex states of mind broken open by structures of representation.

Today, as we write about art history, we are forced into authentic contemplation, forced into feeling stunned until we actually feel the tragedy embedded in the artworks before us. Between the associative nature of context and the permeability of thought, at this very point, intuition, irrationality, and the power of feeling force us to feel compassion for the destiny of mankind. It is at this level that our artistic judgment rings true.

In contemporary Chinese art, aside from the conceptualism of Wang Jianwei, Liu Wei, and Xu Zhen, we also have Ai Weiwei, Mao Tongqiang, and Li Yongzheng. These two classes of artists are similar insofar as we consider the free play of materials and artistic thought. The difference lies in this: the former group intentionally or otherwise strives to maintain a vague ambiguity. The way they see it, reason is just a tacit understanding, some kind of intellectual platitude. The latter group of artists, though, have from the get-go a clear understanding of their artwork. They realize that art is the most effective mode of expression, as they have a clear intention of posing important questions to audience members who are willing to think, inviting us to reach a new level of understanding on these issues. If one were to ask—isn't this just politics?—well then the answer would be simple. Chinese art today *is* political, but it's politics *as* sensibility, and this is exactly what we need!

April 30, 2021

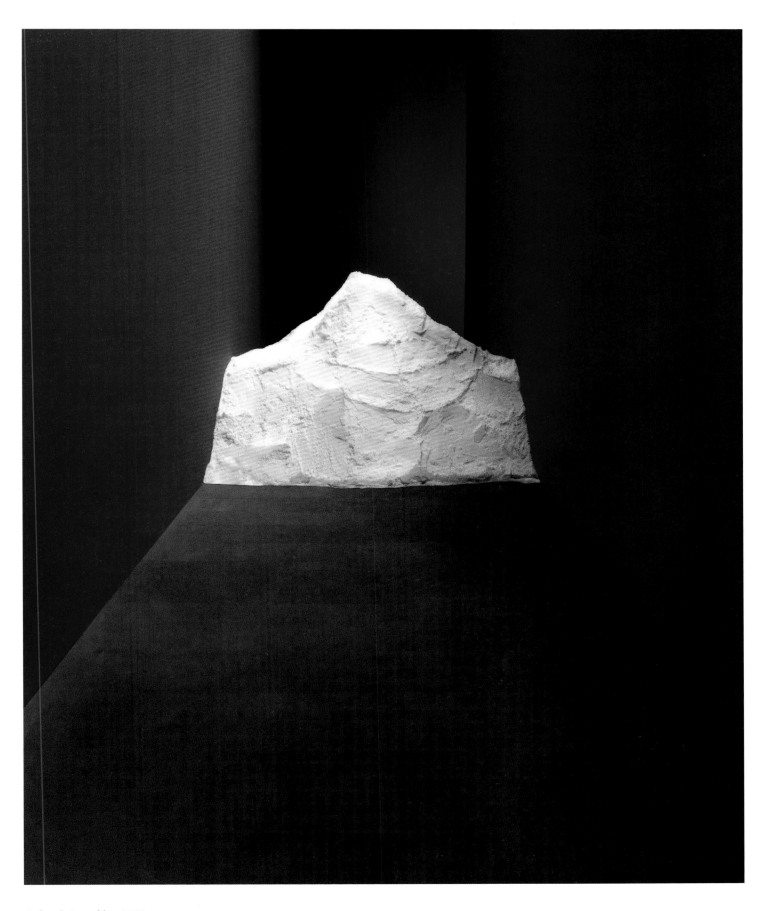

Seized Summit, 2015
Installation artwork
200 x 200 x 160 cm

27

Art as a Life Practice
About Li Yongzheng

by David Rosenberg

Li Yongzheng is an artist of large desert areas. He draws his inspiration far from the crowds, outside the walls of his studio. This results in a singular quality of expression that clashes with the codes developed by artists in large urban centers where humanity is concentrated on itself to a point of saturation. Video maker, performer, sculptor, painter, and digital network artist, Li Yongzheng displays a mixture of alchemy, shamanism, and activism. When you examine his works you may sometimes think of Beuys and his dead hare, Zorio, and his pentacle, Kounellis, and his gas flames, Chen Zhen and *Social investigations*, and also Francis Alÿs and his block of ice in the streets of Mexico City. Like these artists, he recognizes that natural material has a symbolic and initiatory power. Like them, he observes the way in which the properties of material can be in resonance with those of awareness. For example, Beuys chose felt and honey. Li Yongzheng has opted for Himalayan salt and wax—two materials that are at the heart of his approach. From the Sichuan region, the artist recounts the reality around him in a very direct manner but also sometimes in a veiled, allusive way. He starts from intimate experiences, from deep-seated feelings. Everything is exposed to the fire of *inner experience*. He is totally involved in the work and he invites the spectator to do likewise. Thus, when face to face with his installations you must take time to obtain information, to reflect and reconstitute for yourself the scattered pieces of a puzzle that gradually acquires *form*. Li Yongzheng often touches on violent aspects of reality. For example, in his work *Death Has Been My Dream for a Long Time* he addresses the tragedy of child suicides with empathy and dignity. The accidental discovery of a tragic news item in the media—the collective suicide of siblings abandoned by their parents who had gone to work in the city—was a brutal shock for the artist. He pondered, reflected, and also sought information about the social context in which such a tragedy had occurred. Aware that no explanation would cover such an event, he chose to construct a kind of performance: a poetic and spiritual ritual in which he honored the memory of the children.

He used salt bricks to write the last words of the farewell message left by the eldest child: *Death Has Been My Dream for a Long Time*. The artist performed the ritual on Tanggu beach near Tianjin during the rising tide. The sea covered the bricks little by little and they eventually dissolved in the water. Finally, everything disappeared, leaving just the sea and the sky. A video makes it possible to show the work in different contexts, as in a traditional exhibition space for example. Art reflects the transitory and evanescent nature of the world around us. And what counts less is leaving a trace in matter than in our memory and awareness. Thus all his work can be seen as a long initiatory trip, a voyage to the end of the world, to the end of thought and of oneself. It is not surprising, then, that forms of the desert and of the sacred mountain haunt his work recurrently. They are magical places—crucibles where the spirit takes shape.

The artist brings back relics, traces, notes, souvenirs, and fragments from his mental or physical travels. He piled bricks of Himalayan salt to form a mountain that then disappeared as the local public bought each brick for a ridiculously small price. He used five tons of raw salt to recreate the form of the sacred Gangren Boqi Mountain peak in Tibet in a gallery. In a desert landscape, he took a post marking the line of the frontiers of Xinjiang and then placed it on the site of a lost part of the Great Wall in the precise position of a flare that the army had used to send signals. He made a 3D scan of his body and then molded it in cement with the head replaced by a post with barbed wire wound around it. He set hundreds of laser beams pointed to the sky along the western frontier of the country. In the middle of the Xinjiang desert he held a dinner with members of the Uighur community—all this recorded on video. He grouped carpets woven by the Uighurs and covered the patterns with wax or pierced them by laying them on pyramid-shaped points. He also used other carpets, removing all the decorative patterns by cutting them out in circles until all that was left was an empty monochrome red surface.

And he then used Himalayan salt bricks to make an architectural pattern forming a swastika, on which

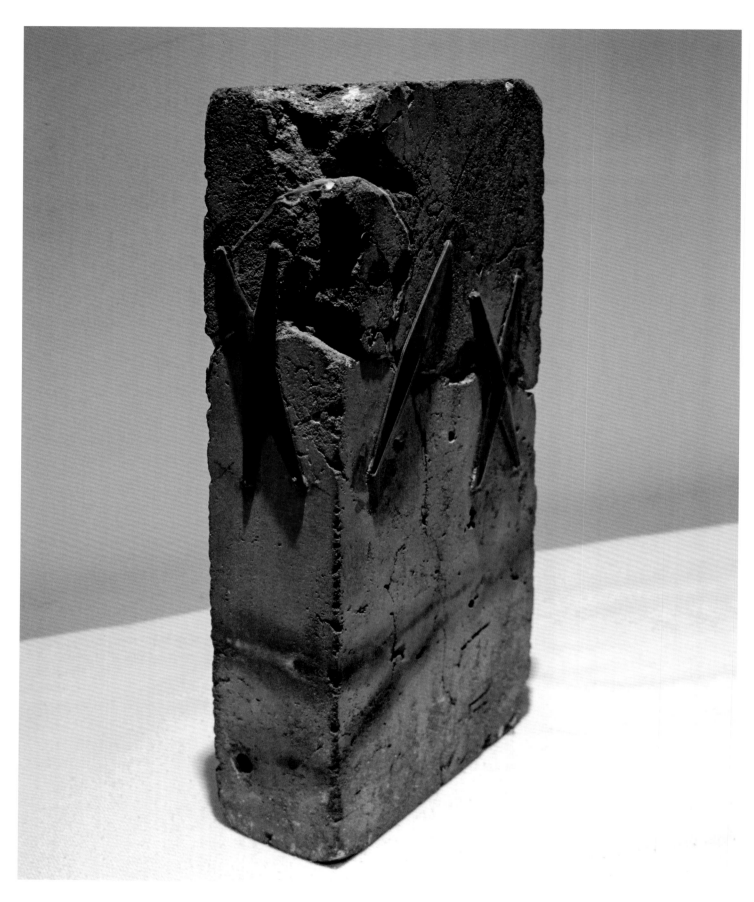

Brick Relay, 2012
Interactive performance art

spectators could walk without visualizing the shape on which they were moving.

The simple listing of these various actions, performances, and installations shows us that the artist addresses highly topical subjects. He thus weighs each of his statements and each of his acts with care. Radical and committed, he uses a singular pathway that takes him far from *Political Pop,* from the acidulated recycling of the iconography and emblems of power. There is something monastic, ascetic, and frugal about Li Yongzheng, thus his attraction to simple and natural materials and the precedence awarded to ritual and action rather than to material forms taken by paintings or sculptures.

In this respect, his approach can also be seen together with the "relational aesthetics" defined by the French critic and theorist Nicolas Bourriaud as being "an aesthetic of the inter-human, of the encounter, of proximity, of resisting social formatting." We can also go a little further back in history—to the memorable exhibition designed by Harald Szeemann: "*When attitudes become form: live in your head*," in which actions and thought processes outweigh finished forms and in which one-off actions substitute genre works and accepted techniques.

Brick Relay is a proposition that is in line with the aesthetics or philosophy that has just been mentioned. Dated "February 19, 2012 to present," the work has a precise starting moment but no completion date is specified. Anyone with a little knowledge of the history of contemporary China will know that the date February 19, 2012, was not chosen at random. It refers to the public protests that occurred in the town of Wukan in the province of Guandong following massive expropriation of villagers with no financial compensation. Following the event, Li Yongzheng used the internet to contact two people he knew who lived in the region and asked them to make two bricks using clay dug at Wukan. One of the bricks was given to a library that had been opened in the town shortly before. The artist took the other one and initiated an endless chain of correspondents via a microblog. He sent the brick to a first correspondent with the only instruction being that he should in turn give it to another person. The travels of the brick were traced and all the conversations and reflections stimulated by the project could be followed on the internet. All was archived for public exhibitions and publications. Ceaselessly accumulating new contributions, *Brick Relay* was co-signed by all the participants. Some just received the brick and sent it without any intervention, while others chose to change its appearance. For

example, one of the correspondents decided to fire the brick again and cracks appeared. Then other people undertook restoration using traditional methods, such as ceramics. Only the message counted. As the artist awarded no particular importance to the brick itself, he fully accepted that it could be lost or destroyed. Likewise, he did not care whether or not this could be described as art. The primary point was that of creating links and triggering discussion, statements, and positions.

Micro-actions at a local level, the creation of communities and individual awarenes … In a way, Li Yongzheng takes the opposing view to political action in the traditional sense of the term. He neither renounces utopia nor aspires to a grandiose aim to which all could be sacrificed, including the values in whose name we function. The artist holds that: "apart from the hope for a new policy, changes can only be carried out by every individual. You have to set out from your own real circumstances. Depart from trivial things, make efforts, little by little."

Dated 2013, *Free for the Taking* clearly illustrates this position. In an exhibition room turned into a temporary printer's workshop, the public was invited to take facsimiles of newspapers of the Kuomintang period printed on the spot. This participative operation can be linked to those created by the Thai artist Rirkrit Tiravanija, who turned certain art venues into pirate radio stations, a collective silk-screen printing studio, and open canteens in which he gave soup free of charge to visitors who could sit at a table and spend a moment together. In this case, the public was present for the production in a series of historically dated "information" — a simple process whose main virtue is to shed new light on the present moment. The artist explained it: "I printed old issues of *Xinhua Daily* that were originally published in the KMT-ruled areas in the 1940s. Many articles talked about freedom and democracy, prompting many youths at that time to fight and even sacrifice their lives. These propositions are sensitive topics in society today." It is stressed that the artist entrusted a child, a symbol of the future, with the task of handing these sheets from past newspapers to the public, like ghosts with a message for us.

In the installation *There Is Salt*, the artist continued to explore the idea that the past haunts the present, that the dead have something to say to us. He spread Himalayan salt crystals on the ground, drawing a map of the Tibetan region in Western China. Small stelae placed at different points of the map showed the places where people had decided to end their lives,

taking their secrets with them. Spectators were invited to walk into the work and hear the salt crunching under their feet, as if they were walking on frost. Each person left the trace of his or her passage through this poignant memorial.

In *Secret Exchanges*, the artist then went toward the secrets of the men and women around him. He set up a kind of primitive economy based on exchange and barter in which he offered people he did not know to share their secrets in return for fragments of paintings that he had never shown publicly. As in *Brick Relay*, Li Yongzheng set up an open network to which everybody was free to make his/her contribution. The project was shown via his WeChat account and on Sina Microblog. Contributions could be sent directly on the internet or by using a kind of booth in opaque glass where, unseen by others, participants could write using the computer placed at their disposal. A secret for a secret—or the art of creating links.

Using the same participative approach, the artist designed a " game" in which each person was invited to search throughout China for a full-size effigy of a policeman in a decor they could choose and then take a photo that would be shared on the networks. This approach follows directly from the project *Do it* started by Hans Ulrich Obrist in 1993, in which artists from everywhere gave instructions to be followed to create a work of one's own. Ostensibly ludic and ironic, the proposal inspired many people around the country and he started to receive photos from many places: sometimes a policeman was set in a flowerbed, while another was alone in the desert, and then a third stood with his feet in the snow at the top of a mountain. In a certain way the artist took the opposite approach to contemporary works showing symbols of power or oppression. Indeed, however iconoclastic or transgressive they are, they hold the spectator in the somewhat passive position of observer whereas here it is quite the opposite. If we take over and manipulate a symbol the experience will be all the more effective. Do it … yourself! Li Yongzheng is convinced that more and more people will feel this encouragement to make their own art. Here, when he is asked what he thinks the future of art will be, he replies, "Professional artists will be equivalent to craftsman, creative actions will emerge in all kinds of trades and professions, and art will become a life practice for most."

The last work by the artist to be mentioned here is *Yes, Today*. Between *Fight Club* and Larry Clark, it assembles in a hard-hitting way all the ingredients used by Li Yongzheng: social investigation, meetings

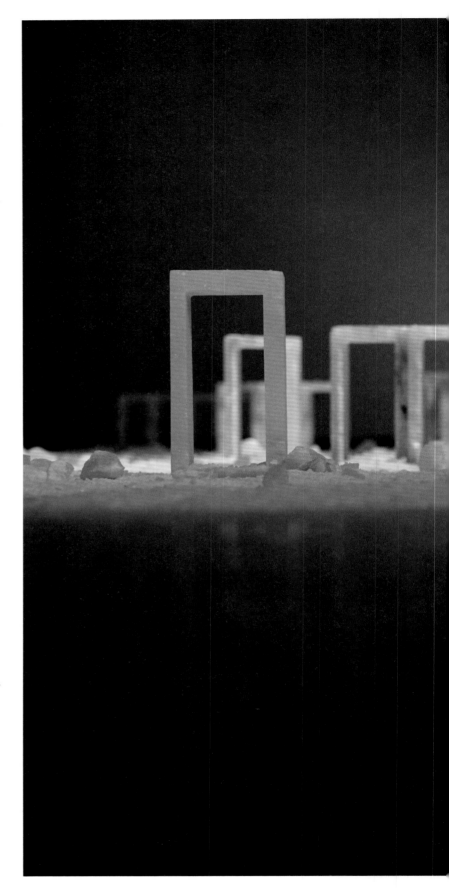

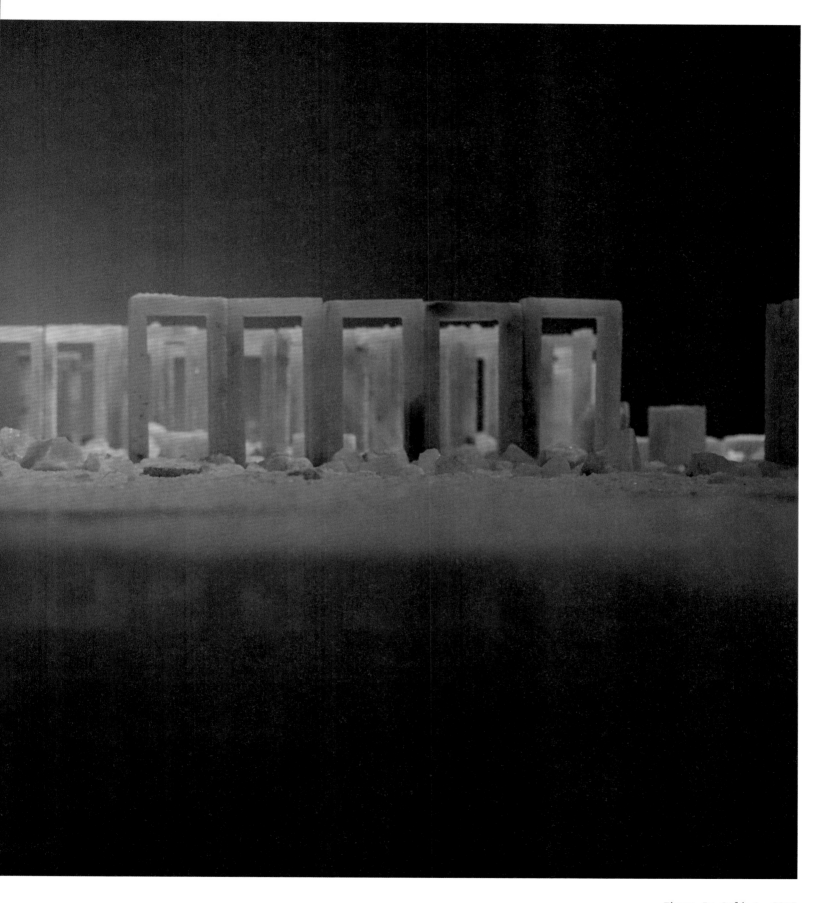

There Is Salt 1, 2017
Installation variable dimensions

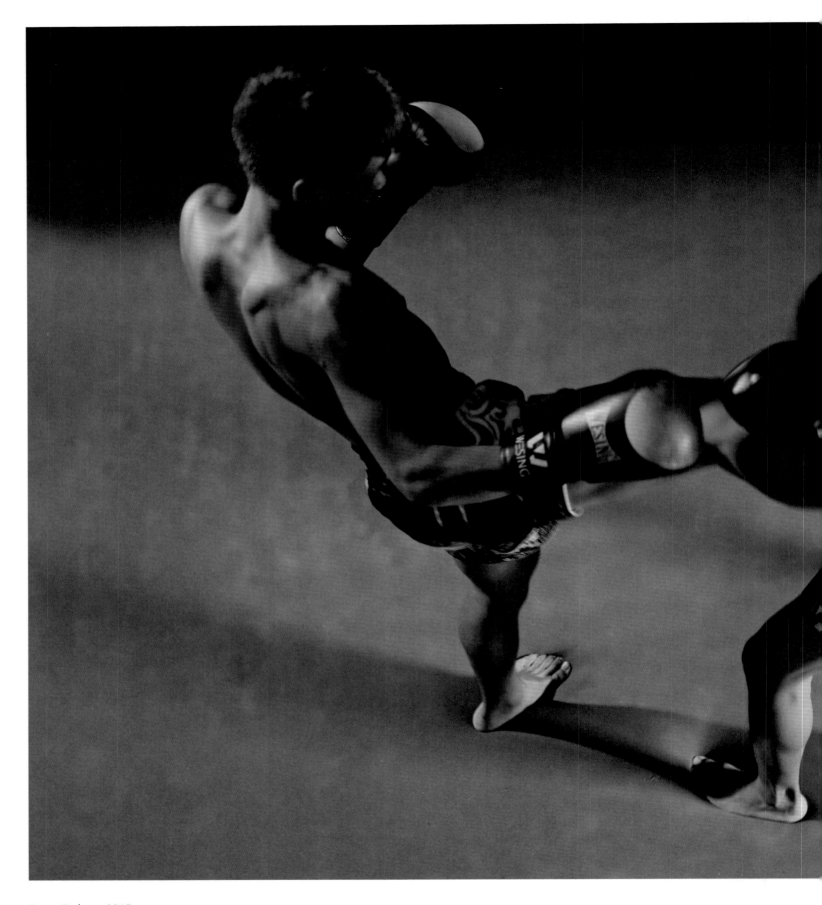

Yes, Today, 2017
Live performance

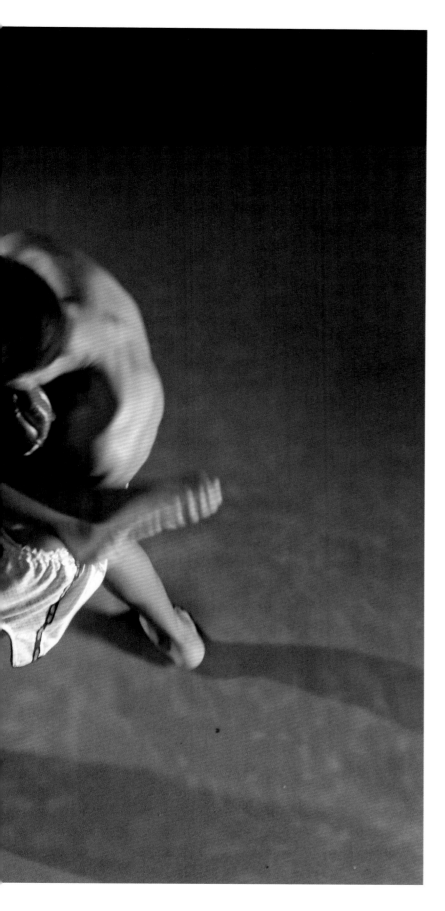

and dialogues, video recordings, the creation of an installation with a documentary part, and a space where spectators are invited to join an improvised boxing fight in this case. One thinks of Arthur Cravan, a surrealist before the time, who both boxed and wrote poetry, and also the politically committed sociologist Pierre Bourdieu, who stated: "sociology is a combat sport." All began with a series of articles about teenagers from the poor areas of Chengdu and the surrounding regions. After learning the rudiments of martial arts, the adolescents participated in clandestine fights for a little money. Once the phenomenon had been made public, it seems that the authorities put a stop to it and sent the teenagers back to their families. Li Yongzheng went to meet them and asked them to talk about themselves in front of the camera, and also to repeat some of their fights, going as far as the exhibition room. When the ring was empty, two pairs of boxing gloves were made available to visitors who wished to face each other. There was no need to explain the metaphor—it smacks you in the face like a straight punch or a well-placed hook.

Art as a Boxing-fight, Art as a Life Practice.

Defend Our Nation

Medium: Ready-made, installation artwork

Materials: Bricks, video

Size: 530 x 110 x 110 cm, variable

Description: The artist departed from Chengdu, traveling 7,000 kilometers round-trip. At Luobubo (Lop Nur) Center, an abandoned military site, the artist used new bricks to repl broken and old bricks forming the words, "Defend Our Natio

Explanation: Luobubo is situated in Xinjiang Uighur Autonomo Prefecture, near a lake in the southeast. The lake is located at the lowest point of the Tarim basin, where the Tarim River, Kongque River, Che'er River, and Shule River all come together, forming China's second largest saltwate lake. By the 1960s, this lake had completely dried up and was thereafter nicknamed the Dead Sea. Loulan city, in the northeast, is famous for its Silk Road, which was active fo eight hundred years, until the seventh century when it fel into disuse. On October 16, 1964, Luobubo detonated its fi atomic bomb

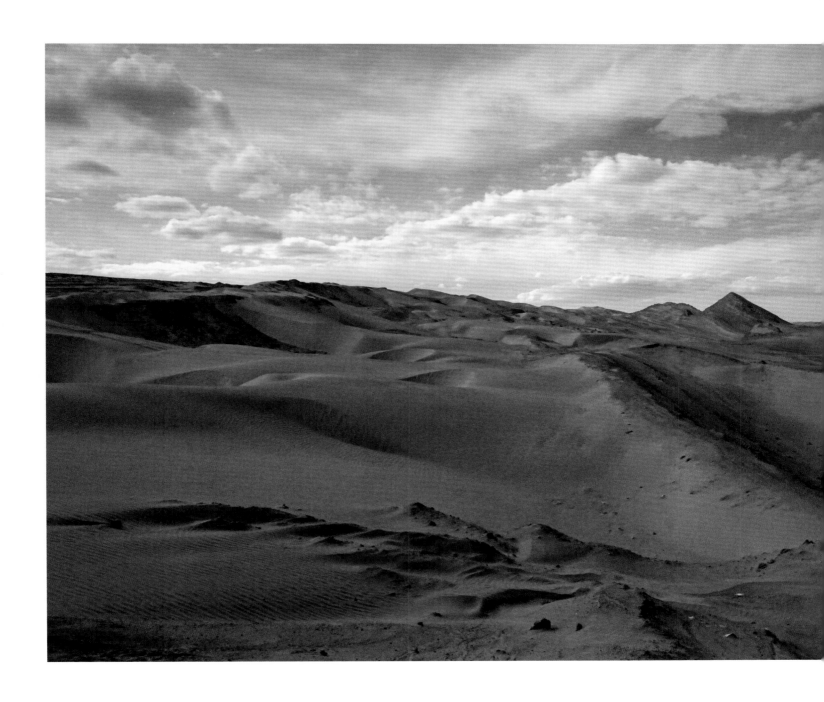

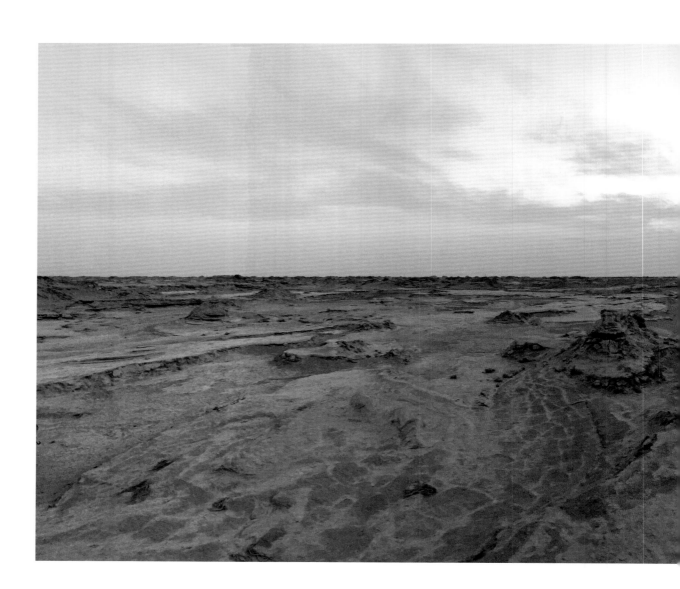

Defend Our Nation, 2015

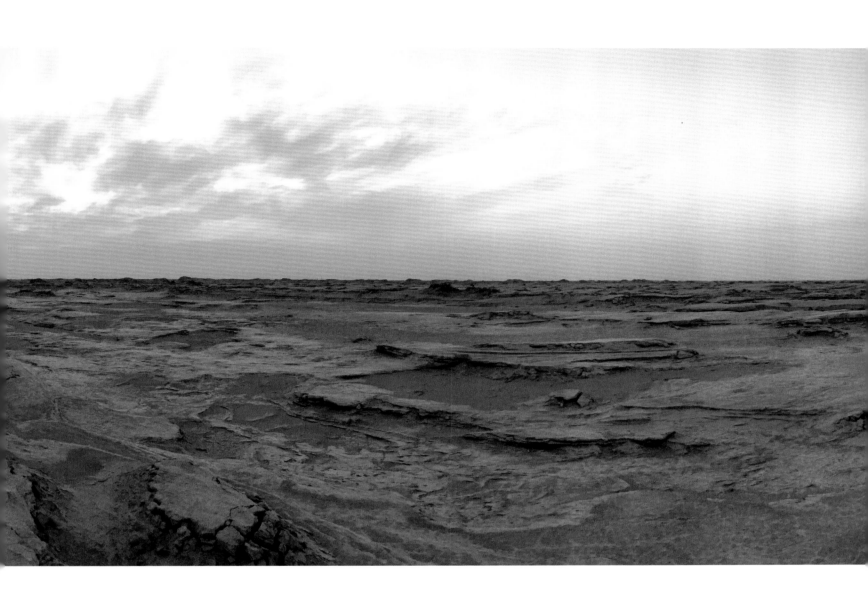

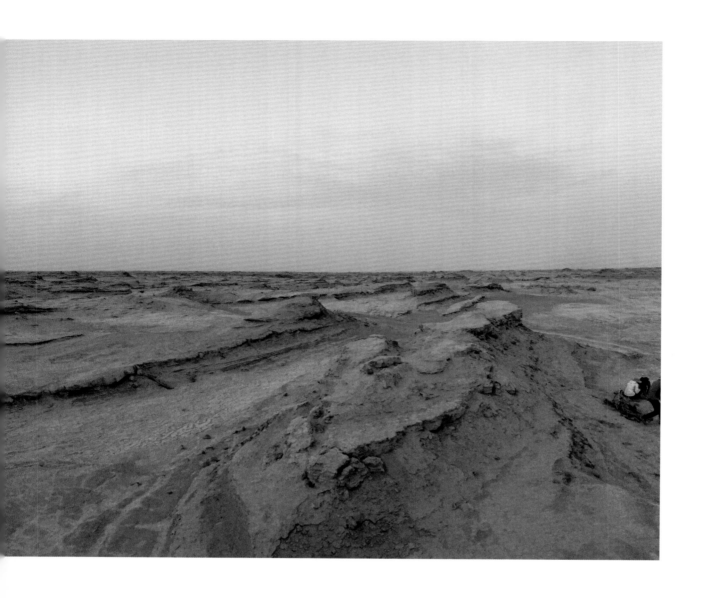

Defend Our Nation, 2015

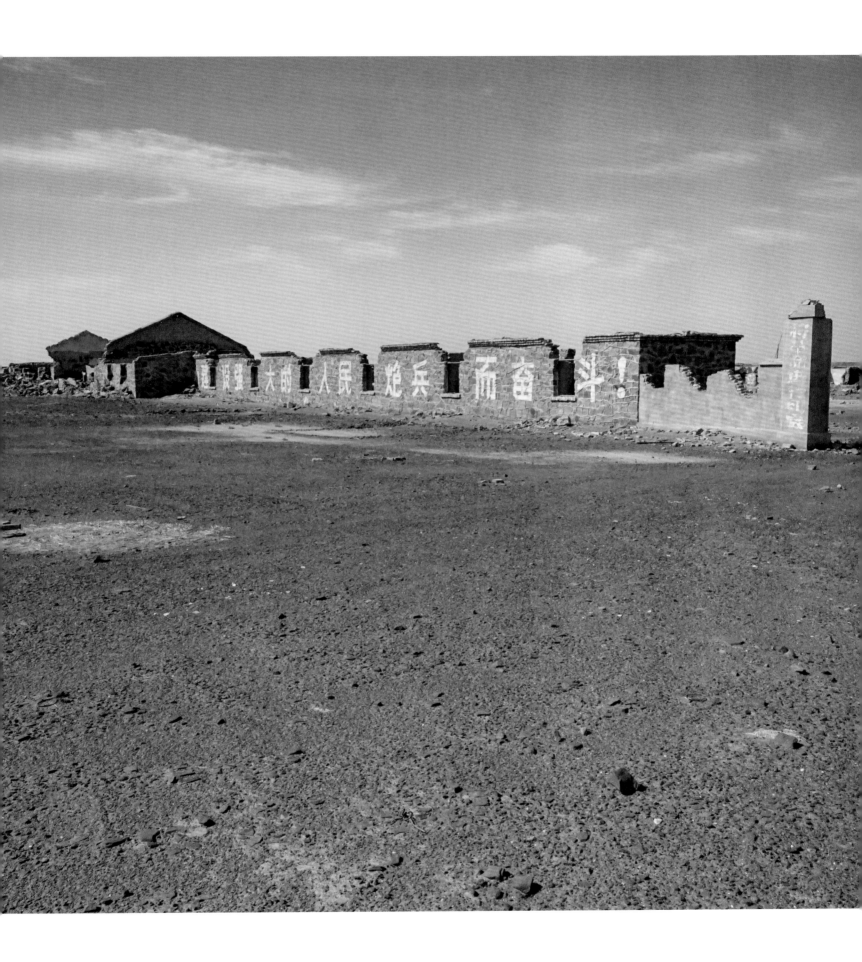

Defend Our Nation, 2015

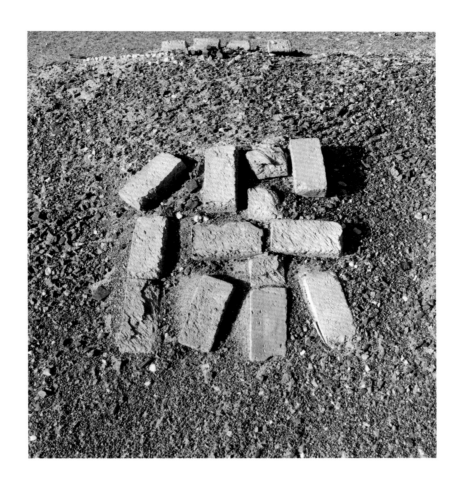

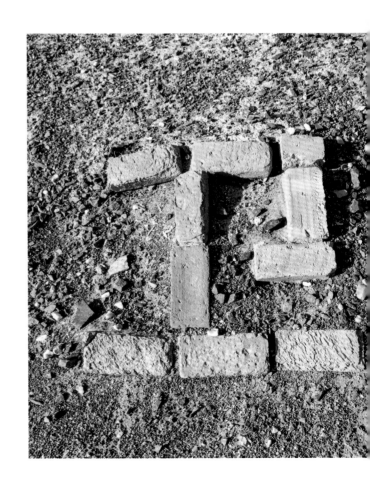

45

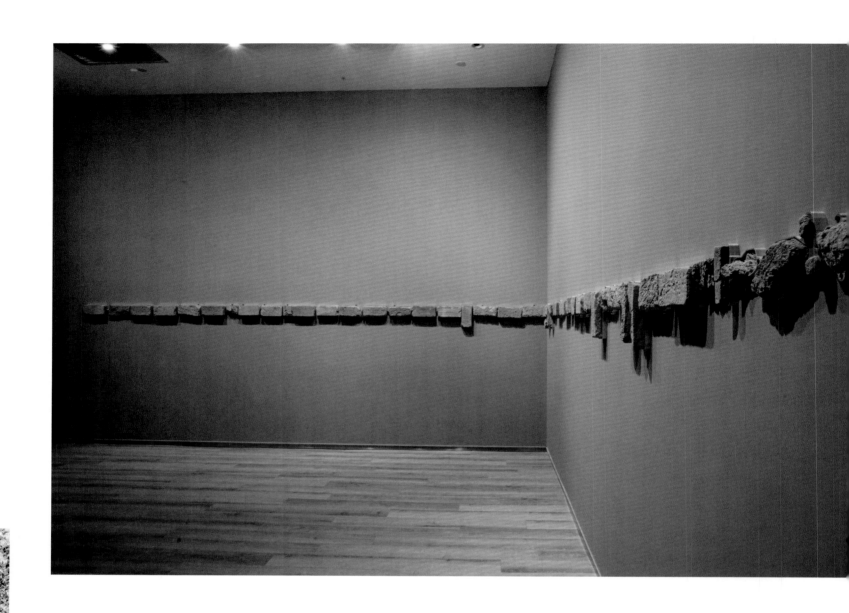

Defend Our Nation, 2015

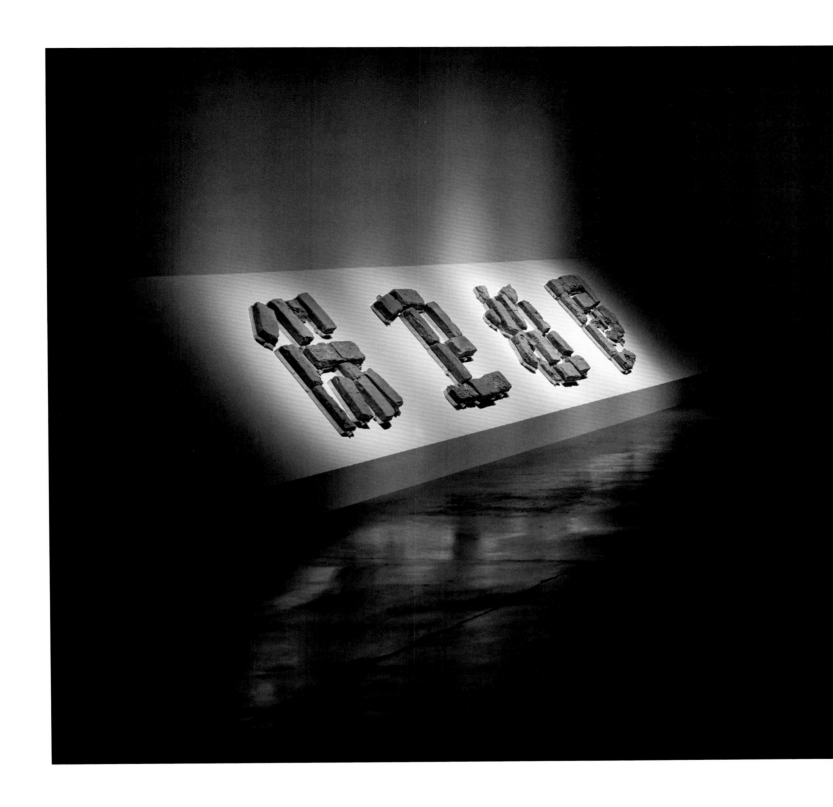

47

Defend Our Nation
A conversation between Lan Qingwei and Li Yongzheng

Lan Qingwei: When you headed out from Chengdu to Lop Nur, did you know when you got there that you'd find the words "Defend Our Nation" spelled out in bricks?

Li Yongzheng: I have an adventurer friend who's been to the heartland of Lop Nur. One time, he was exploring and taking pictures when he found this sign, right in front of an old, abandoned site. He said that area was named Xin Kaiping Airport, which connected the Lop Nur nuclear testing site to the rest of China. Lop Nur had been a nuclear and hydrogen testing site since the 1960s; even China's first atomic explosion went off at that site.

Lan Qingwei: How did you feel when you first saw the bricks? How was it to see them laid out like that, after so much time had passed?

Li Yongzheng: When I set out that day from the army corps 34th regiment base and headed into no-man's land, it took until six or seven o'clock for me to finally see those four Chinese words. There I was, in the setting sun, standing in front of this huge defunct and desolate military installation. It was such a cold feeling, lonely and tragic, as if I'd arrived at the end of the world, as if I were in the midst of the apocalypse itself. After that, I came upon other defunct military areas with other billboard slogans, mostly having to do with world and human liberation.

Lan Qingwei: So why did you fixate on "Defend Our Nation," and not on other slogans?

Li Yongzheng: I felt that these specific words resonated well with what's going on today.

Lan Qingwei: Can you talk more specifically about the process of replacing the old bricks with the new ones you'd brought with you? Why this "replacement"?

Li Yongzheng: I brought a slew of brand-new bricks to the site, and together with my assistant, set to work, replacing all the old bricks. I also marked each of the old bricks with a code number denoting their original placement. My main reason for replacing them was that I didn't feel comfortable just carrying bricks away. Not that anybody would ever notice or mind, but it was the principle of the thing. Replacement was how I rationalized taking those bricks.

Lan Qingwei: This is not the first time you've used replacement in your works. It seems to be a thematic transformation of sorts, as if you are attempting to allow various elements to compose your artwork, as if you were hidden on the sidelines, a witness of sorts. What's your thinking behind this? Can you talk more about your creative process?

Li Yongzheng: In this case, replacement was a rationalization for taking the bricks away, my way of making it right. As for my audience and how they think about this replacement, what they see in it, what they think, and what they bring to the artwork; these are things I can't control. What I haven't anticipated is what I need most.

Lan Qingwei: Lop Nur is a naturally difficult place, but it's also an abandoned space. What *Defend Our Nation* conveys is a sense of contrast. Whether originally there or constructed since, can you tell me more about the historical, political, temporal, and living expression in this artwork?

Li Yongzheng: Lop Nur is in the Uighur Autonomous region of Xinjiang, known as the Dead Sea. For 100,000 square kilometers around, there is not a single trace of humankind. But it's in exactly this place that, from the time of the Great Famine in the 1950s up through the end of the 1980s, tens of thousands of military personnel came to invest their lives and work in the building of China's first atomic bomb. China stopped nuclear testing in the 90s, and our military installation was forgotten about. This place used to be verdant, with growing grass and flowing water, giving rise to great civilizations. Today we can still see traces of 3,000-year-old sun cemeteries, river cemeteries, and ruins from Loulan, which 1,500 years ago was an important site along the old Silk Road. It's so hard to put into words, this feeling of place. Every word I try to use seems vapid, dead, useless in trying to describe the specter that this place has become. What I see are the traces of the prospering and flourishing life that used to be here. I don't see the slogans, they're just like nuclear and hydrogen bombs, empty expressions of terror and hopelessness.

Lan Qingwei: Have you considered additional ways of exhibiting this? For example, making it more of a free-standing structural work, adding to it in some meaningful way?

Li Yongzheng: I show this work differently depending on the exhibition space, especially its video component. One of the videos has this voiceover that says, "We spent over five long hours slowly traversing a single extremely steep slope, through a limitless salt marsh eroded over long years. Our tires were sliced twice, and when night had nearly fallen, at last we saw a dam, so high we could barely see the top. We drove up to it, taking a right, seeing a light flicker in the distance. This dam had been built at the edge of Lop Nur, creating a salt lake that is 150 square kilometers in area. Its salt water spurted up from beneath, an emerald green turning white, as ice along the lake's edge. It was so surreal, such an unfeeling paradise at what seemed like the end of the earth. This was a government project site, harvesting potassium chloride."

Lan Qingwei: Did you encounter any trouble with the authorities when making this artwork?

Li Yongzheng: Lop Nur is still under military command, and when you enter the region, road signs read, "Military Zone, Entry Forbidden" or "Heavy Contamination, Unauthorized Entry at One's Own Risk." We were met by a patrol at the edge of Lop Nur, but nothing really happened, and I entered alongside a goods inspection company. But also, when driving into this area you needed a guide who was intimately familiar with the region's topography, and you needed off-road vehicles with special equipment to deal with treacherous terrain.

Lan Qingwei: Your artwork often operates on a level of simplicity, as if created through a pinhole. Your thinking is very complex but the spectators see something very simple, in some cases just a single shape, line, or action. But what they perceive then refracts inwardly, giving them the time to pause and realize the complexity to which you were alluding. In your eyes, would you say this artwork is relatively complicated, or not?

Li Yongzheng: It is. As you enter this artwork, you have to know a bit about Lop Nur's background, and you need to know contemporary China's cultural context as well. For example, you need to be at least aware of the South China Seas situation, of popular opinion concerning the country's intentions and the rising surge of the Chinese people's patriotism. I want to remain as simple as possible; this is a relatively sensitive topic. It's heavy, serious, and hard to talk about.

Lan Qingwei: This artwork has three main components. Bricks are the first, "Defend Our Nation" is the second, and "replacement" is the third. You juxtapose these three elements and get your resulting artwork. Which would you say is the crucial and pivotal element? Would you say it was the change in environment from Lop Nur to a museum exhibition space?

Li Yongzheng: It's all a part of the artwork. What's real is what's important. Bringing it into an exhibition space just magnifies a sense of what's real. The artwork is merely a manifestation of this sense.

Lan Qingwei: What will you do with these bricks after the exhibition? Will they be permanently displayed somewhere, or dispersed into collections? Or might they perhaps undergo another transformation, into another artwork?

Li Yongzheng: I'm not sure. Who can say anything definite about the future? We'll have to see what spark sets off the next incarnation.

Border Post

Medium: Video, installation

Duration: 17 minutes

Description: The artist removed a post from the Chinese Xinjiang border and transported it to coordinates N: 93 • 34'25" – 93 • 46'56" E: 40 • 10'05" – 40 • 22'58" where there is an ancient segment of the Great Wall of China dating to 2,000 years ago. The post was then carried, following the perimeter of this old crumbling border wall, until it arrived at an old fire beacon where it was then placed in the ground.

Explanation: In ancient times, fire beacons were used to light fires to convey important messages. It was an important military defense facility and was built to prevent foreign enemy invasions. It is the oldest but most effective method of messaging.

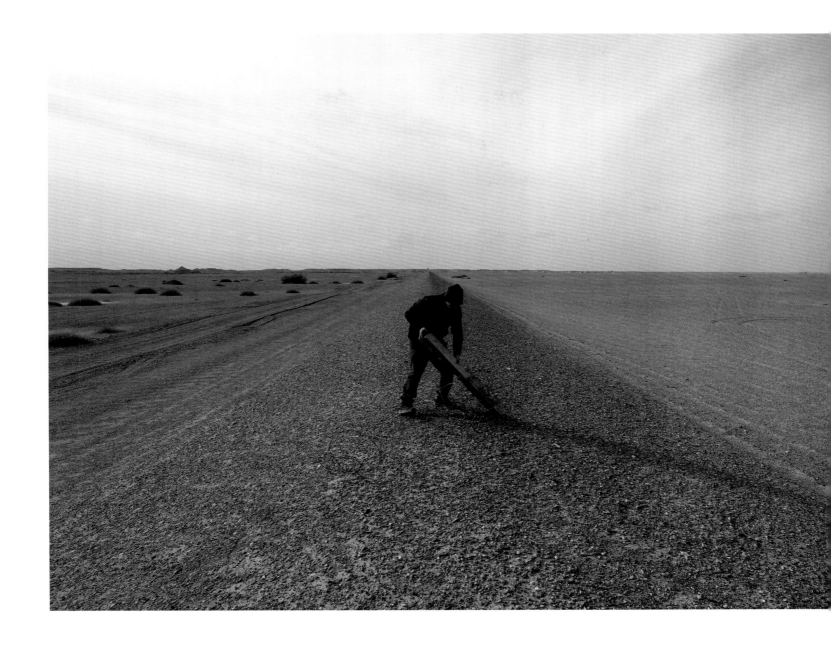

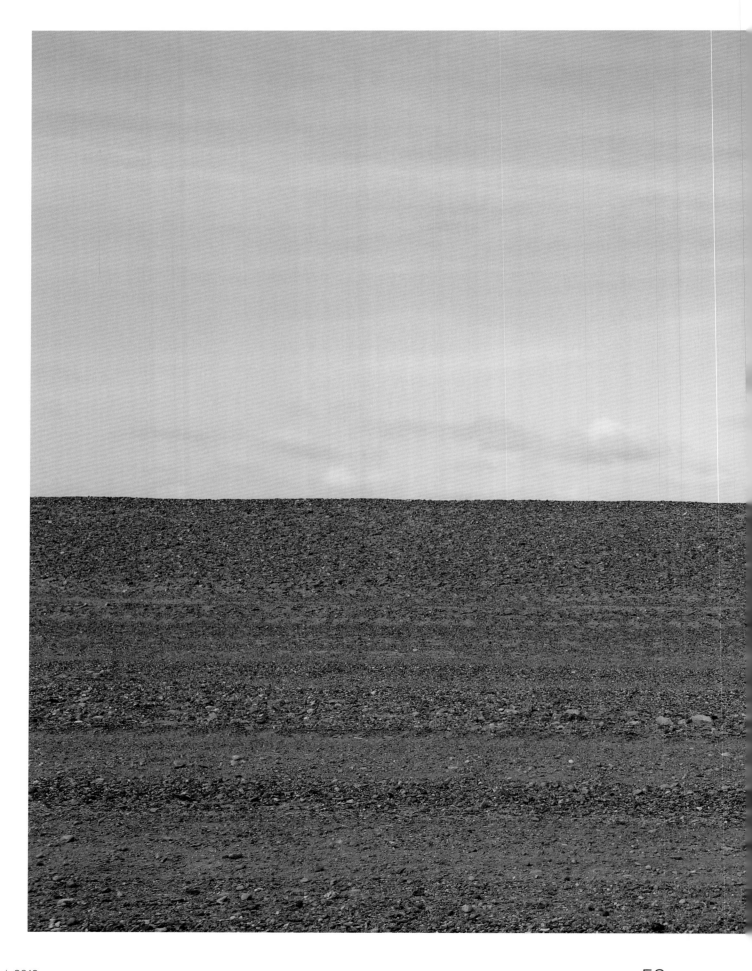

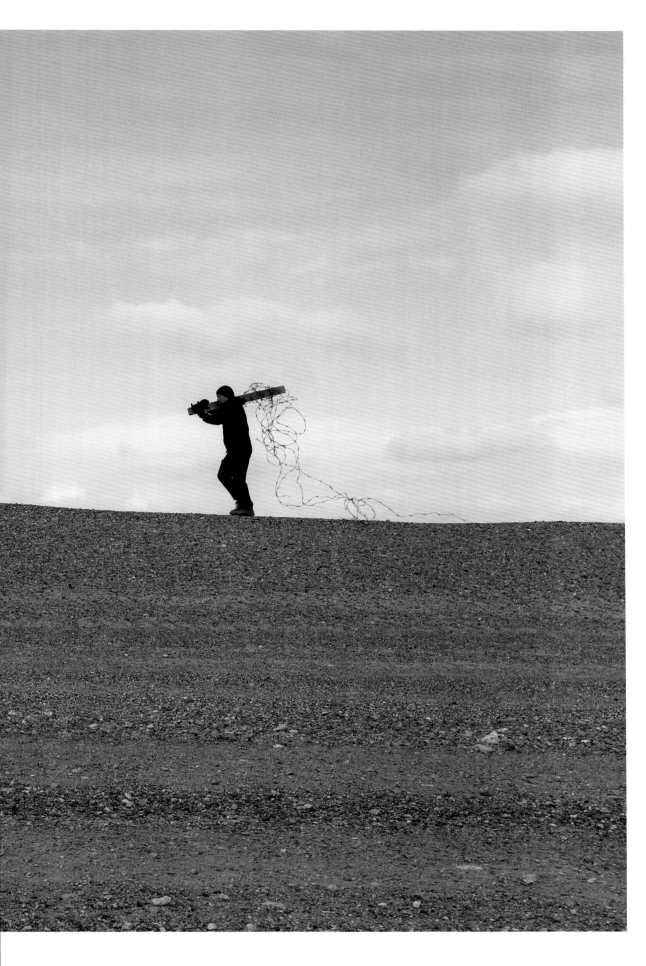

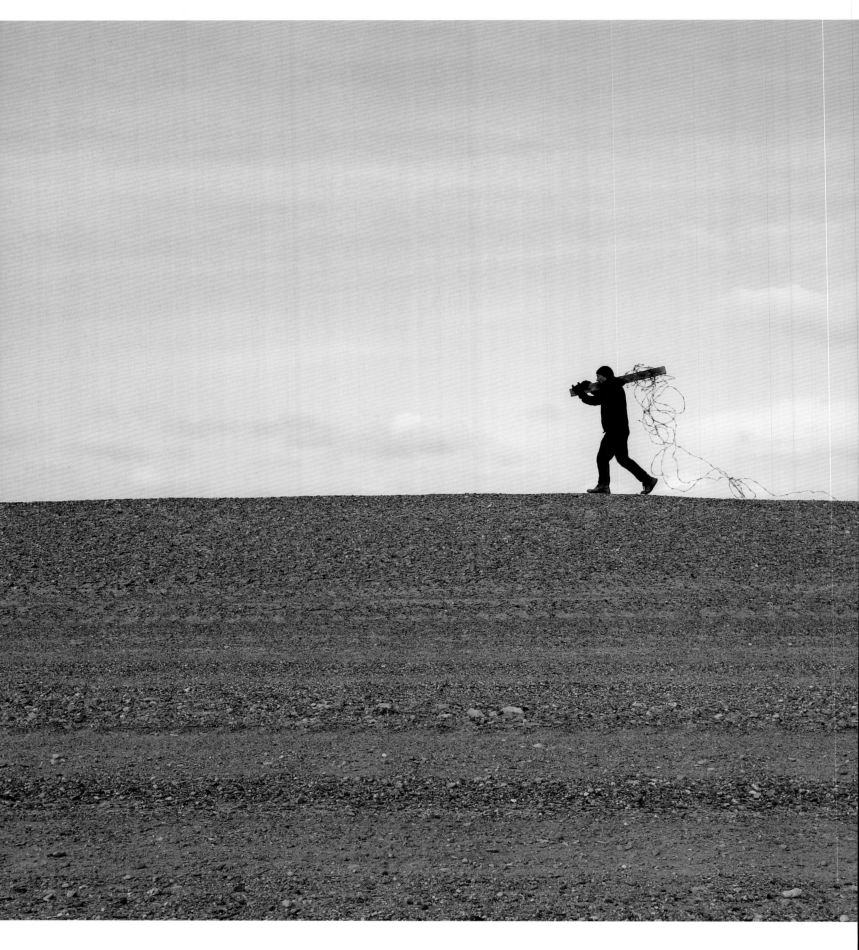

Border Post, 2019

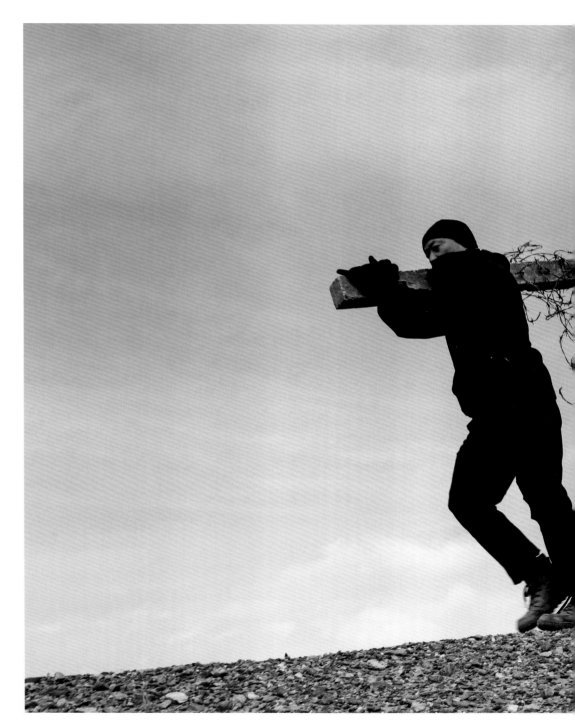

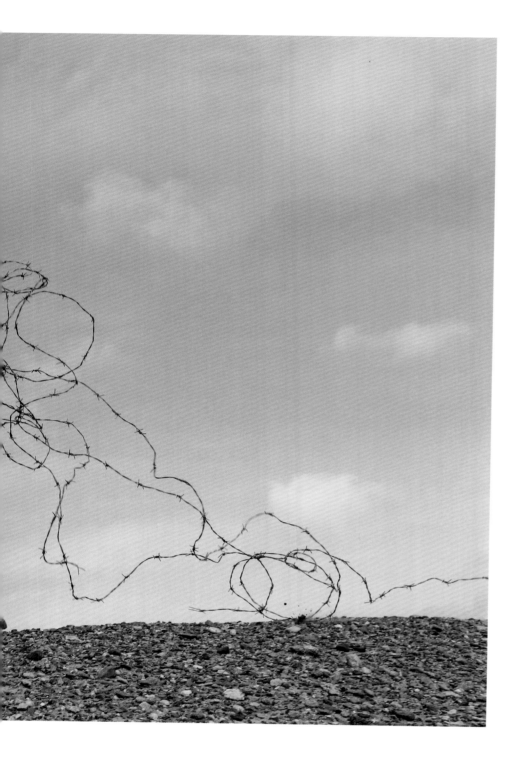

Border Post, 2019

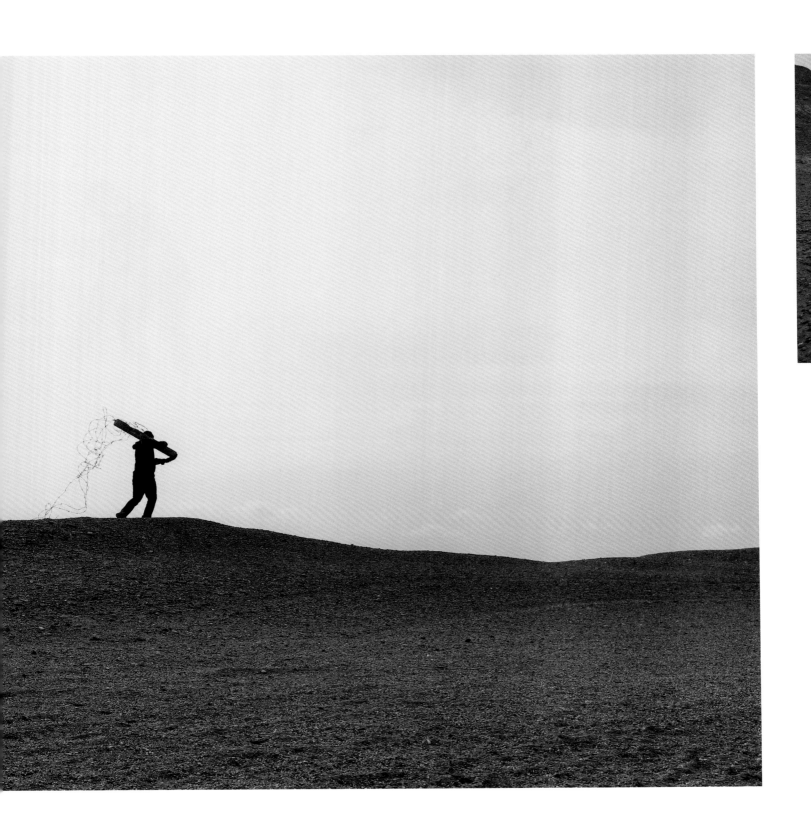

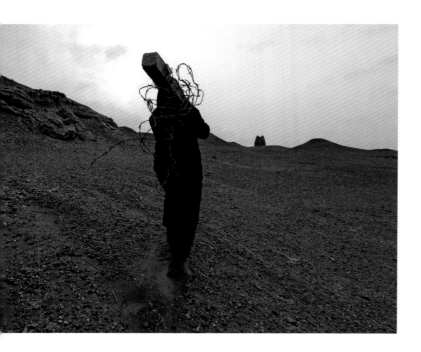

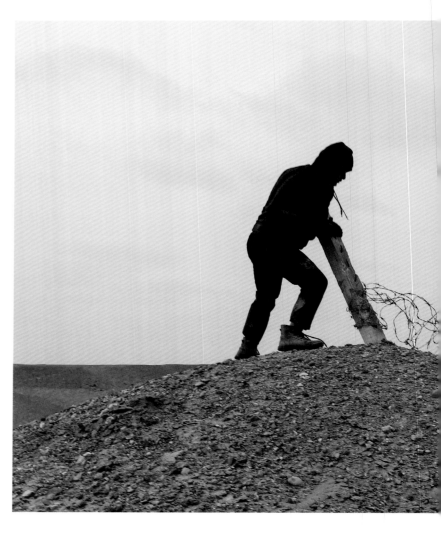

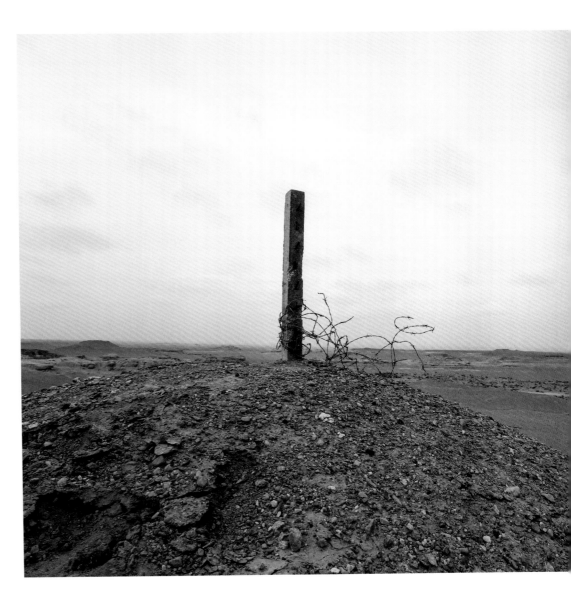

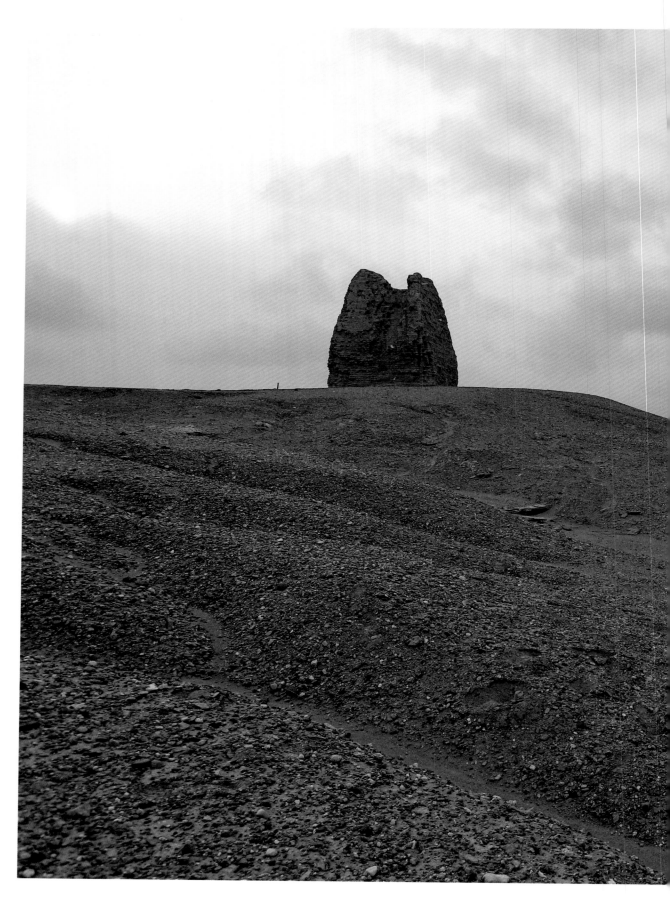

Border Post, 2019

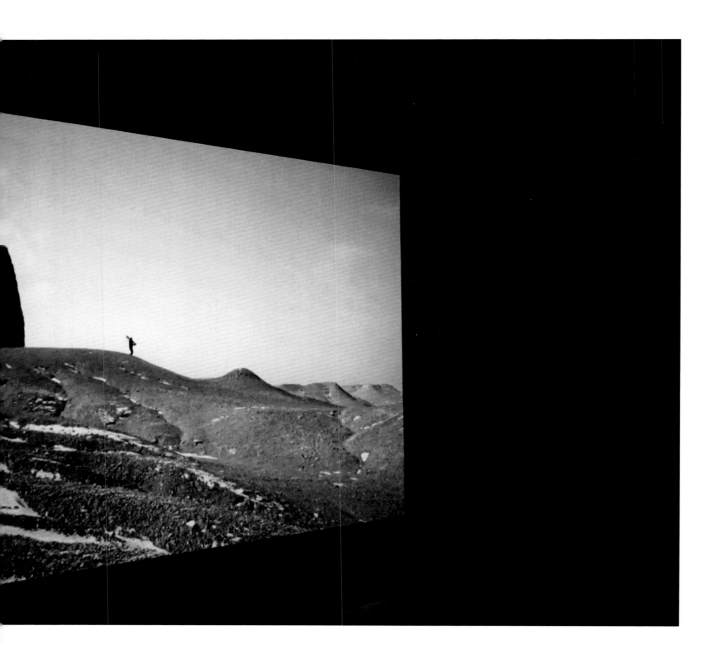

Border Post, 2019

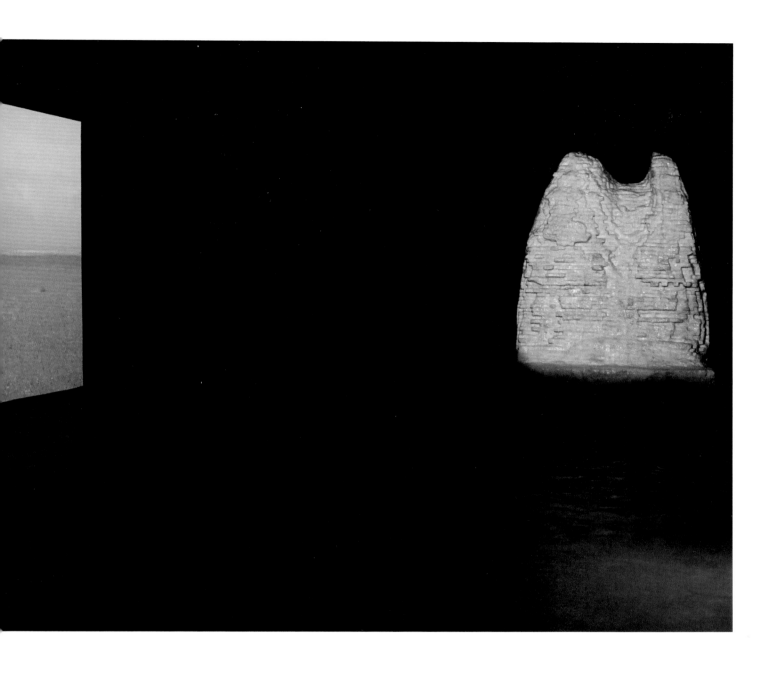

edium: Installation, video

aterials: Laser pens

uration: 4:30 minutes

escription: Laser pens were placed along a 100-meter section
of China's western border. The laser beams interwove with one
another, creating the effect of a flickering red net in the
hazy air.

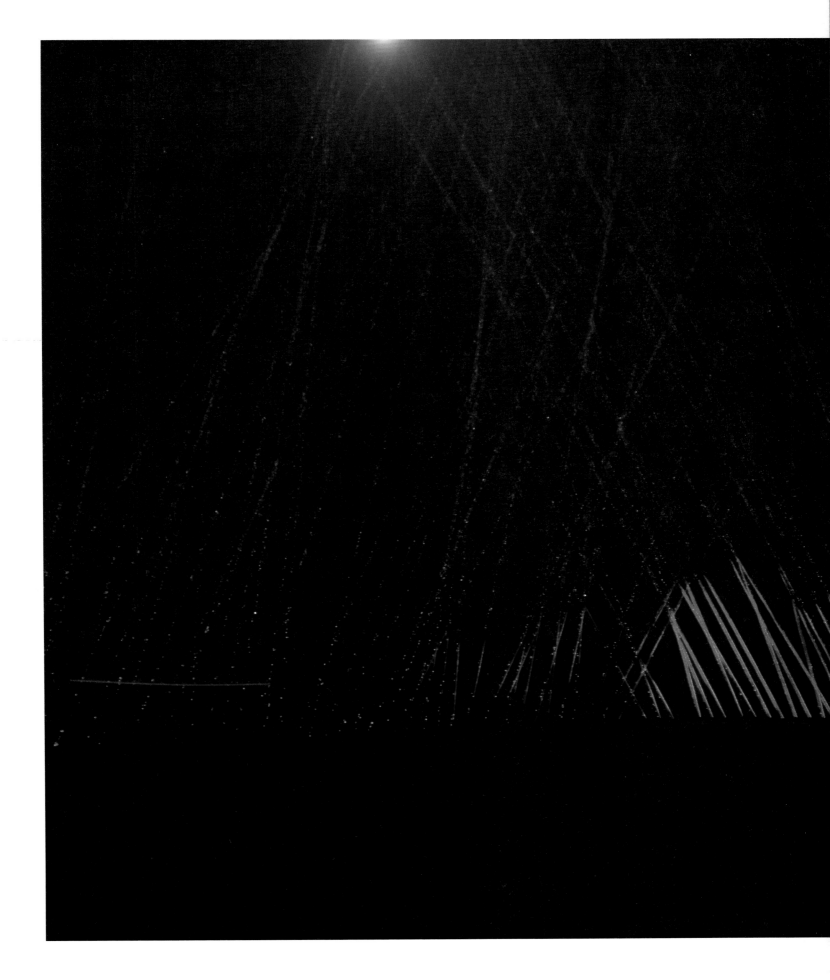

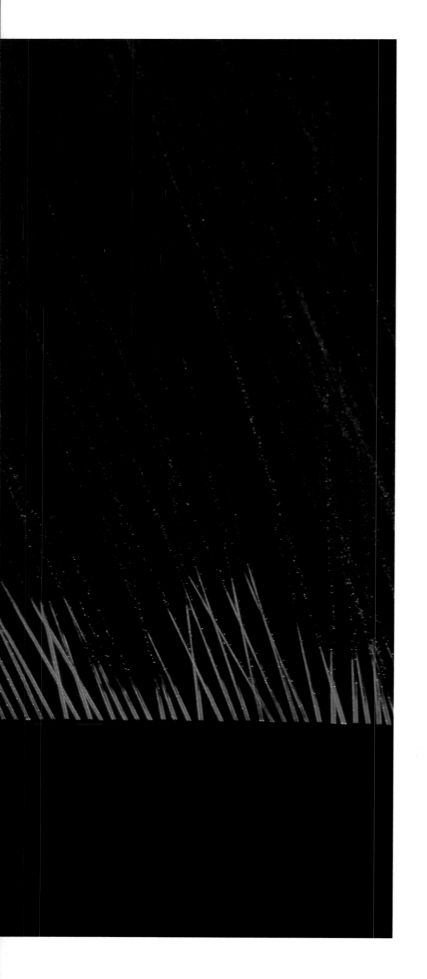

Lasers, 2019

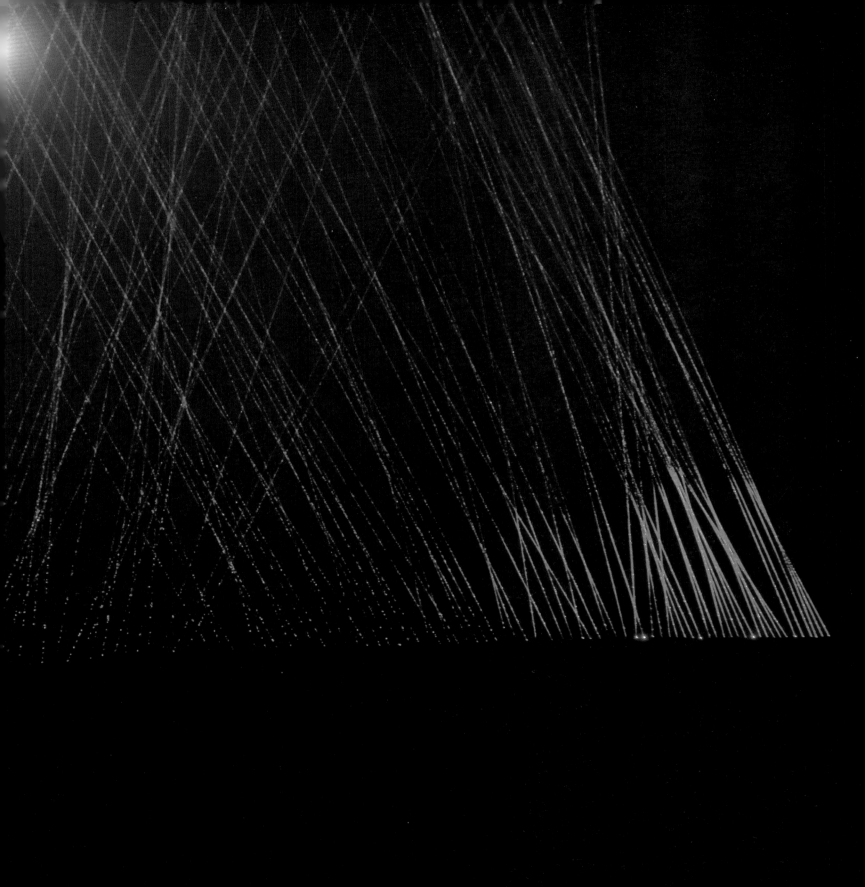

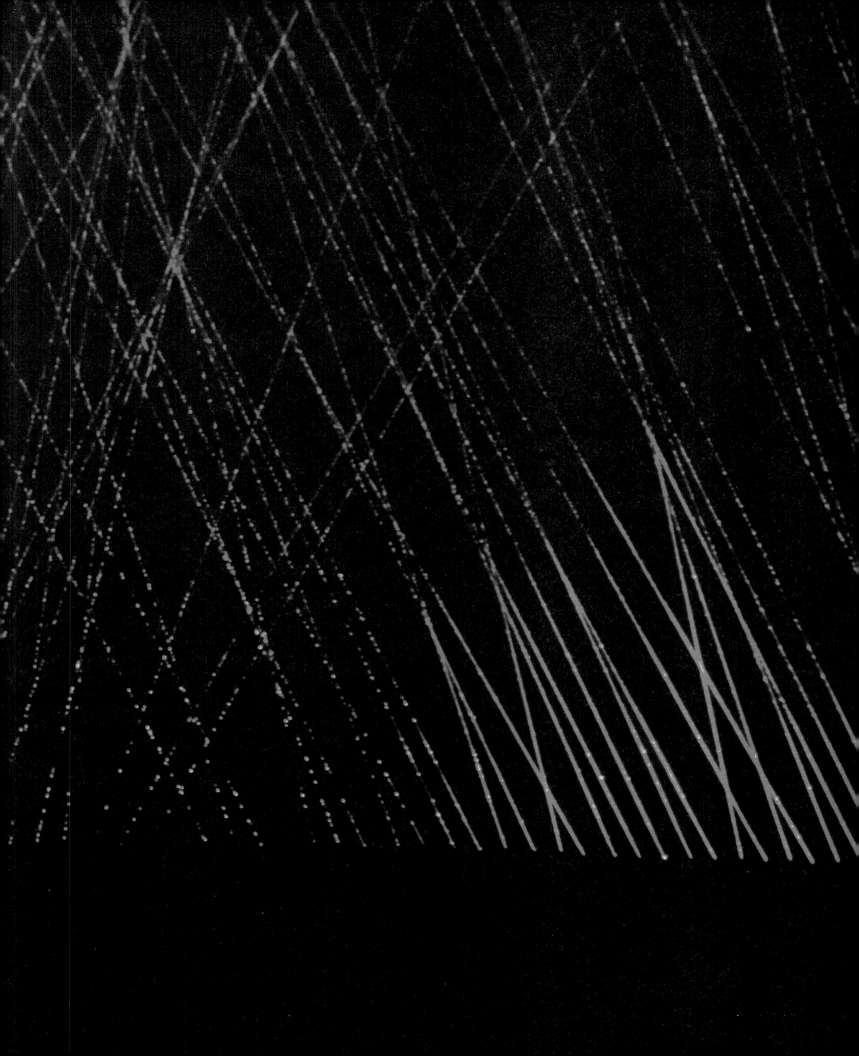

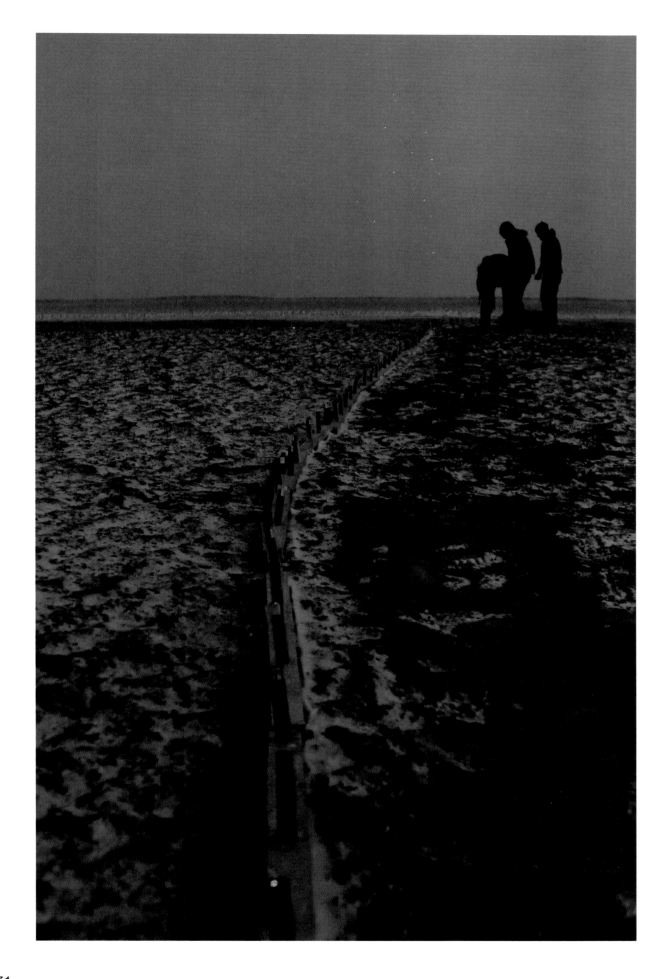

ferent Kinds of Willpower
ferent Will 1

um: Oil painting

: 200 x 360 cm

73

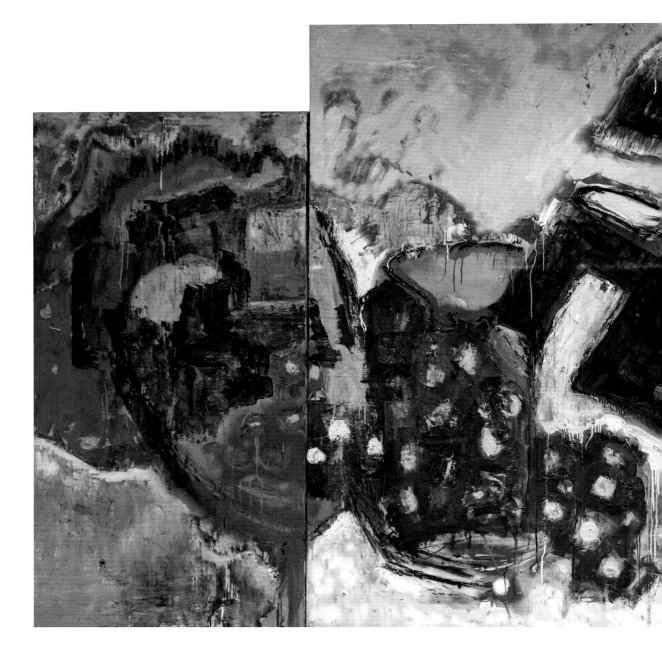

Different Kinds of Willpower - Different Will 1, 2019

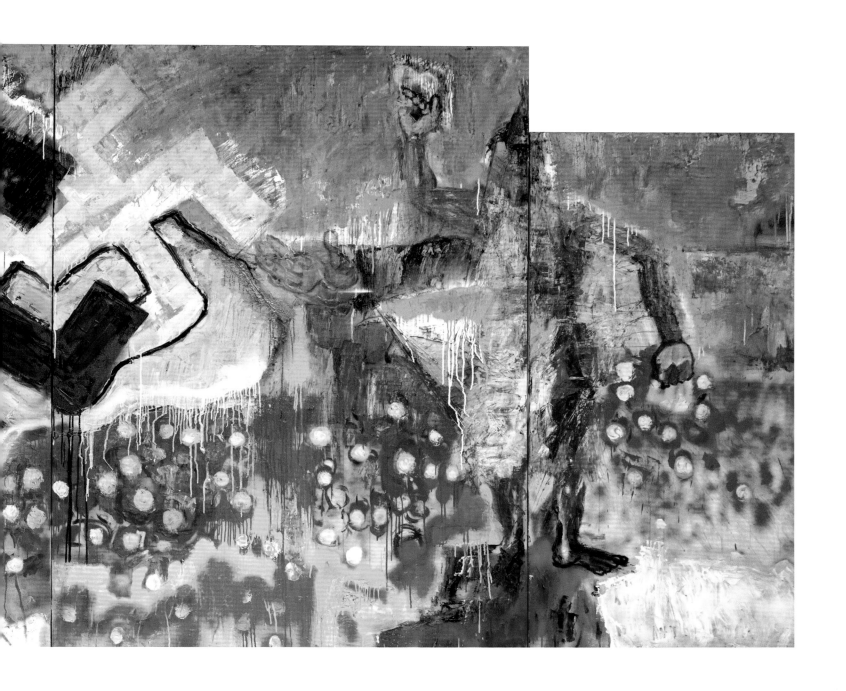

Different Kinds of Willpower
Different Will 2

<u>Medium</u>: Installation

<u>Materials</u>: Himalayan salt bricks

<u>Size</u>: 1500 x 600 x 150 cm, variable

<u>Description</u>: The installation is comprised of a 150-centimeter-high swastika made of Himylayan salt blocks set on the floor. Both sides of the symbol are connected to the exhibition space wall so that when looking at the work, it is difficult for the audience to see the full shape.

<u>Explanation</u>: The swastika is a sacred symbol for Tibetan Buddhism in the Himalayas, a religion that experiences love and compassion. It is also an ancient human symbol that appeared in Sumerian patterns six thousand years ago. However, it is mostly known for its usage by the Nazis in the twentieth century.

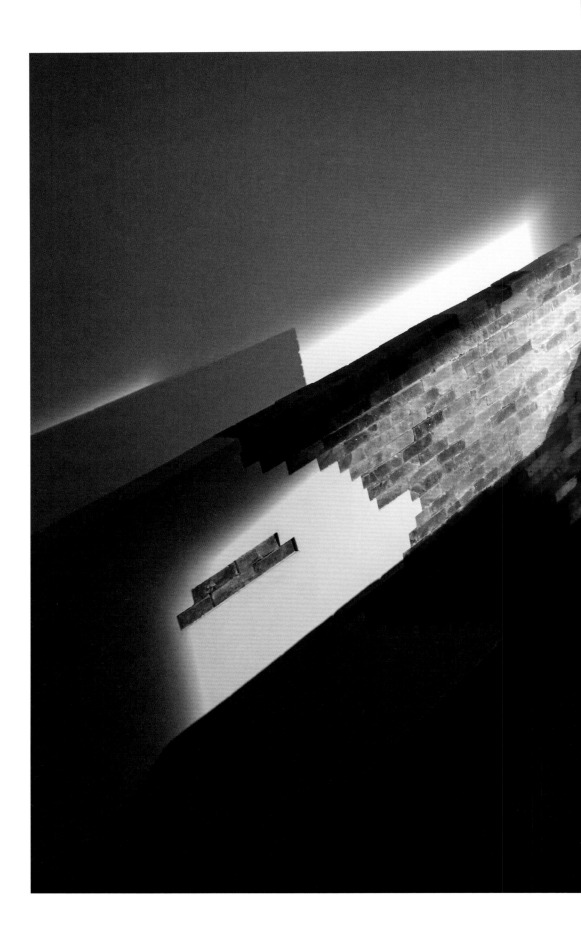

Different Kinds of Willpower - Different Will 2, 2021

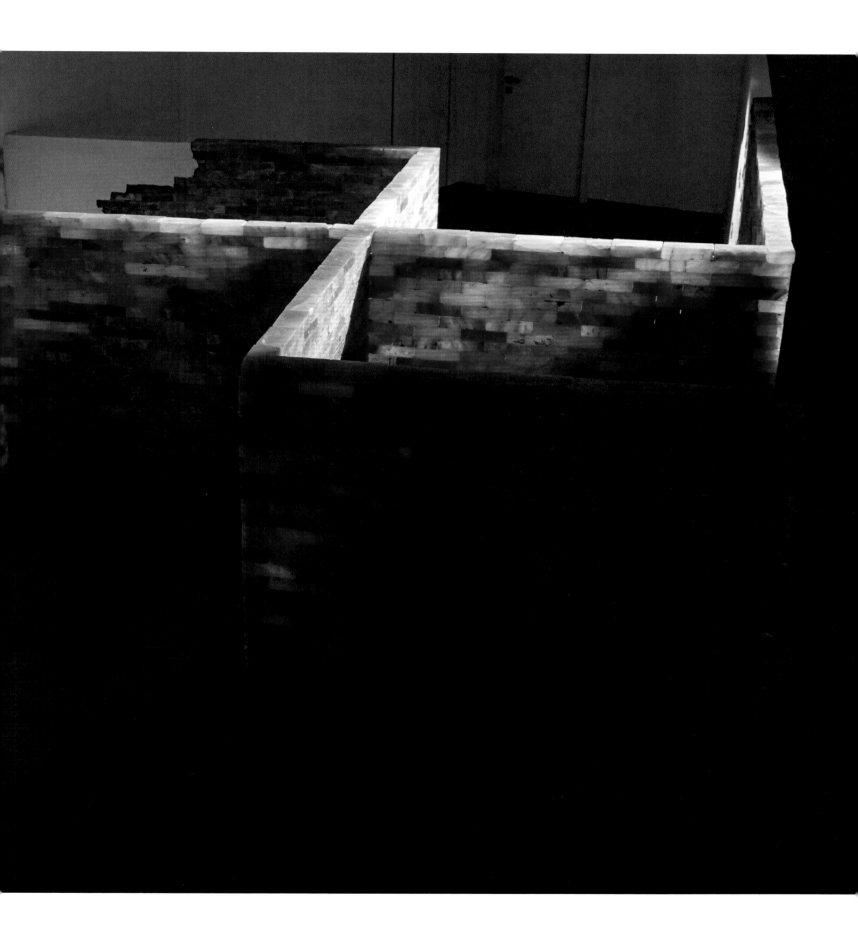

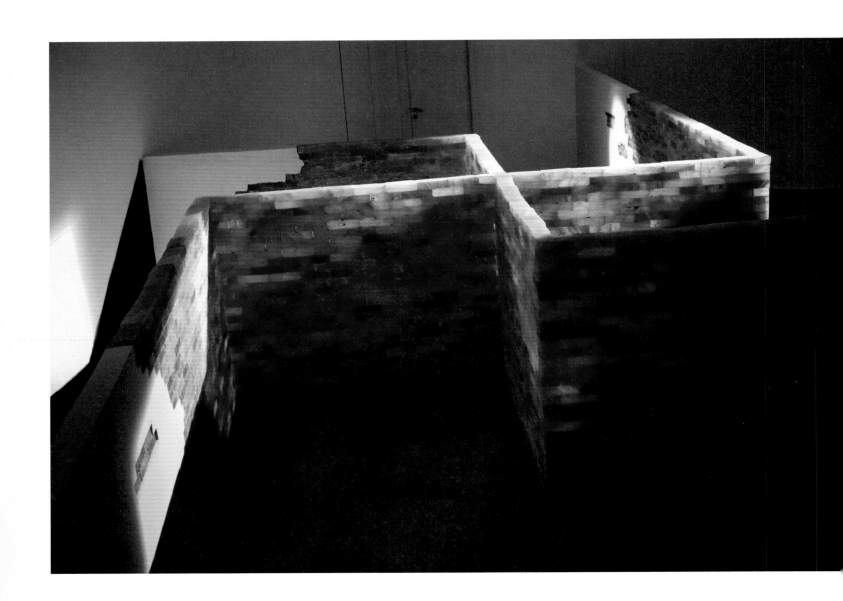

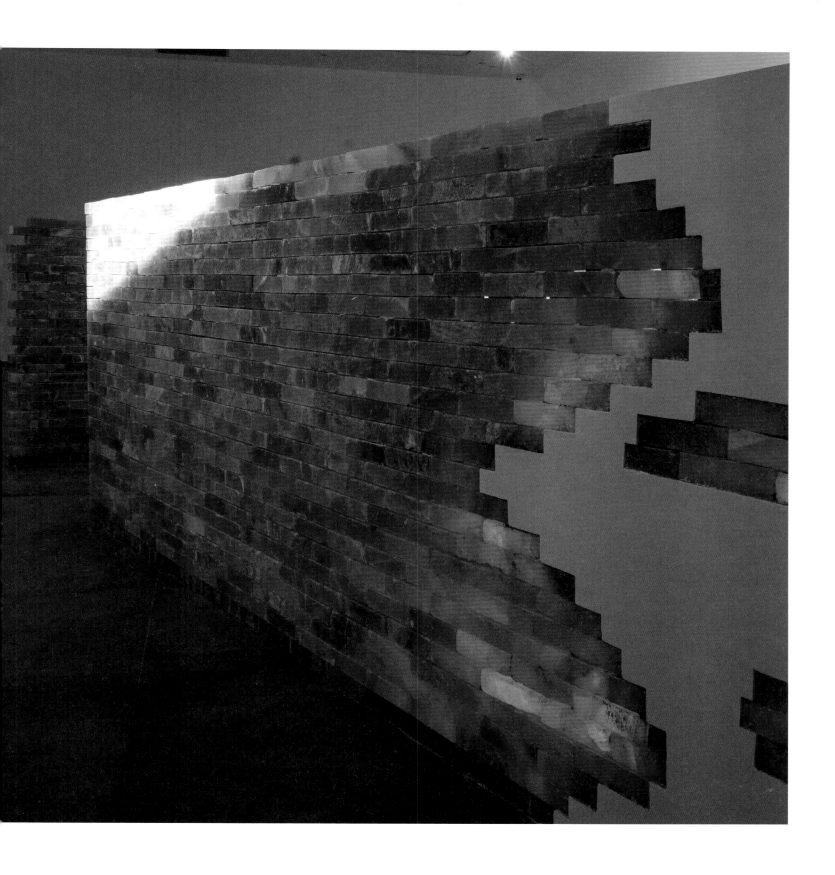

Feast

<u>Medium</u>: Two-Channels video, installation

<u>Duration</u>: 12:30 minutes

<u>Description</u>: During the outbreak of COVID-19, the artist departed from the south of China and drove to the Xinjiang desert wilderness. There, a banquet was held that was attended by Uighurs, a Chinese ethnic minority.

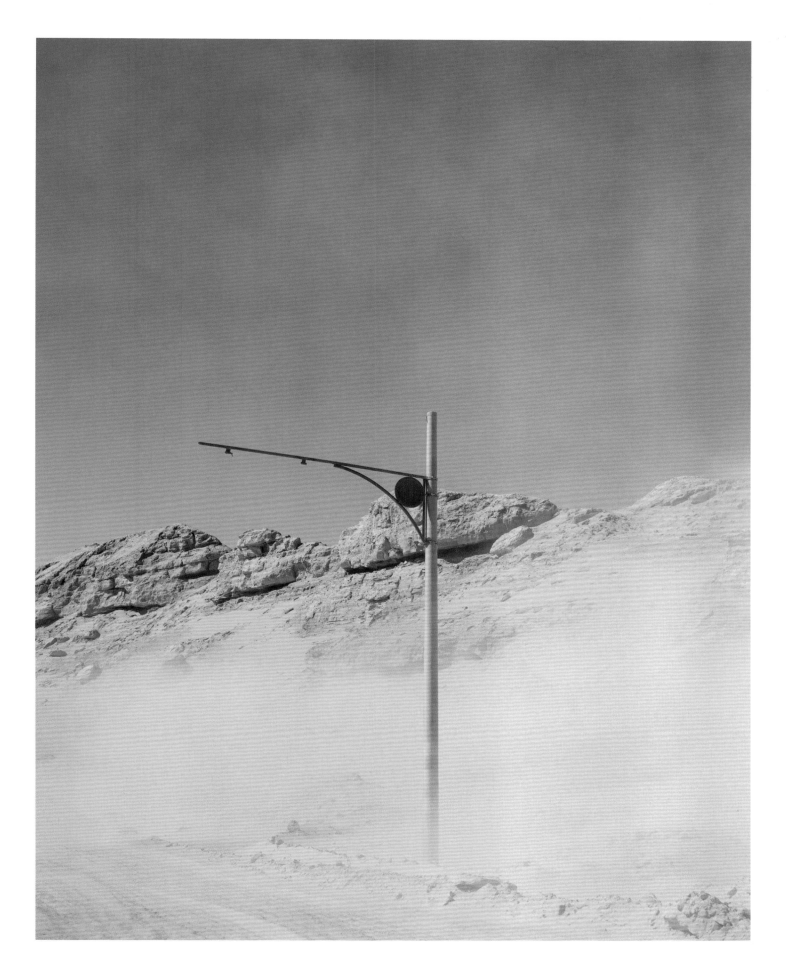

83

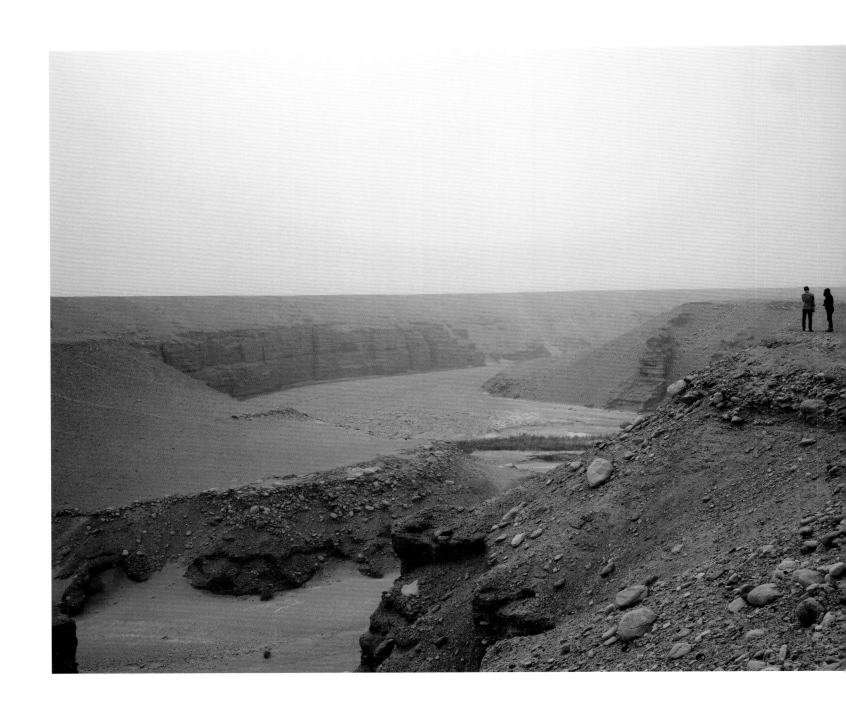

Feast, 2020

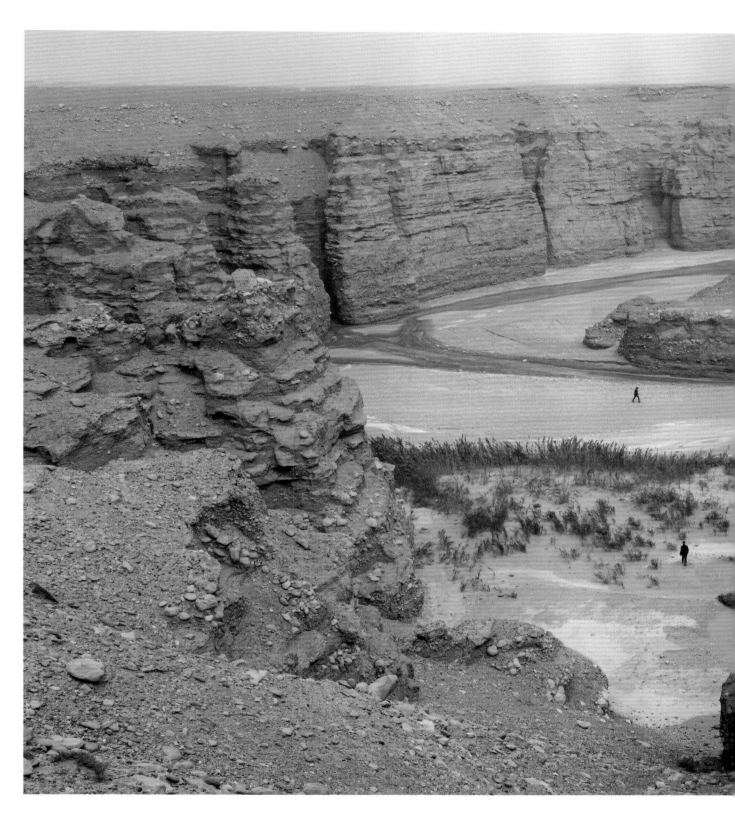

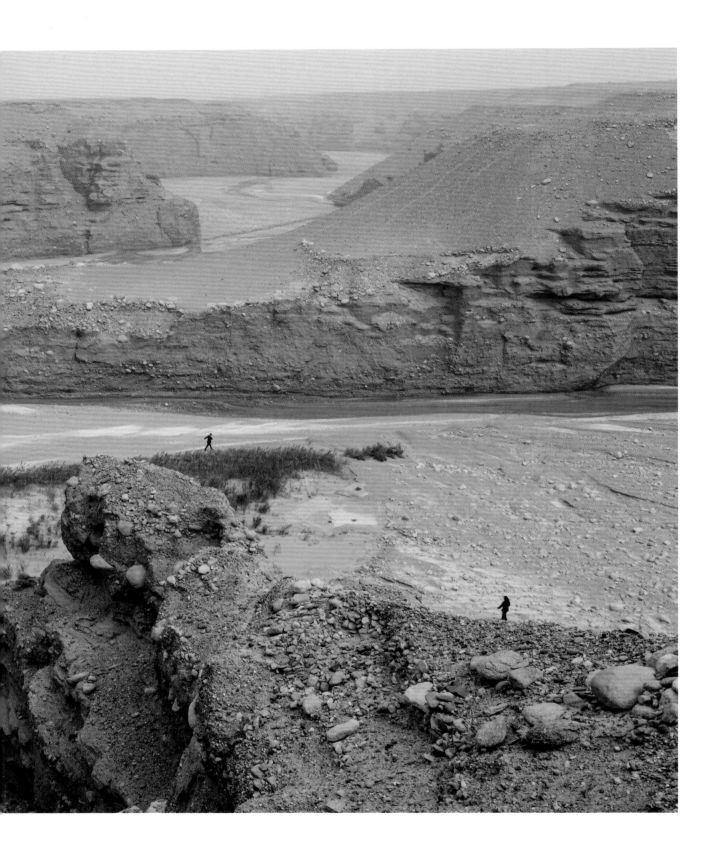

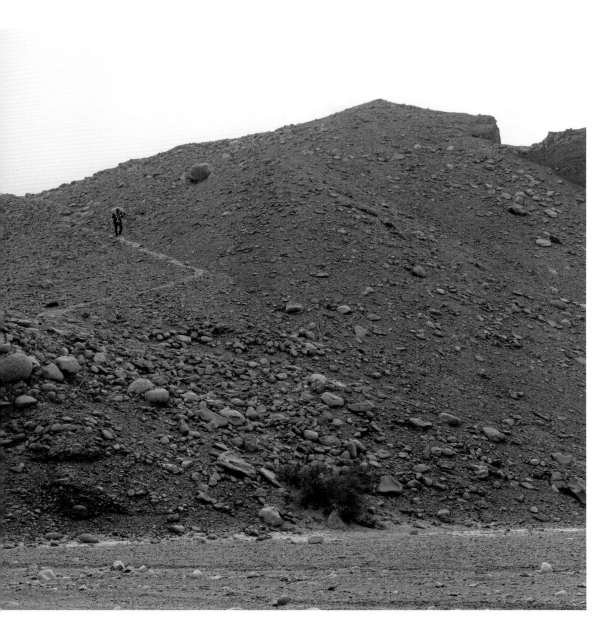

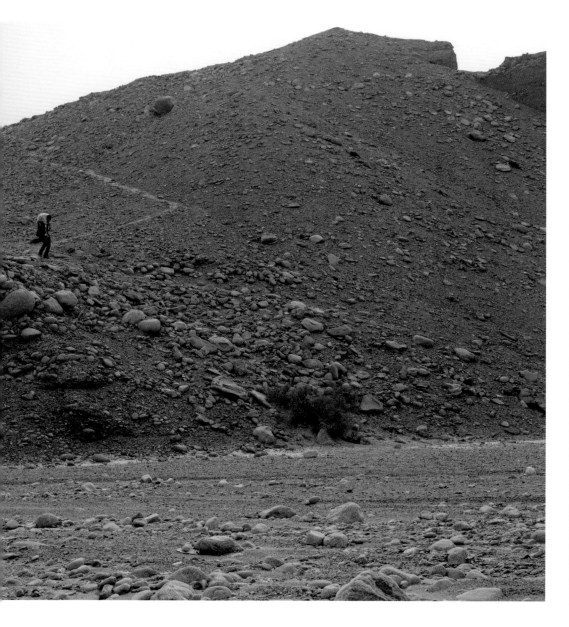

Feast, 2020

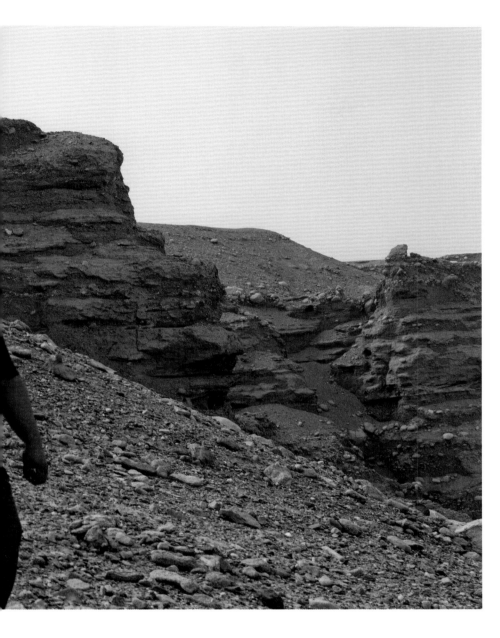

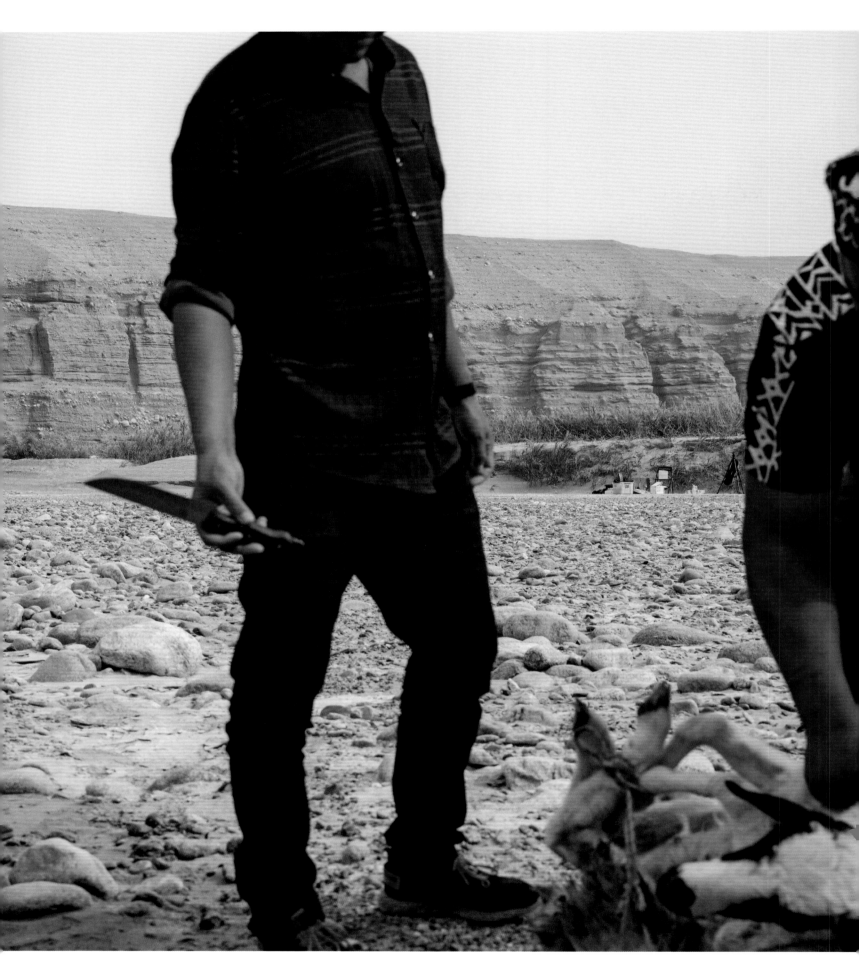

Feast, 2020

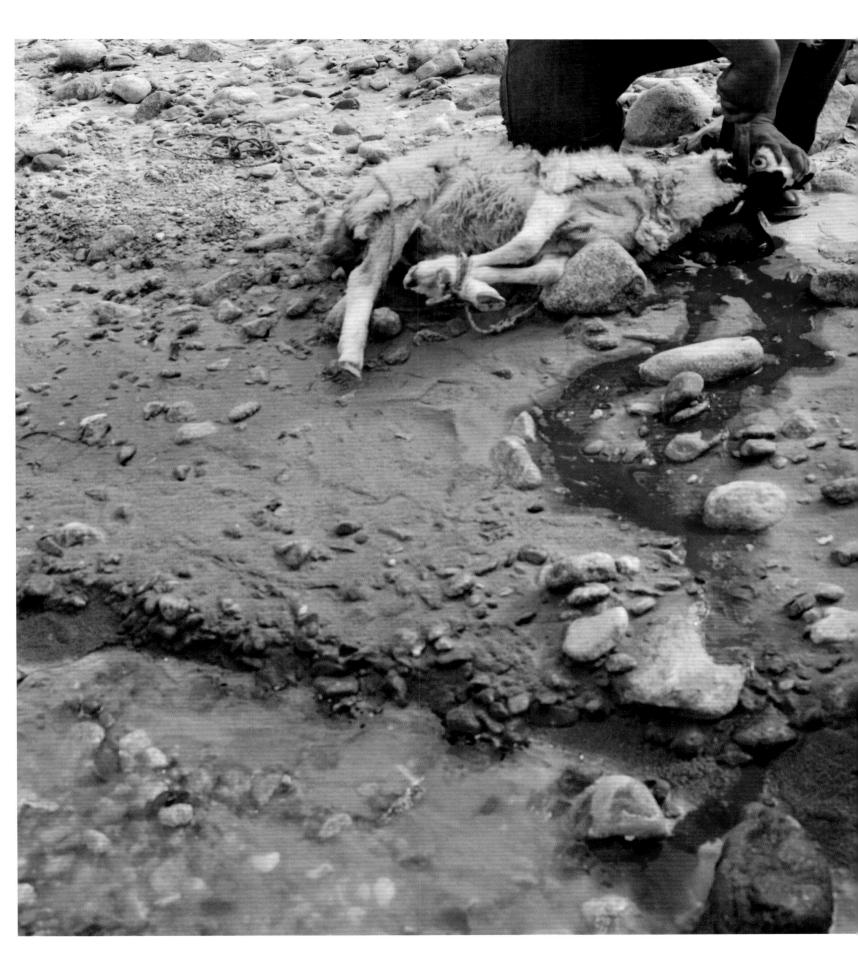

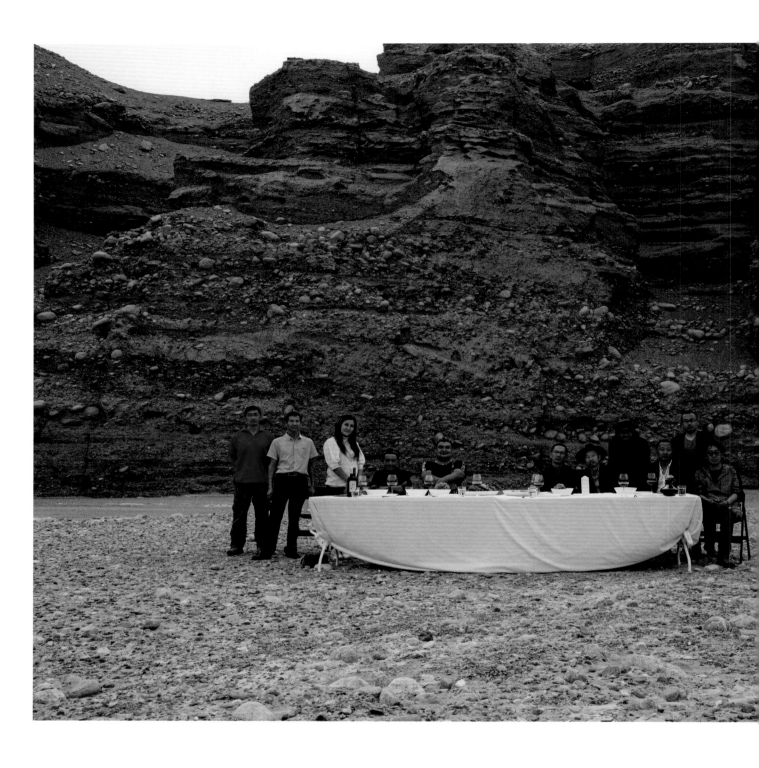

Feast, 2020

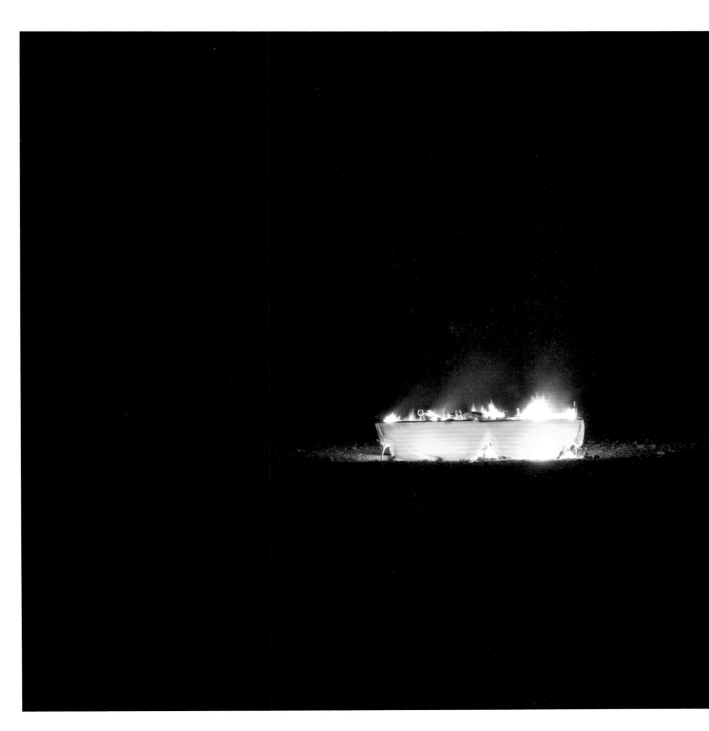

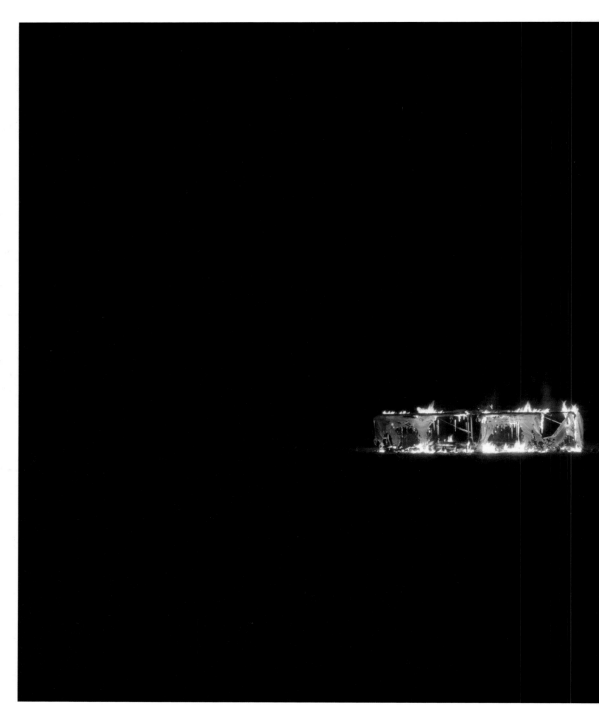

handmade carpet, wax

ist bought handmade carpets online, crafted
weaver from Ding'er, after the weaver and
to move into a new home. The carpets were
candle wax and modeled to form different
rts, flowers, mountain peaks, etc.

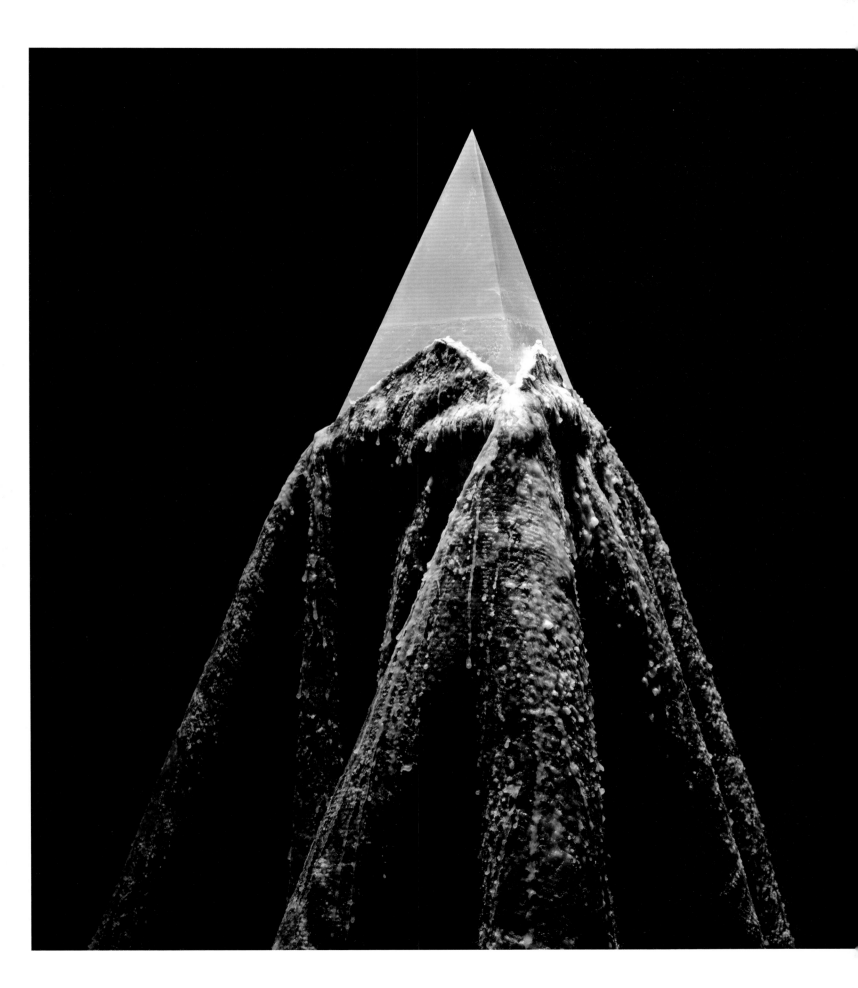

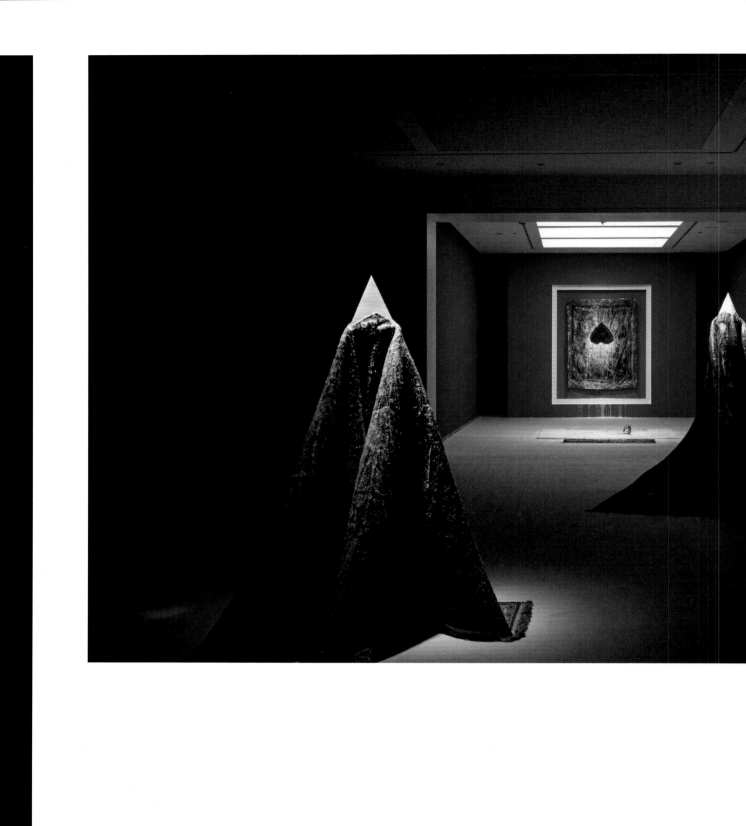

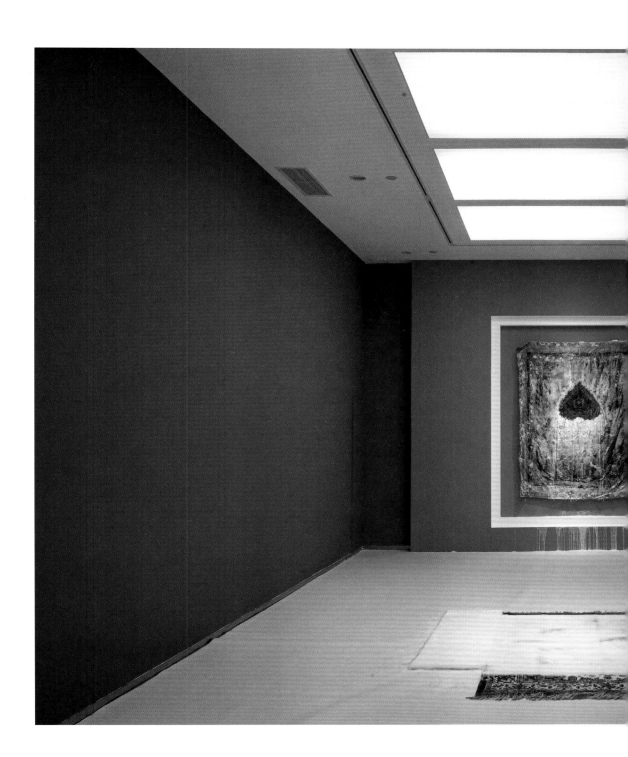

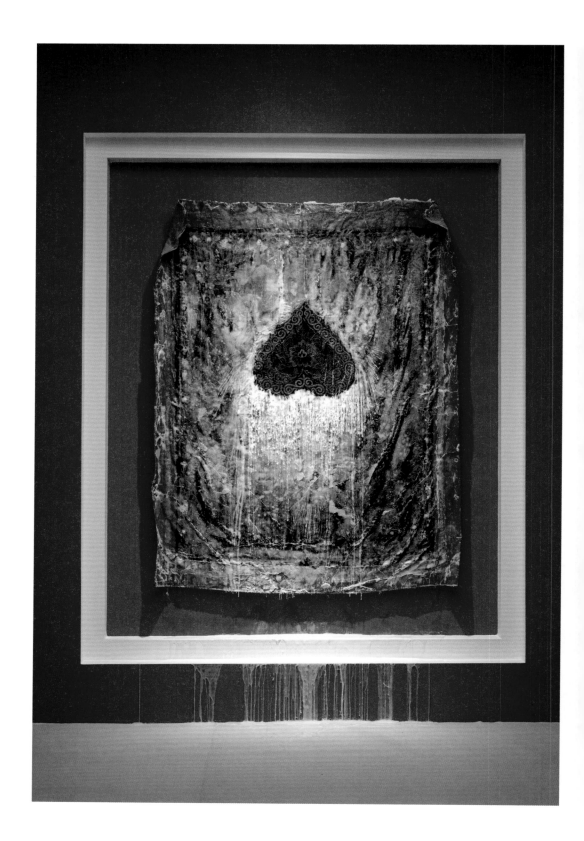

Xinjiang Carpets - A Family from Ding'er, 2020–2021

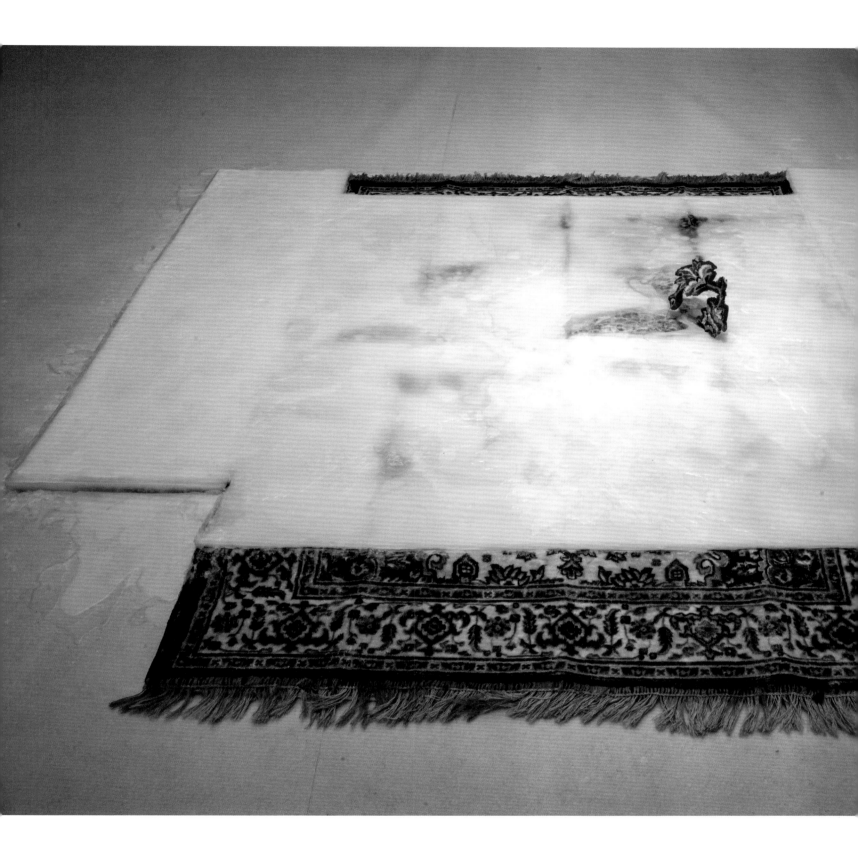

Xinjiang Carpets - A Family from Ding'er, 2020–2021

Xinjiang Carpets
Flying Carpet

Medium: Installation

Material: Xinjiang handmade carpet

Size: 1000 x 250 x 10 cm, variable

Description: The flower and grass patterns on the red background of the Xinjiang Carpets were cut out with circular molds of different sizes. In the exhibition space, the cut-out carpets were then hung from the ceiling and laid on the floor, while the cut circles were set on the wall and floor on the opposite side. Since some parts of the carpet were damaged during the cutting process, the artist replaced them with gray, painted copies.

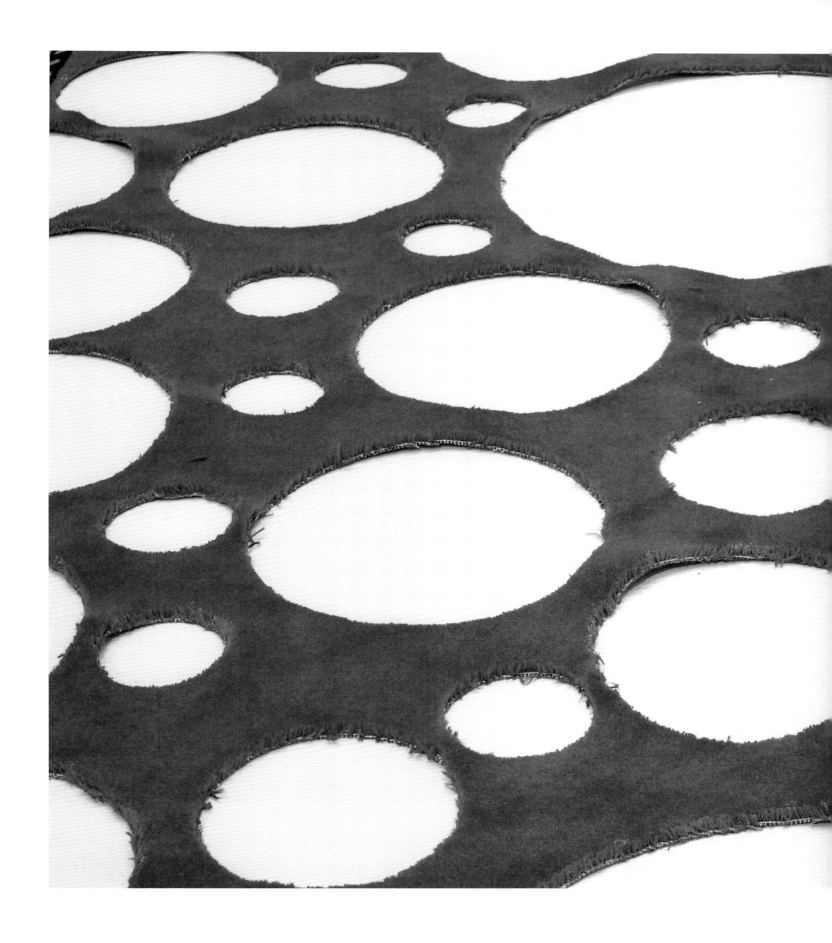

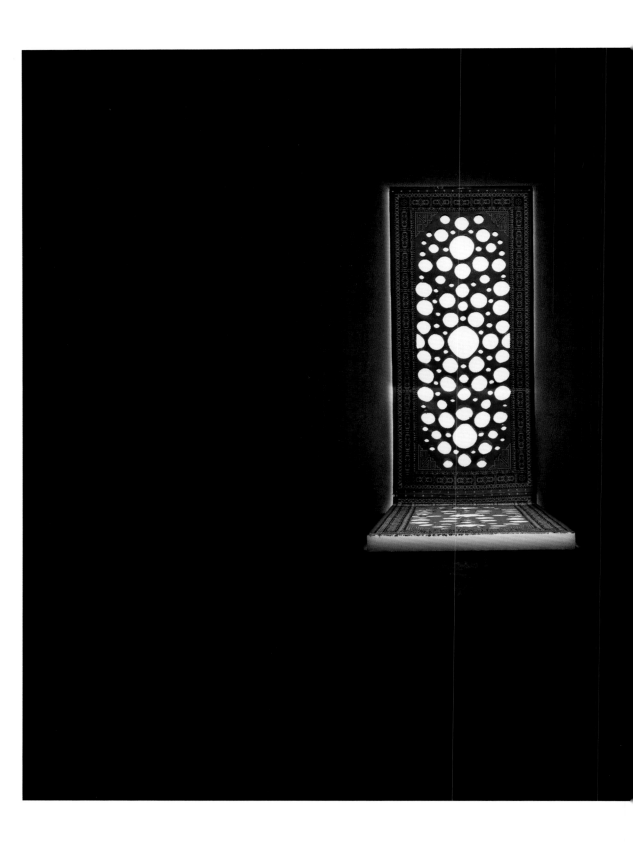

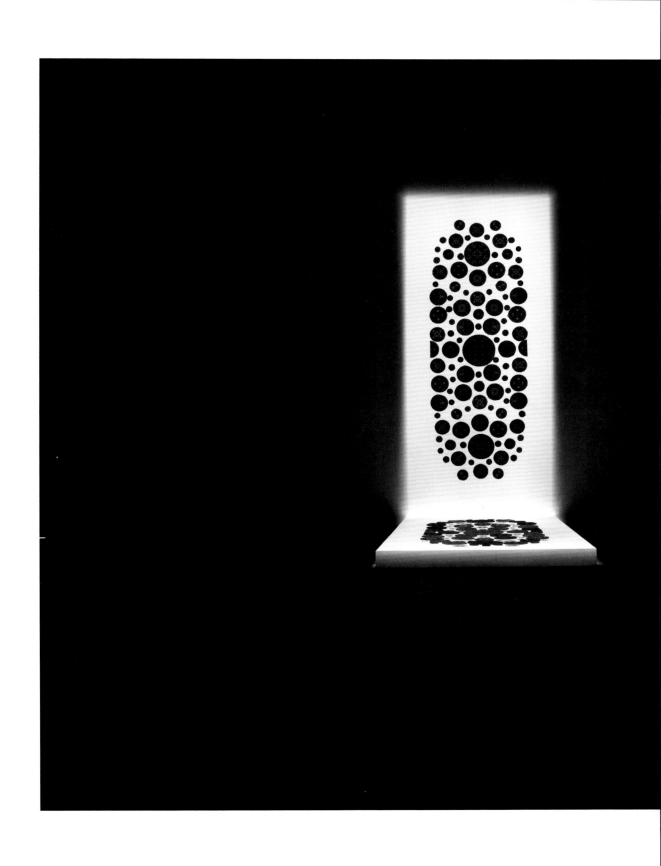

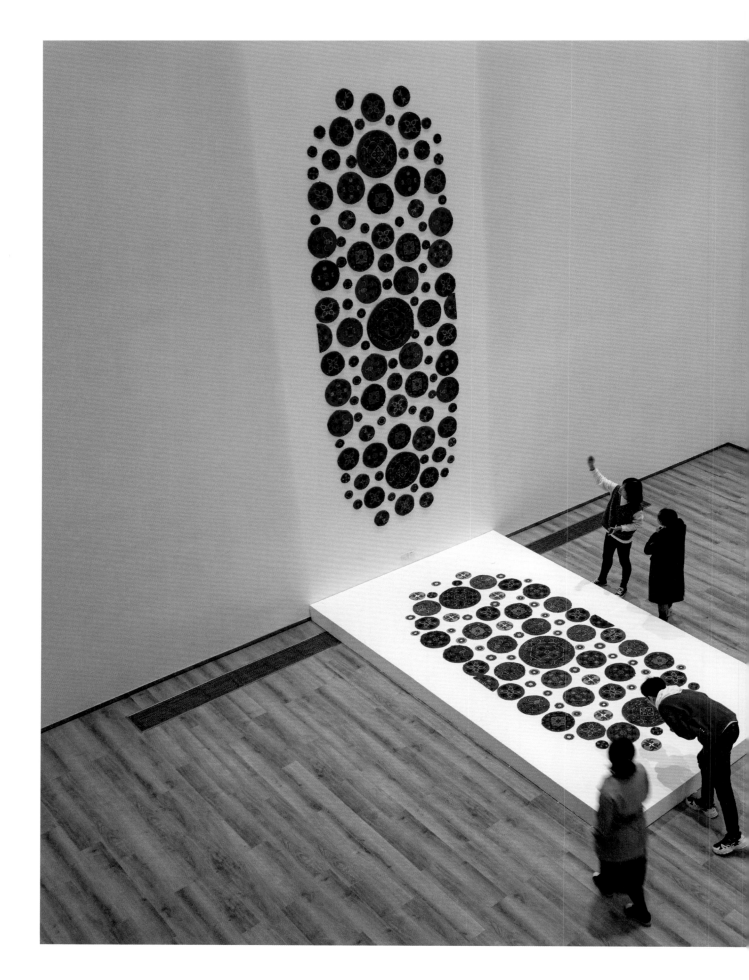

arpets - *Flying Carpet*, 2021

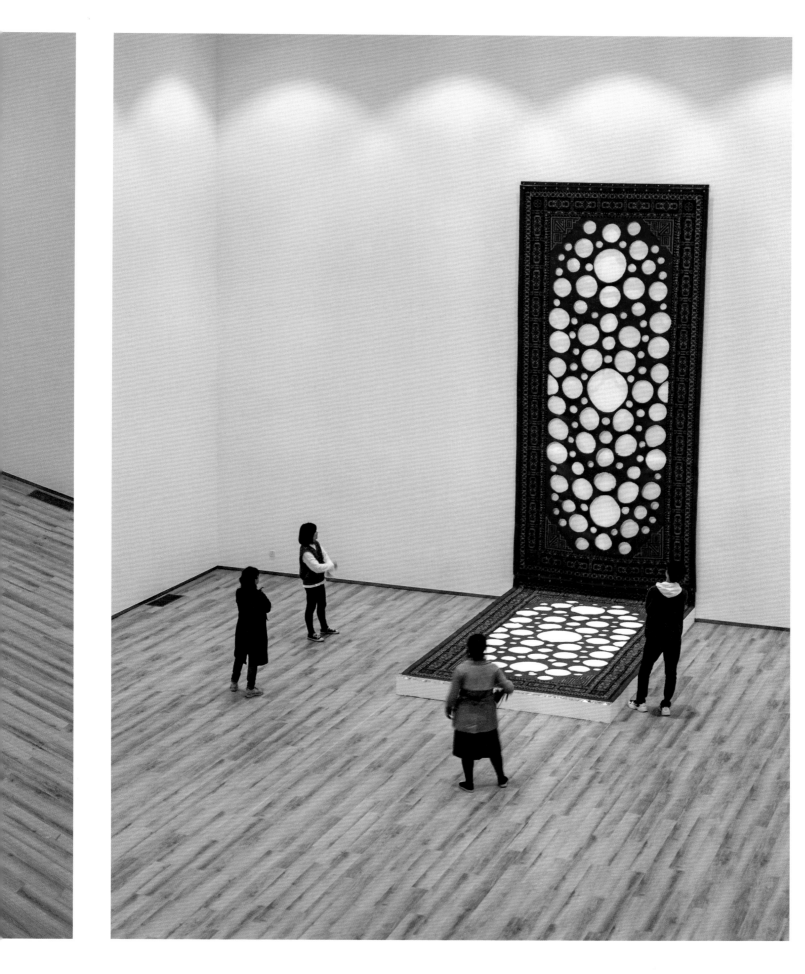

Territory

Medium: Installation, sculpture

Materials: Cement, barbed wire

Size: 500 x 500 x 250 cm, variable

Description: Using a 3D printer, the artist scanned his body
to create a life-sized cement sculpture, replacing the head
with a central pillar and suspending barbed wire branching
out from it.

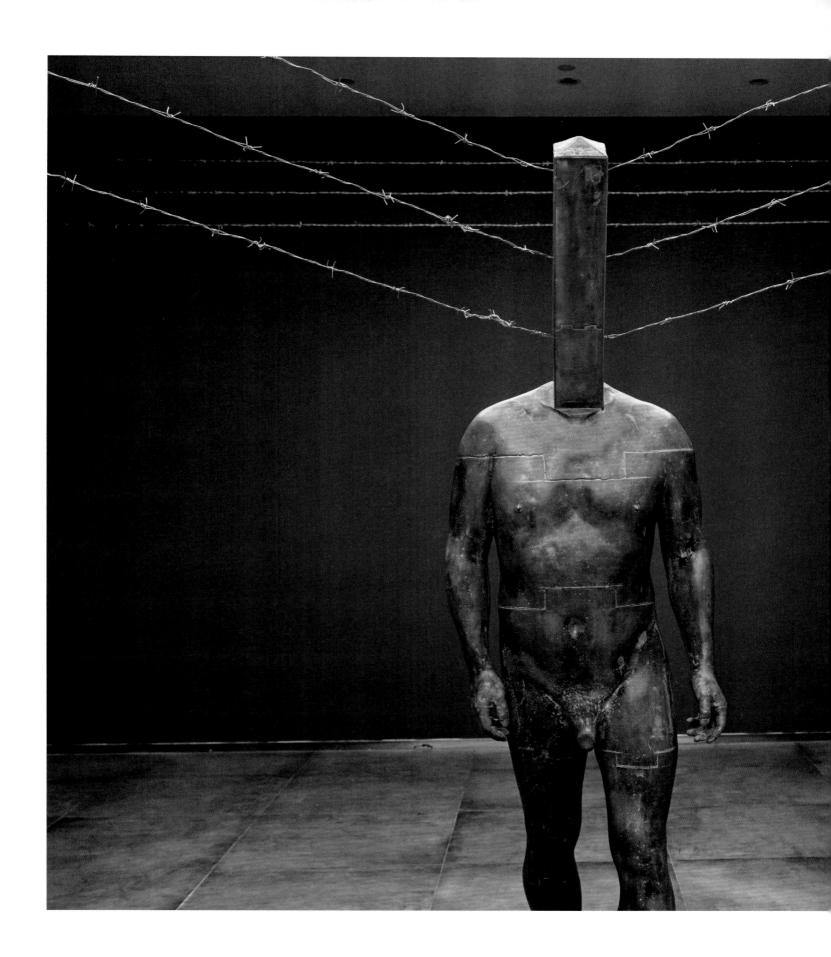

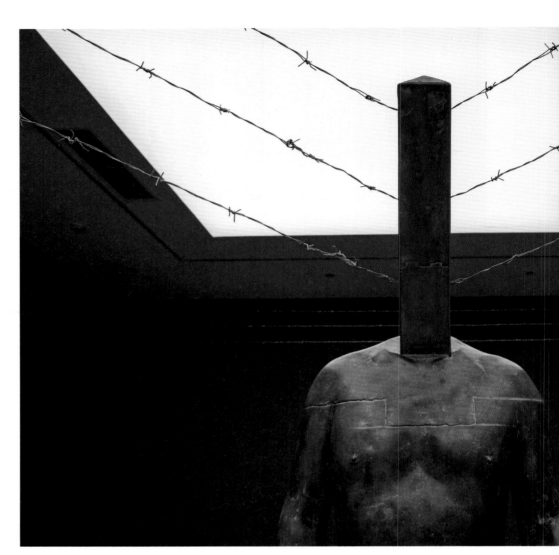

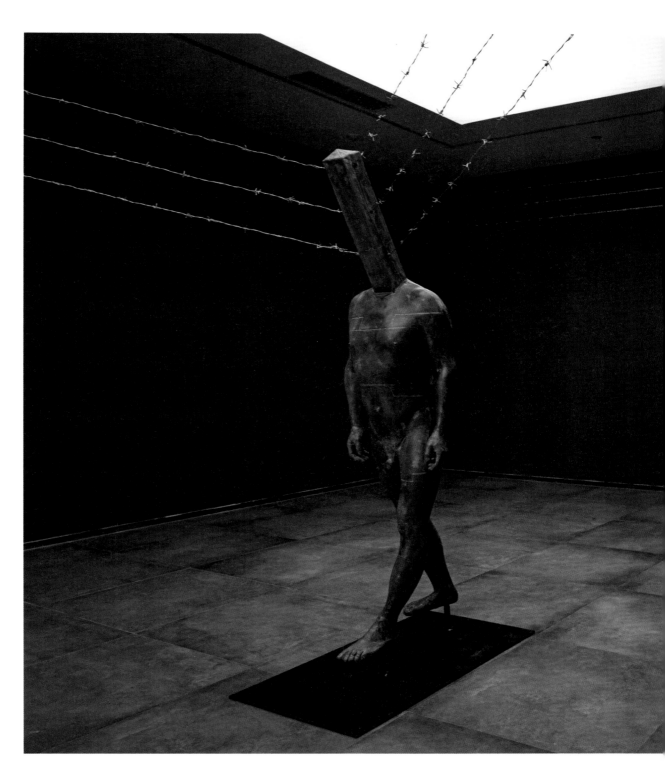

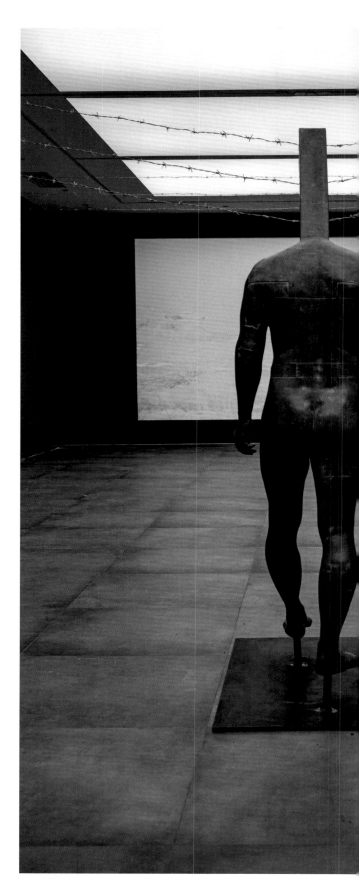

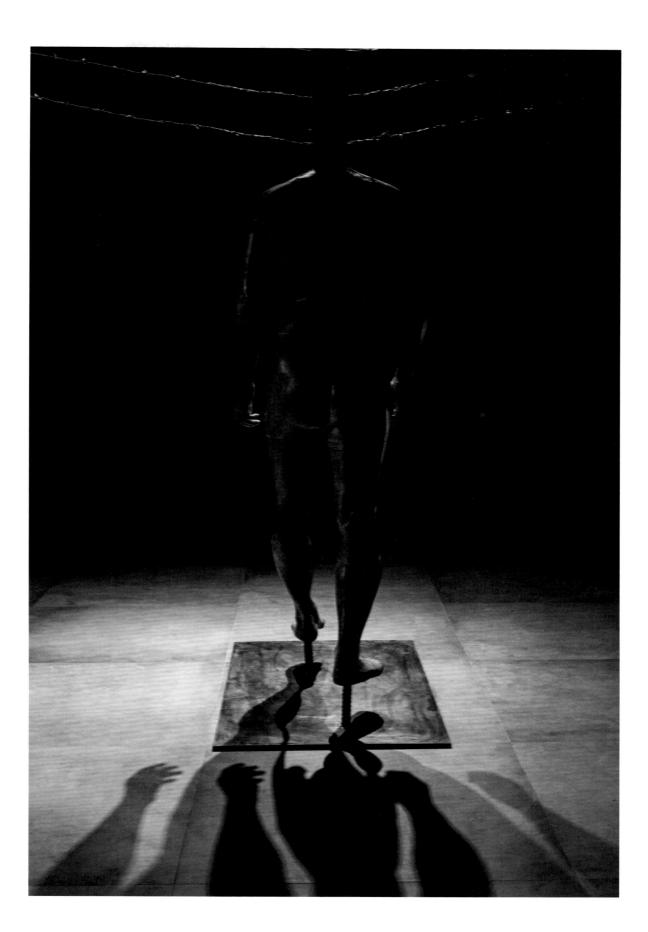

ARTWORKS

Salt at Gangren
Boqi Mountain

DECEMBER 2009
RE-INSTALLATION: MARCH 2012

Medium: Installation artwork

Materials: 5 tons of salt, a humidifier, a sponge, water,
 propylene

Size: 240 x 240 x 130 cm, variable

Description: Located in Tibet, Gangren Boqi is known throughout
 the world as a holy mountain. It has been identified as the
 center of the world by Hinduism, Tibetan Buddhism, Tibetan Bon
 religion, and ancient Jainism.

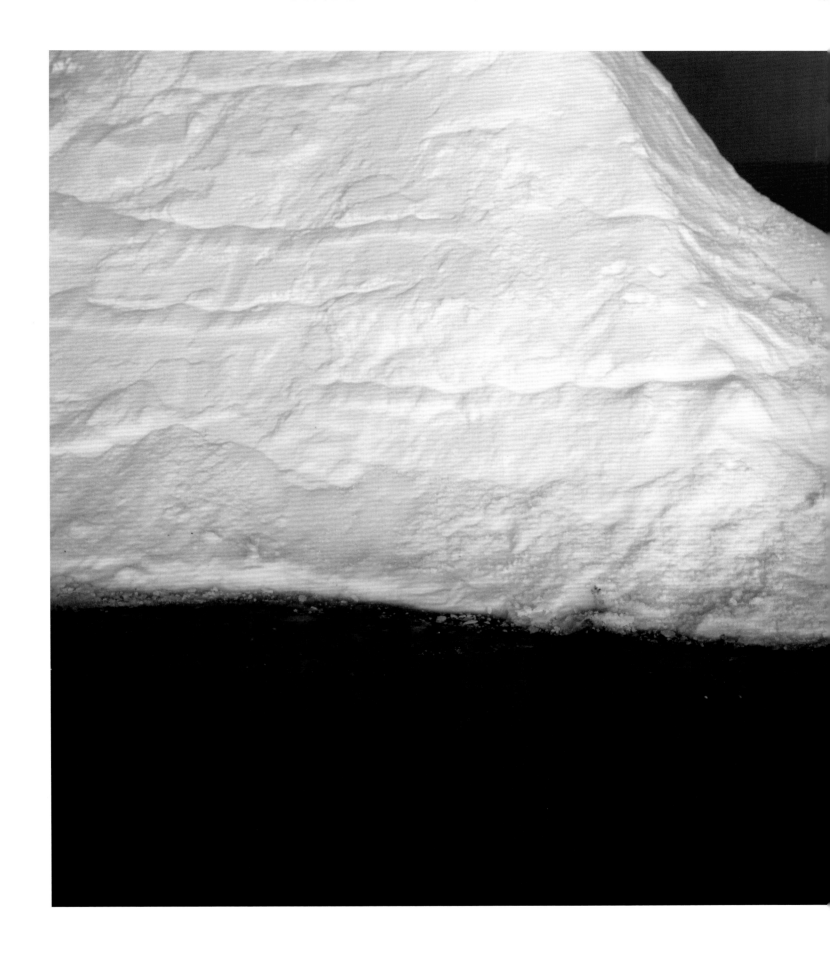

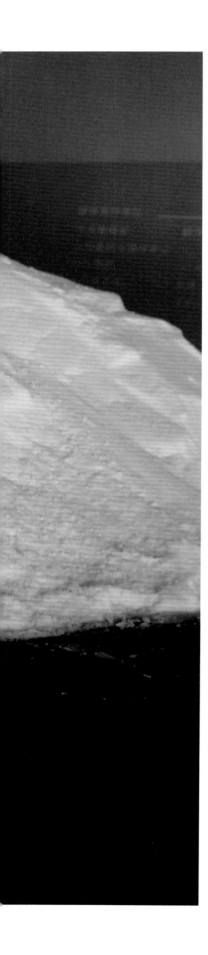
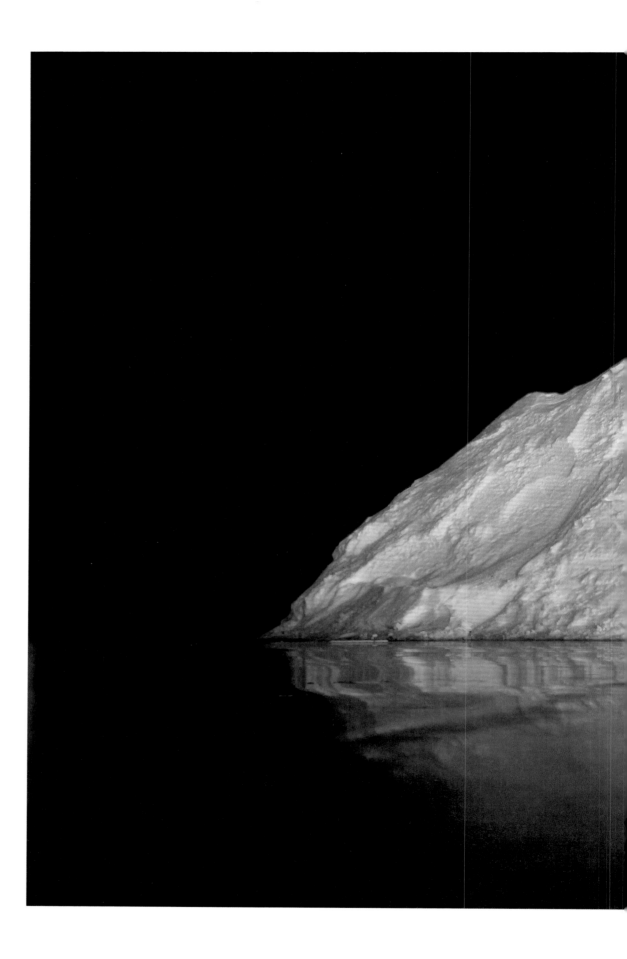

Salt at Gangren Boqi Mountain, 2009/2012

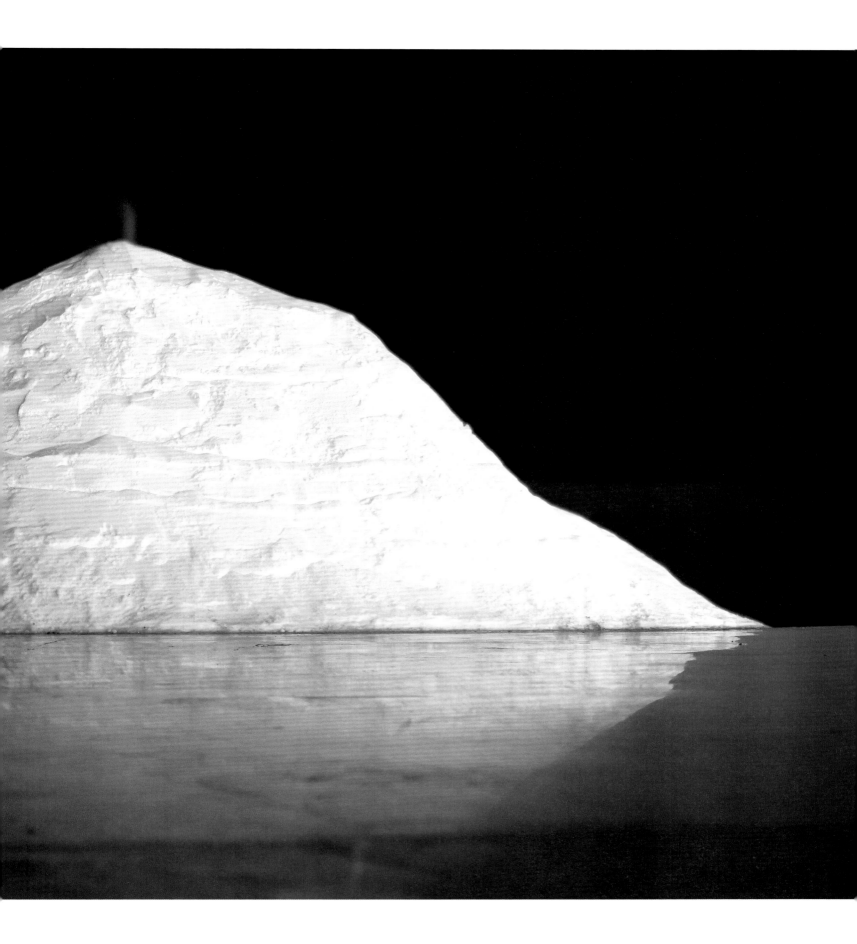

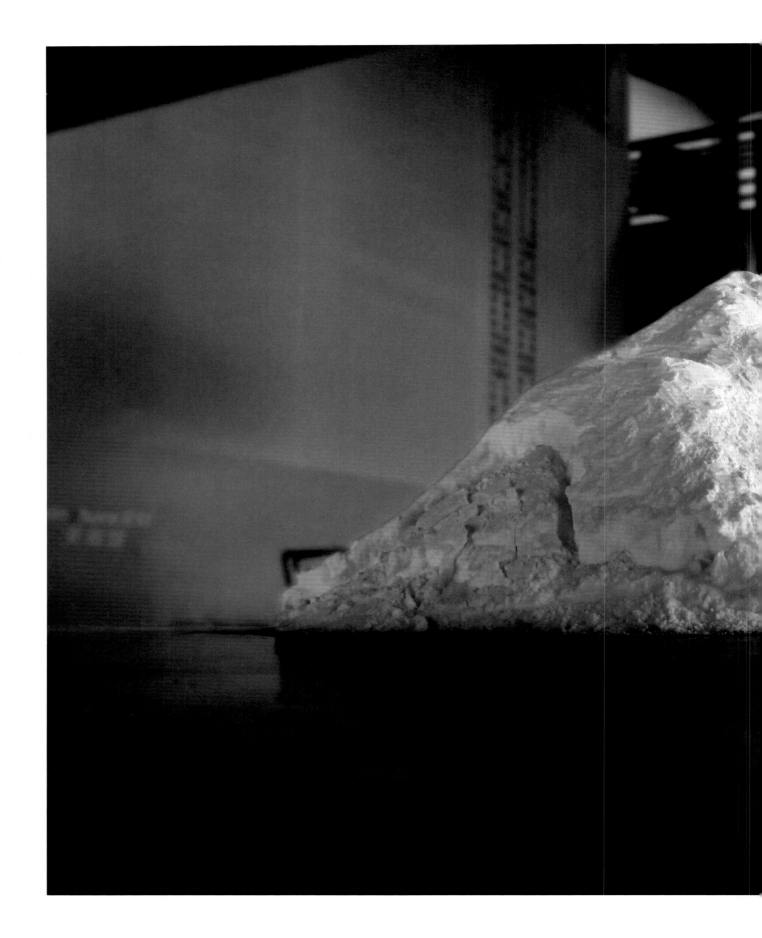

Gangren Boqi Mountain, 2009/2012

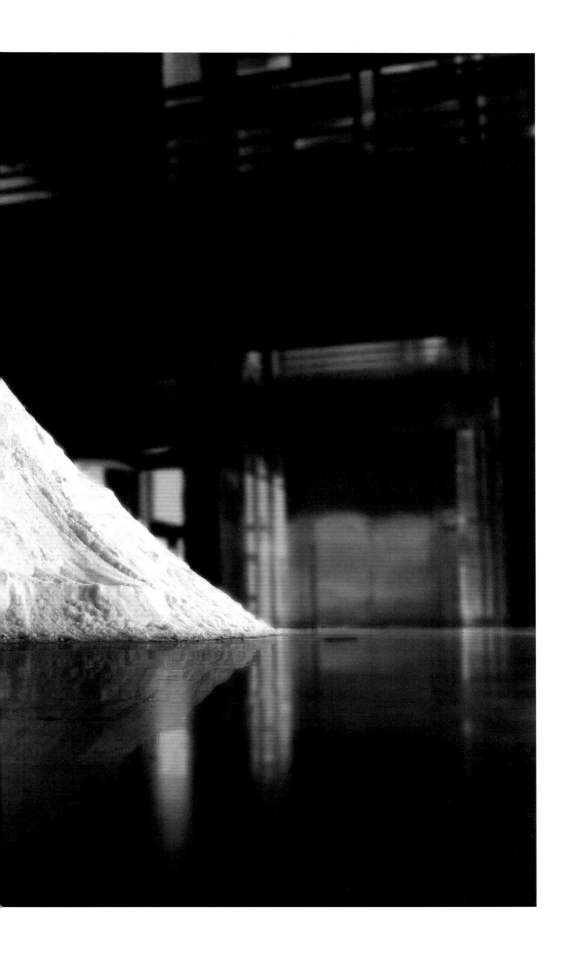

nteractive performance art

oricks

er the "Wukan Protests," which took place in
g Province) on February 19, 2012, Li Yongzheng
ine friends from Wukan, "@Xiong Wei - New
and "@Wukan Chicken Extract," to Chengdu to
with clay that had been collected in Wukan.
bricks was donated to the library that was
in Wukan. The other brick was passed from hand
nteers who were recruited via the microblog.
2012, when the brick was mailed to the first
Yongzheng, it has traveled to most parts of
s mail, passing through the hands of dozens of

racking of the traveling brick, the information
ist by all the participants, the people's
versies, and new ideas evoked by this action
are all integral parts of this work that will
er in the form of an exhibition and book. The
the passing of the brick over time has made
tents and meaning become more and more complex.
s are also the co-creators of this piece of
own the co-naming right of this work, and
an also publish his/her passing process as an
istic work or handle it accordingly.

f a village in Guangdong, and the Chinese characters that
this place could be interpreted as "the Gate of Utopia."

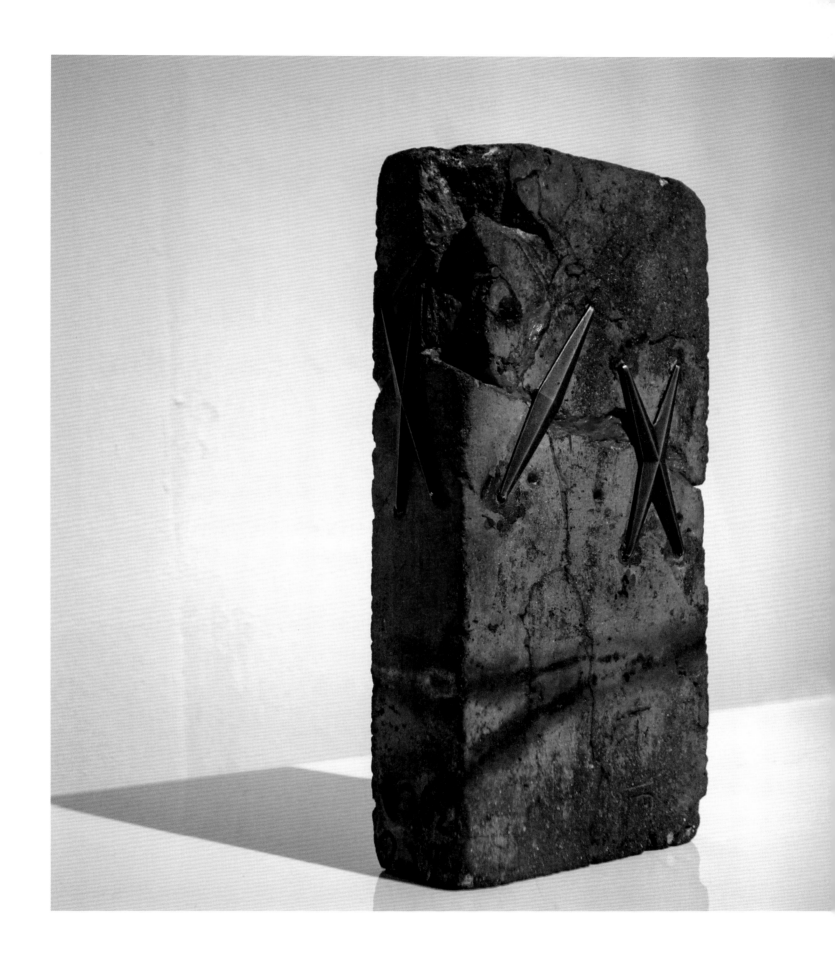

Brick Relay, 2012–present

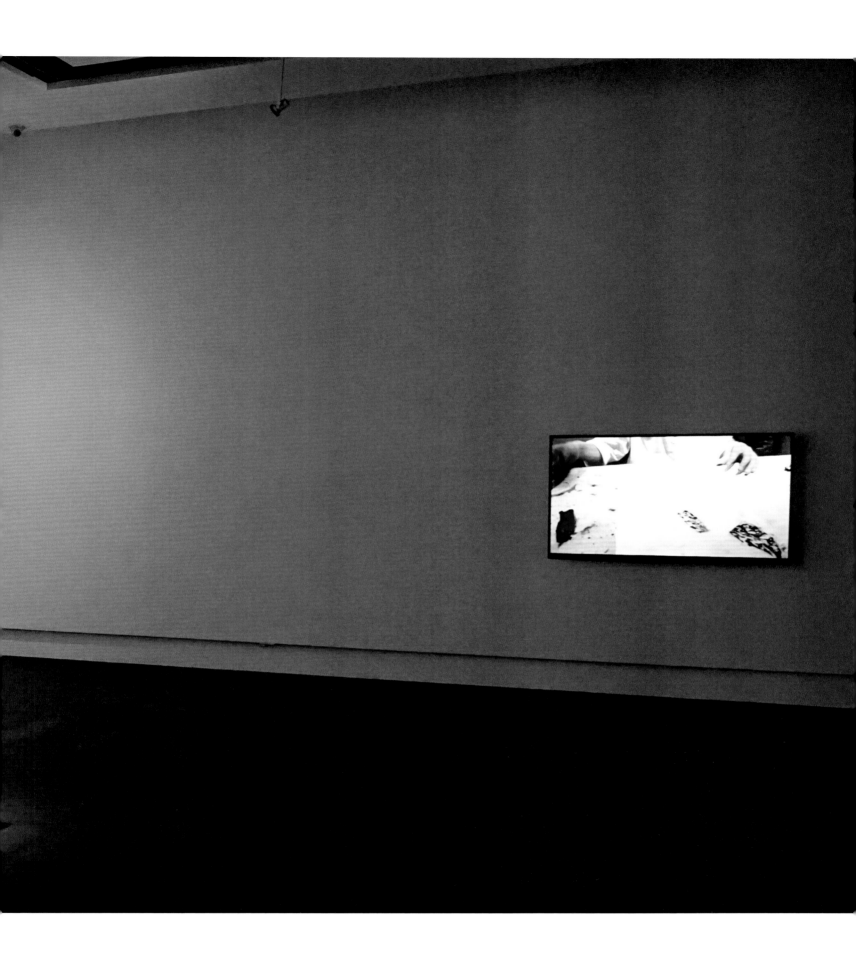

欢迎加入"传递一块砖"计划

1、委托新浪微博网友@新启蒙熊伟快递广东陆丰市乌坎村泥土两公斤。泥土已于2012年3月1日上午寄出。

2、计划在四川成都市仁寿县团结镇花梨村窑口，制作出建筑用砖两块。

3、通过微博或其他网络平台，征集愿意通过快递的形式，接受其中的一块砖的志愿者。

4、志愿者接受砖后须通过微博或其他网络平台找到新的愿意接受此砖的自愿者，并将砖快递到新的志愿者中。

5、志愿者收到砖后，在不损坏砖整体性的情况下，也可以用各自的方式在砖上留下印迹。

6、志愿者在接受砖时，须留下相关的照片或影像资料，以及快递到下一个志愿者的信息，并通过电子邮件发与发起人。

7、志愿者在接受砖后，也可以中止传递，但是必须将砖快递回发起人

8、这次活动的传递过程与路径，以及所有志愿者发与艺术家的相关信息，将成为作品"乌坎之砖"重要组成部分，将在后续的展览中展出。

9、欢迎大家加入"传递一块砖"的活动。

10、有兴趣的朋友请私信我。

2012年3月3日

@李·勇政 V
#传递一块砖#乌坎的泥土加上成都田野中的黏土，在永鹏师傅的指导下，几经反复，终得师傅捏两块，阴干几日后，便可以入窑烧制了。任何有关此活动的信息，都是作品的一部份，期待大家朋友们的参与。

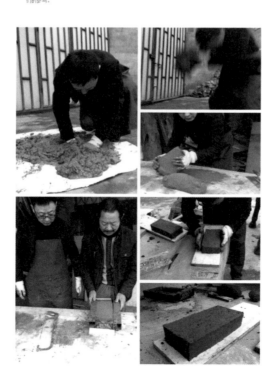

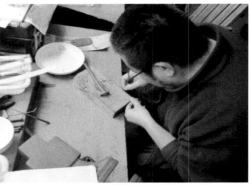

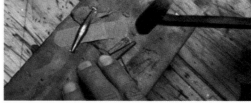
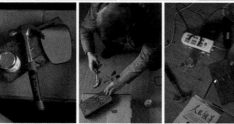

左在老 传统工艺修复乌 坎之砖。创可贴大亮❤哈哈

一个具体而典型的社会事件,艺术家把它转化为一块砖,但这不是创作的结束,而是开始 这件作品真正的力量恰恰不在于艺术家的创作,而是传递过程 这是大众化的力量 这是公共空间的力量 @彭冲天敌 @张晨初艺术空间 @待你听 @杜子建 @张与焘 @张子康 @张宝全 @雷颖 @曾辉1965 @刘胜军改革 @杭间HangJian

,所有的参与者都在创作一件新的作品//@徐家玲3 这夏,尤其是用传统手段修复,使得作品本身光亮不少 传统工艺修复乌 之砖。创可贴大亮❤

梦镜7023

空间无限、时间无限的作品。@赵子龙ART 一个具体而典型的社会事件,艺术家把它转化为一块砖,但这不是创作的结束,而是开始 这件作品真正的力量恰恰不在于艺术家的创作,而是传递过程 这是大众化的力量 这是公共空间的力量 @彭冲天敌 @张晨初艺术空间 @待你听 @杜子建 @张与焘 @张子康 @张宝全

ling👍 〰//@焦兴涛 //@刘春尧V //@赵弥 //@小混蒌

李勇政 V

你决定啊,每个接收人,也是下一次传递的决定人。//@金子art 回复@Manu李万旭 @李-勇政 可以出境吗? 我个人倒是觉得出境挺好的😊 //@Manu李万旭 此砖可否出境? 我们在法国 //@金子art:非常荣幸参与这一环节,我会电话@魏言-异述的

的刀匪言🌀 //@李永开-- @蔡工六 @cq黄小陆 @刘摄影师路长江 @1314杂志 @藏工集萃 @龚剑--真是

拔鸟毛

//@金子art 非常荣幸参与这一环节,我会电话@魏言-异述的 🌀 //@刘骐鸣 很有幸参与到艺术家李勇政先生的作品中,展览结束当日有可能我不在帝都,这样则无法亲自传砖传递给艺术家金子小姐。如果是这样,则请@金子art 童鞋直接到尤伦斯"取件"~电话联系@魏言-异述 童鞋即可。

李永开-- @蔡工六 @cq黄小陆 @刘着圆圈 @李丹 @1314杂志 @藏工集萃 @龚剑--真是不可不戒 修复

何工sunchaser

//@李-勇政 @曾妮1220 🌀亲切的面孔,有陌生感的作品! 👍

艺术很诚实! 艺术作品的呈现跟阅历的长期储备和思维是在限定之下获得的,是在有限的时空中把艺术推到 《大意》//@李-勇政 当代艺术不能代表现在的文化,科 带来的变化,也许比艺术更为重要。(大意)

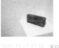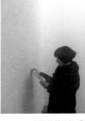

常乐的耳朵 V:乌坎之砖

工作室 我想等我九十岁的时候接收到她,再次传递 这是

海之子在路上:传递一块砖,李勇政作品

不急 👍 //@焦不急 战士二字多余。乌者黑也,坎者坷 '本身就是一个好名字。//@李-勇政 //@麦克牛仔好! //@艺家艺非 此砖名:乌坎战士 ? //@2B血型 刘春尧V //@赵弥 //@小混蒌123

街买的创可贴,已经被蚂蟥钉锁定在裂痕上。乌坎,

这块砖最后能进入中国历史博物馆//@真名叫海潮

2012-11-30 18:26 来自iPhone客户端

一早沐浴更衣喷点点 能与传说中的李勇政 那一瞬间有点像个病 @魏言-异述 @小混蒌

李-勇政 V 回复@尹小龙的:帮

明河mk ☆ //@刘骐鸣:兴高彩烈 去,只要有朋友们 没上海 //@李-勇政 //@小混蒌123

田甬1836 @8mg梁建成来了 感 //@明河mk 传 方都还没有去,只 线图对象还没上海

原作者没有多大关系了,原作者的愿望与立意已变得无义与无意,都在每个接收者那里显现。//@梦镜7023 命运,掌握在传递之人手中。本来作者发出之时, 一种放任自流,很像是抛弃。#传递一块砖# //

散文章没凑,但太多就消装了,特别是那个创可贴,太 小混蒌123对! 不过所有的作品和活动都可以用这 样 延续话题,带来歧义,每个接收者都可能赋予了这块砖不 无论你怎么看去它很脆弱但它还是一块砖,在对

蒌123. 对! 不过所有的作品和活动可以用这 样一句 话题,带来歧义,每个接收者都可能赋予了这块砖不同的 你怎么看去它很脆弱但它还是一块砖,在对抗的时 与钢铁对抗的武器,无论钢铁怎么强硬它必

到意来//@小混蒌123 每个传出者应该负责下方案, 角度的讨论。//@小混蒌123 对! 不过所有的作品和活 朋! //@李-勇政 延续话题,带来歧义,每个接收者都 运。//@小混蒌123 无论你怎么看上去它很脆弱但它还

还经常喊大家拍砖吗?这也是它的意义 不过意义之外的 述 //@赵弥 //@小混蒌123 @北村独立工场 @ 蕾云 @成都齐盛当代艺术博物馆 @陈伟才-cc @文豪 @马德葵葵 @姬国柱 @焦兴涛 @刘春尧V

可以 //@小混蒌123 我忍不住了,要说说,作者出去点 大家也都在砖上做装饰或用砖作装饰,这和一块砖 参与者在上面画画,这不是在传递砖,是在传一张 @熊与燕子 @镜观自省 @魏言-异述 @艺家艺非 @

的照片🌀

装饰是强权者赋予乌坎的意淫形式,一群公知和艺术家 了。//@小混蒌123 我忍不住了,要说说,作者出去点 大家也都在砖上做装饰或用砖作装饰,这和一块砖 恨水没了!

@白番claudia ☆

乌坎之砖今日收到! 完好无损。拿到手里。感到很多人的体温。@李-勇政 @熊与燕子 @杜佬峡 @杜蟥云 @俞心樵 @刘骐鸣 @吴永强教授 @ARTIST王缪 @粉红稿 @赵弥 @曾妮1220

来自

数文章没凑,但太多就消装了,特别是那个创可贴,太 小混蒌123! 不过所有的作品和活动都可以用这 样 延续话题,带来歧义,每个接收者都可能赋予了这块砖不 无论你怎么看去它很脆弱但它还是一块砖,在对

2012-12-12 50:09 来自iPhone客户端 转发(3) 收藏 评论(1)

白番claudia ☆

乌坎之砖 本打算嵌入一瓶毒药 但手头没有得力的工具 钻孔挂上一个十字架 但愿主保守这个多灾多难的国家 @李-勇政 @熊与燕子 @尹小龙的 @曾妮1220 @激动美女-南泥 @刘小建 @凯澜霍尔 @刘骐鸣 @杜佬峡 @杜蟥云 @方法度-坚 @吴永强教授 @粉红稿 @dear赵亮 @周爷 @吴巍 @岳杨小处 @TT就是teaberry

2012-12-14 20:48 来自微博 转发(76) 收藏 评论(24)

白番claudia ☆

@杜蟥云 @李-勇政 @刘小建 你可以联系@白番claudia 了。//@刘骐鸣 回复@白番claudia:下一个你又寄给谁? //@白番claudia 回复@粉红稿 李勇政用乌坎的泥土烧的砖在艺术家手里来回传递 每个人在上面均可留下自己的痕迹

白番claudia ☆

乌坎之砖 本打算嵌入一瓶毒药 但手头没有得力的工具 钻孔挂上一个十字架 但愿主保守这个多灾多难的国家 @李-勇政 @熊与燕子 @尹小龙的 @曾妮1220 @激

曾妮1220 V

阿门!

刘骐鸣 V

🌀 勇政与基督文配! @老歌300 @俞心樵 //@吴巍 阿门! //@曾妮1220 阿门!

杜蟥云

@左小祖咒 @马惠东 @邵译农 @苍鑫2012 @原弓 @沈其斌 @艺术家金锋 @山右一仁王中文

白番claudia ☆

//@李-勇政 //@张莉娟LindaGallery 智疑,是第一步!

尹小龙的 V

传递信念传递希望! //@杜佬峡 上帝保佑中国。//@尹小龙的 我期待中、、//@杜蟥云 @左小祖咒 @马惠东 @邵译农 @苍鑫2012 @原弓 @沈其斌 @艺术家金锋 @山右一仁王中文

方法度-坚

哇 更下次的传递了 呵呵 已经有了 @刘骐鸣 的血 @杜佬峡 的好运的麻将和 @白番claudia 的信仰的十字架了,期待下一个 呵呵 //@

晴天杜喱喱

国与国之间是明争暗斗,会技巧性使用"信号"传递这一招来真假迷惑对方。但我们这儿,百姓常接这一招,弄得大家搞球不懂是咕信号? //@鲁晓东 今天着

熊与燕子 ☆

我再镶嵌佛珠进去"包容乃大"😄😄

Manu李万旭

到的每个地点每个痕迹 希望清醒每个灵魂 还有那些张狂者们有快儿板砖"小心你们的那些虔荣小乌纱"😄😄😄

白番claudia ☆

//@李-勇政 @尹小龙的 传递信念传递希望! //@杜佬峡 上帝保佑中国。//@尹小龙的 我的期待中、、//@杜蟥云 @左小祖咒 @马惠东 @邵译农 @苍鑫2012 @原弓 @沈其斌 @艺术家金锋 @山右一仁王中文

徐家玲3 编者时下的人都

艺术家金锋 V 这块砖好像一直在 传递希望! //@杜佬 左小姐咒 @马惠东 一仁王中文

白番claudia ☆ 一直没得竞争激烈 白番claudia //@李 中国。//@尹小龙的 苍鑫2012 @原弓

张羽藏法书 乌坎本来就是汪政 政 //@张莉娟Linda

梁玺 这块砖越发潮了

吴永强教授 V 接九、传递 制!

木易四水 V 一块越来越迷人的

木易四水 V 每次再见那块砖, 态,传播的趣味正

杜佬峡 保佑是希望的意思, 的,他保佑吗? 佑中国。//@尹小 @苍鑫2012 @原弓

白番claudia ☆ 原本是溜下的。和 始想念我的那块砖

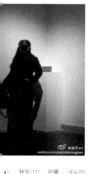

我们广东高兴地转让了一袋泥土的使用权。//@李·勇政 转发微博。

@金子art V
即将到来的一块砖·金子的文章·博客〔聚艺厅〕- 艺术国际·Artintern.net
http://t.cn/zjVRF0B

王大军'dada
金子，把它递了再奇 //@金子art //@李·勇政 //@摄影师赖长江 我们广东高兴地转让了一袋泥土的使用权。//@李·勇政 转发微博。

李永开~~
啷敢传下去 //@李·勇政 //@摄影师赖长江 我们广东高兴地转让了一袋泥土的使用权。//@李·勇政 转发微博。

杜佬峡 V
刚才收到了这样的包裹，明天来处理这事儿。//@李·勇政 好，太棒了，我会为这块砖出一本画册。

@金子art V
发表了博文《一块砖的一天》·一块砖，前身是广州的一捧土，经李勇政之手成为一块砖...http://t.cn/zzjiJsEu

梦镜7023
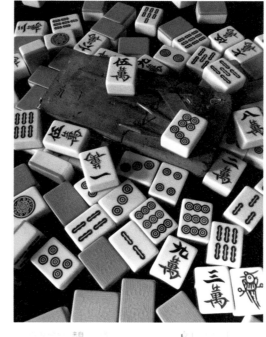

@杜佬峡 V
那四砖在我这里就是这样：乌坎砖与绝对的好手气。@虹妖精 @白蕾claudia @刘澍鸣 @金子art @yangweidong66 @尹瑞林art @豆虫仁波切 @张峻刚 @小混蓝123 @梦镜7023 @Manu李万旭 @王清川微博 @李一翼

力法度·坚
好期待看着这个传奇的砖现在在哪。又是怎么样的了，是在以什么样的方式传递呢，真心好奇。

@尹小龙的 V
今天收到了乌坎之砖谢谢@白蕾claudia，明天我将带上它在深圳的各个地标点留影。

@白蕾claudia V
这块牵引众人视线的著名砖头，在我家停顿重生后业已启程，我包裹得极认真，但愿它一路平安。@尹小龙的 注意查收

唐佩贤PY V
呵呵！看来大家都从新给予了这块砖生命哈。

龚剑-真是不可不戒
真正的希望 愿它一路平安 //@白蕾claudia //@李·勇政

龚剑-真是不可不戒

混混昏浑腼腼 //@李·勇政 //@梁蕊 这块砖越发疯了！够荒诞！够讽刺！

尹小龙的
尹小龙的：谢谢美女，我收到不管它停留几天，我都把它当成一种信仰并珍惜上面的每一个印记，并把它传交给下一个人！(10秒前)

白蕾claudia

这就是传递的意义所在 //@尹小龙的 尹小龙的：谢谢美女

坤良自在 V
横拙的、狂野的、不羁的，咋欸没點兒细腻的呢？//@李永开 //@龚剑-真是不可不戒 //@李·勇政 //@梁蕊 这块砖越发疯了！够荒诞！

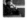

杜佬峡 V
去吧，看你的了。//@曾晓1220 //@李·勇政 //@刘澍鸣 //@杜曦云 //@尹小龙的 //@艺家艺菲 //@杜佬峡

豆虫仁波切
申请 //@尹小龙的 回复@豆虫仁波切 到了，到了，到深圳了？

尹小龙的 V
乌坎之砖传递的意义，神圣而又关系到每一个人

山右一仁王中文 V
见证！

凯湘崔尔
转起 从另外一个角度看深圳

多济薏颜
很有意义 @白蕾claudia

谢平xieping
结束与开始 //@李·勇政

邵译农

@尹小龙的 V
#传递一块砖#深圳第一站：南头关

杜佬峡 V
女朋友？你是说砖与性？找个女朋友吧。

梦镜7023
接受了老峡绝对的运气和勇气

梦镜7023
//@熊与燕子 //@李·勇政

老伊蜀泰
//@新启蒙歆伟 支持//

鏒荣荣-Sisu
支持并关注~愿乌坎砖传递来的泥土 //@新启蒙歆伟

城中传飞鸟：哈哈哈哈，那块砖
(2012-12-9 20:21)

尹小龙的 V：回复@杜佬峡 发

//我的名与姓中有··, //@尹璐林art 😊很
//佬峡 是的，好运乌坎，好运中国，好运世
老峡杜哥给它施魔法吧！😎

//@梦谶7023 峡气十足，下一步你再给他

这块砖又将在路上。#传递一块砖#//@李·
你再给他找个女朋友吧！😄

嘟新的创造，这些挑战所带来的结果，可能
的思考与契机，传递就是制造一扇扇门，只
递活动最有趣的地方。//@梦谶7023 接受了
砖又将在路上。#传递一块砖#

考与契机。//@李·勇政 传递开始于你们离
鸡精

断成两截，打上补丁，泰然处之···

回复

(·9 15:36)

查看对话 回复

个角度看深圳🎵 //@尹小龙的 //@艺家艺
马惠东 //@邵译农 //@苞鑫2012 @原弓 @沈

仁王中文 🈲见证！//@舨与燕子 带我们
//@艺家艺菲 //@杜壤峡 //@杜壤云 @左小
@原弓 @沈其斌 @艺术家金锋 @山右一仁

日快递还能用 //@尹小龙的 乌坎之砖传递
我的手里只停留三天然后传递给下一位接力
@曾筱1220 📷 //@李·勇政 //@刘巢
艺菲//@杜佬峡

a 籍实了。末日快递还能用 //@尹小龙的
每一个人'在我的手里只停留三天然后传递
看你的了。

K //@山右一仁王中文🎵见证！//@舨与
//@尹小龙的 //@艺家艺菲 //@杜佬峡//@杜
@苞鑫2012 @原弓 @沈其斌 @艺术家金锋

👍 转发(3) 收藏 评论(1)

Art on the Internet: Brick Relay
Curator: Du Xiyun

The changes that the internet brings to human existence are revolutionary, and art is no exception. Photography was a shock to classical art and gave birth to modernism. The rapid spread of internet technology also makes once avant-garde contemporary art become "classical contemporary." How should art face the internet? New questions arise in art, unresolved ones. People with sensitivities, though, see enormous potential.

Mobile internet is much more democratic, open, and low-cost. Its new mode is one where the initiator of a creative project just lights a flame, inciting crowd-creation, investment, and consumption. Core possibilities are triggered constantly, opening up to, and generating, possibility. *Brick Relay* is entirely created and transmitted online, in the spirit of online artistic creation and modality, a force of Chinese contemporary art that is innovative and historically important.

Innovations

1. All previous works were in the name and mode of art, an artist creating a social event, arousing attention from public media and transmitting. In *Brick Relay*, the artist creates a brick, then passes the right of creation on to all participants. Every participant takes part in creating the work and its transmission, interacting on social "we-media."

2. All previous works were mostly fit for display in art museums, expressing a well-formed wave of artistic authority and control. *Brick Relay* is made for online creation and transmission. It doesn't need a museum at all, which overrides and renders redundant high-cost museum exhibitions.

3. All previous works were created just once. The creation of *Brick Relay* is endless and can be created and transmitted continuously. In addition, it is open to all new participants, with their new modes of creation and transmission, which may or may not relate to the brick itself.

4. *Brick Relay* does not advocate any absolutely "right" value. This work allows every participant to reveal their individual values, through the process of creation and transmission of this work. This respects every participant, calmly probing and showing facts.

It's only just begun...

Du Xiyun: Why do you engage in art while doing business?

Li Yongzheng: I was looking for something to do after work, like others do with dancing, singing, or playing mahjong. Art felt so far away. I'd been producing for a long time, but I felt disconnected from the art circle and didn't exhibit.

Du Xiyun: What kind of fun does art bring to you?

Li Yongzheng: It's not fun or un-fun. The way I see it, art is natural, as it should be.

Du Xiyun: Over the years, has your artistic attention shifted? How about your methodology?

Li Yongzheng: There haven't been many changes, just the reality I encounter, which proliferates in the inner mind like wild weeds. I used to shoot for making contemporary art or being easily understood as contemporary. Now I no longer care. How can you define what's actually only just happening? Whether or not it's contemporary art, or even art, is not so important anymore. I don't really have a methodology. Anything by any means possible.

Du Xiyun: Does the reality that you have encountered give you a sense of safety?

Li Yongzheng: Danger from reality is real; I could feel it early on. Nevertheless, more sentimental reactions are nervous reactions. I have to get used to that. There is no once-and-for-all solution. That's what makes life fun.

Du Xiyun: What issues are you interested in now?

Li Yongzheng: A lot, for instance the impact of cloud computing and big data on real life, whether or not 4G and 5G will overturn internet usage habits, or whether or not the emergence of a virtual community can lead to the decline of sovereign nations. There's also the relationship between quantum physics and Buddhism, whether or not anti-corruption without guaranteed legal rule will lead to more rampant absolute power, and then there's this year's housing price trend. Of course, there are things that come up every day, which I try to handle with as much efficacy as possible.

Du Xiyun: How do you consider the relation between thinking, artistic expression, and real action?

Li Yongzheng: Thinking passes time. There's no need to waste time getting worked up. I don't think about artistic expression. All expressions can be art. Expression is real action.

Du Xiyun: Thinking and action are different, action is indescribable. What do you think?

Li Yongzheng: Knowing and doing should go hand in hand as much as possible. If you just talk, do and believe superficially, then all your thoughts arise outside of you. A lot of people strategize without moving forward. This'll come back to bite them.

Du Xiyun: Can you talk about what's happening these days?

Li Yongzheng: For A4 Gallery's 2013 Second Young Artists Experimental Season Exhibition, which you curated, I created *Free for the Taking*. It used an old printing machine with which I printed old issues of *Xinhua Daily* that were originally published in the KMT-ruled areas in the 1940s. Many articles talked about freedom and democracy, prompting many youths at that time to fight and even sacrifice their lives. These propositions are sensitive topics in society today. Jonathan Spence spoke of Sun Yat-sen saying, "Many revolutionaries, either on paper or before the revolution's success, would talk about democracy, freedom, and constitutional government. But really, the same person will skillfully eventually use any means, even autocracy, dictatorship, or intolerance." Whether it's an individual or a group, if knowledge is always used as some kind of strategy, then all these ideals drift past like floating clouds, poisoning present reality. Even if we aren't talking about magnificent or past things, when we do things today, we have to be familiar with corresponding implicit rules. On many occasions these things will run contrary to a person's values. We usually talk about ethics, conscience, fairness, and justice, but in real practice, how many people have really thought it through? I don't encourage abstract ideals or ethics. I hope the individual can start with himself and reflect on things he's learned in order to formulate reliable actions guided through thinking. Thought and action are two sides of a coin. Bringing knowing and doing together is a real praxis.

Du Xiyun: But really, why is it that someone will skillfully use any means, even autocracy, dictatorship, or intolerance to get what they want? What are they thinking?

Li Yongzheng: There is an old Chinese saying: "Talking eloquently about morality, while thieving and prostituting in private." We have a tradition of saying one thing but doing something else. Placing oneself at a certain height of morality can both satisfy one's preference for spiritual cleanliness, and also help you cheat others. There are big problems in both our tradition and our education. So, apart from the hope for a new policy, changes can only be carried out by every individual. You have to set out from your own real circumstances. Depart from trivial things, make efforts, little by little.

Du Xiyun: How do you understand "today's implicit rules"?

Li Yongzheng: Rules that can be clearly explained are no longer implicit rules. A master who understands implicit rules needs experience, intuition, and very thick skin.

Du Xiyun: The *Wukan Brick* was passed from place to place, from person to person. Everyone did something different with it. What do you think of that?

Li Yongzheng: The most interesting thing about *Wukan Brick* is each and every participant's different attitude toward the brick, their treatment of it, interaction with it, and re-creation of the artwork. Online, each participant had their own topic to discuss, thus helping sustain the impact of this historical event on the public. That's enough for me, my view toward the Wukan incident is no longer important.

Du Xiyun: What problems arose in doing *Wukan Brick*?

Li Yongzheng: What happened in Wukan evolved into a public incident that was widely discussed on Microblog. I want to join the discussion in my own unique way and the idea of passing something along via internet was already on my mind before the Wukan Incident. Back then, I wanted to pass something useless along, with no value or symbolic meaning. It was just purely for the sake of relay, just like many people use social apps like Microblog and WeChat. The aim is just communication and expression, without trying to pull off something grandiose. In my view, everything on the internet goes through a change.

The thing becomes something other than it originally set out to be. This is why I am so interested in changes brought to art by the internet. I don't believe in an ultimate unchanging beauty, nor do I have trust in fundamental or absolute spiritual forms. No one form is superior to another. So-called spirituality can only be manifested in human-to-human communication, and in encounters with actual things. Perhaps, like this brick.

Du Xiyun: So, when you sent this brick out, you didn't expect to ever see it again.

Li Yongzheng: That's right, I have no way of controlling how someone interacts with this brick or disposes of it. Nevertheless, when I sent it to the first person, I attached two conditions. He had to send it to the next person, with these same instructions, and he couldn't destroy the brick.

Du Xiyun: Has anyone broken the rules?

Li Yongzheng: Kind of, but I don't really mind. This brick has its own fate. For instance, it got put into an electric kiln and baked for 16 days, breaking it up. Later it got repaired by others using traditional Chinese methods involving ceramic repair. Everyone who got the brick did something different with it. I don't want to mess with that.

Du Xiyun: What if someone totally destroys it or throws it away?

Li Yongzheng: Both non-existence and destruction are kinds of an end.

Du Xiyun: How does this brick's encounters reflect current views on democracy?

Li Yongzheng: Under the overwhelming authority of ear-splitting mainstream discourse, an individual's voice is often unheard. It would be better to practice what you preach, stay away from trivial things, and work hard to realize your values. Magnificence is only realized in action.

Du Xiyun: Are you prepared to enter the exhibition and sales scene now?

Li Yongzheng: *Brick Relay* was suspended in June 2013, and one reason was to attend an exhibition in

Venice. Of course, if this piece of work can be sold or collected in a museum, I personally have no problem with that. But really, this piece of work is jointly created by all its participants. Any discussion related to it on the web will be regarded as a part of this work, therefore it is necessary to solicit the opinions of all deliverers on whether or not to sell it, as well as how to distribute or dispose of the sales proceeds.

Du Xiyun: Mobile internet represents an earth-shaking revolution in technology. In your view what new possibilities will be presented to art against such a background?

Li Yongzheng: Twenty years ago, people began to discuss the impact of the internet on enterprises. Back then there was the idea that all enterprises would become internet enterprises, and as it turned out, this statement is correct. Looking at enterprises with competitiveness today, either they are enterprises that display an existent entity in a digital way, or they are brand-new enterprises with manufacturing, management and sales established through digital upgrading. In my view, the impact of mobile internet on contemporary artists will also resemble the impact of the internet on enterprises. There will be more instances of a kind of virtual artform that purely exists in mobile internet. Traditional forms in contemporary art will inevitably rely on mobile internet as their main medium for communication and exchange.

The impact of digitalization on art today will appear more immediate. With the emergence of we-media, decentralization, and power destabilization, we find centralized artistic discourse and the age of masters drawing to an end. We'll all have "fifteen minutes of fame" in a fast-paced placeless, spaceless, and timeless propagation that will turn many people into transient dazzling stars. Professional artists will be equivalent to craftsmen, creative actions will emerge in all kinds of trades and professions, and art will become a life practice for most.

Du Xiyun, Curator, Art Critic, Vice-Director of the Shanghai Himalayas Museum

printing press, newspapers

1, 1938 to February 28, 1947, *Xinhua*
ommunists' legal publication in the
inued as such until the outbreak of
set an old monochrome offset press
printed some copies of *Xinhua Daily*
tween 1938 and 1947 and that were
im was to bring up some issues that
historical field, as well as to

ten-year-old child to sell these
her exhibition.

Free for the Taking, 2013

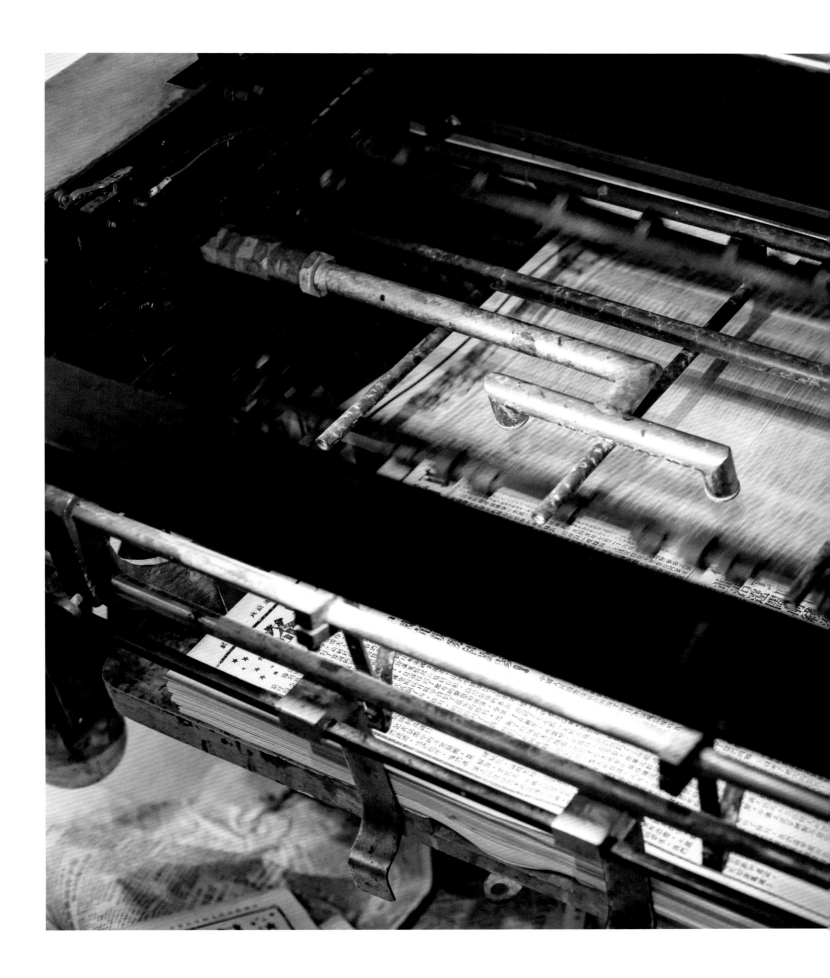

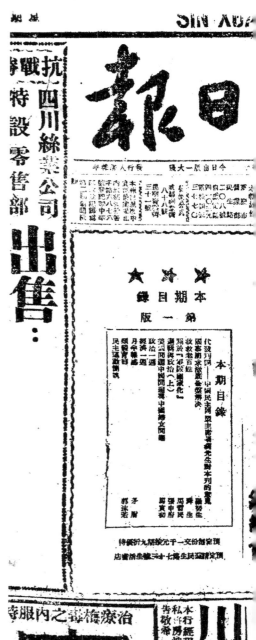

Free for the Taking, 2013

蔣主席宣佈八條件

戰時局發表談話

全國黨派共同和平建國

—解放區軍隊和政權，有功抗戰，不
親密化外。漢奸偽軍必須澈底解
，不可姑息，不可利用。

導論

由廢除新聞檢查制度說起

沈友谷

麥克阿瑟發表談話

居然主張保留的日本重工
業，還說日本在遠東仍居商
業領導地位。

新民

創刊號出版

▷星

發行人：陶行知

定價五百六十元

抗建明堂

重慶文化
西來街廿號 重慶

大本營昨正式撤消
杉山自殺島田被捕
麥克阿瑟下令解散黑龍會
逮捕廣田緒方等首腦人物

（日本東京電）日軍遵從麥帥總部的命令，已將日本傳統的武士刀和北越武器掃數繳還盟軍……

朝鮮記者向盟方控訴：
日本仍控制朝鮮
並仍操縱朝鮮境內憲兵大樓

民主的東北在新生中
哈爾濱市和省方的自治政府，已
經恢復並行使職權。

Free for the Taking, 2013

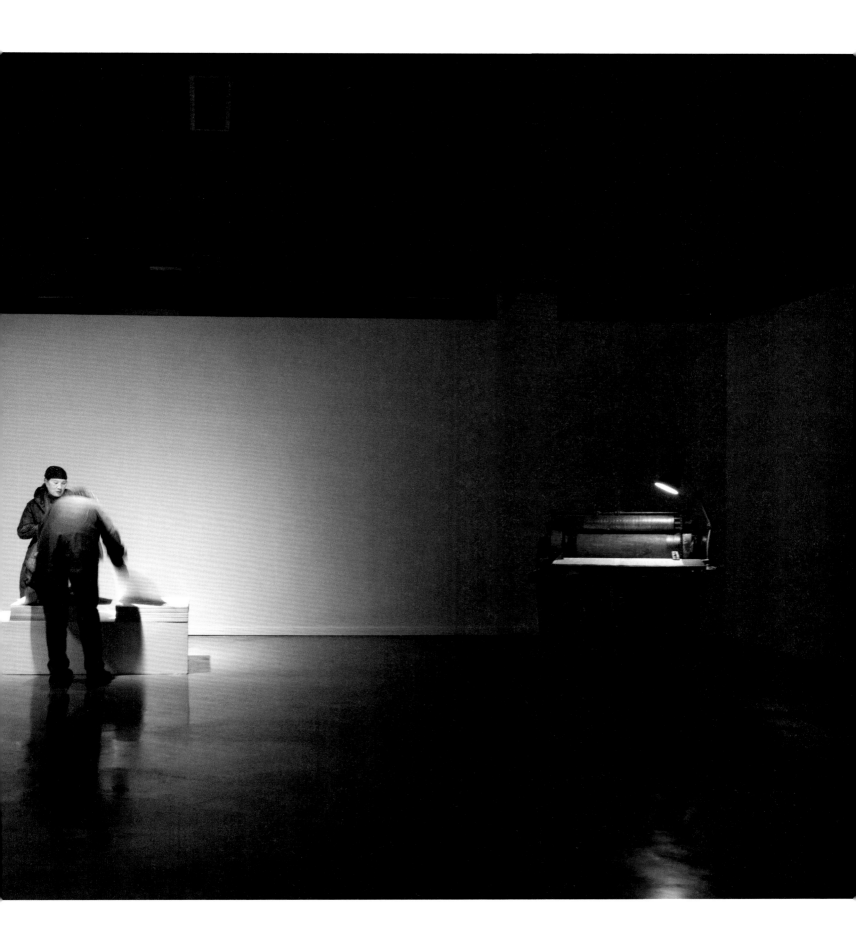

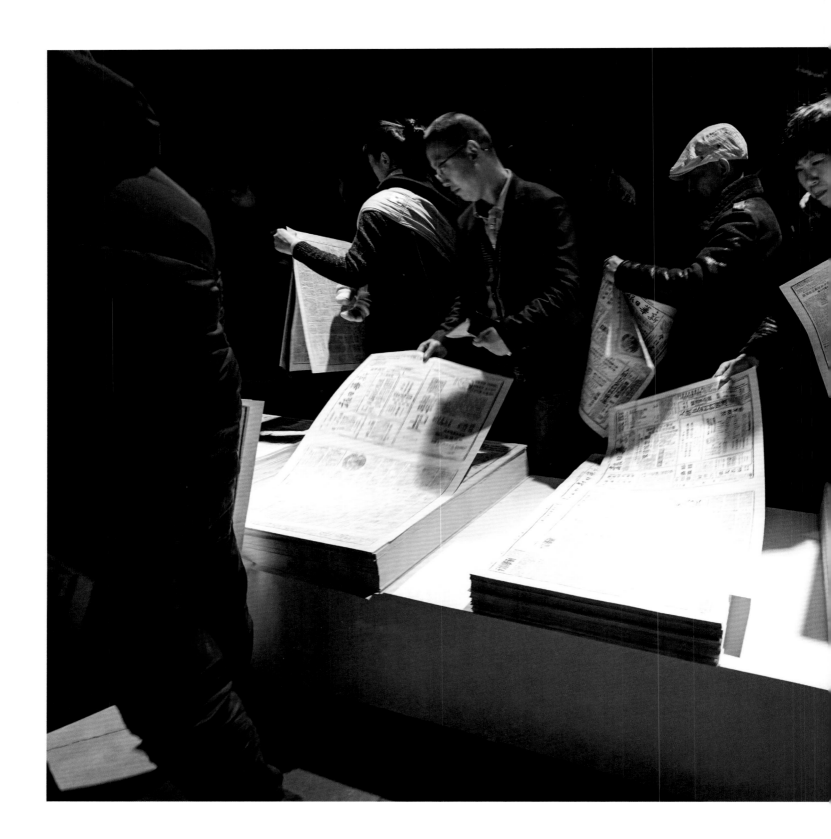

Free for the Taking, 2013

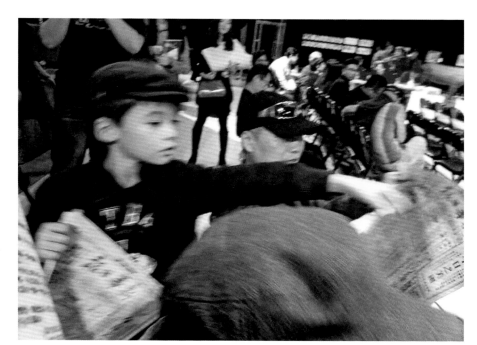

Secrets Exchange

JULY TO SEPTEMBER 2014

Medium: Interactive installation artwork

Materials: Computer, glass-walled room

Description: On May 30, 2014, Li Yongzheng posted the following
message on Sina Microblog and his personal WeChat:

"From 1998 to 2008, painting was my personal secret, for I did
not participate in any exhibitions in that decade.
I'll split these paintings into pieces, as the smallest is
30 cm x 40 cm, with a separate signature on each piece.
Anyone, even anonymously, can send me an email to tell me a
personal secret story that he has never told to anyone before.
The story should be more than 300 words. He will get a framed
piece of work from me in return. At the same time, I will get
the right to dispose of these emails. I look forward to your
participation. tangzss@qq.com"

Within a month from when the *Secrets Exchange* message was posted
on Microblog and WeChat, 231 emails and a total of 164,000
words were received. The activity continues, as one after
another, netizens send their secrets, and then the artist
sends oil painting pieces to them by mail.

●●●●● 中国移动 📶 上午12:51 58% 🔋⚡

李 勇政

98年到08年一直在家画画，也没参加任何展览，画画也算是那十年我个人的秘密。我将这批画分割了，最小30cmx40cm，每张独立的签名。任何人只要给我发一封email，写一段他经历的不为人知故事，字数最好不低于300字，匿名写也可以，我就送他一幅分割后装好框的作品。我会根据来信字数的多少决定送的画的尺寸。同时我将拥有对这些邮件处置的权利。非常期待大家的参与。tangzss@qq.com 🤝🤝

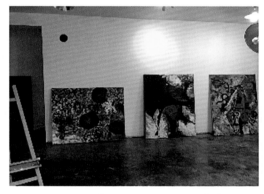

5月30日 凌晨0:52 删除

评论 😊

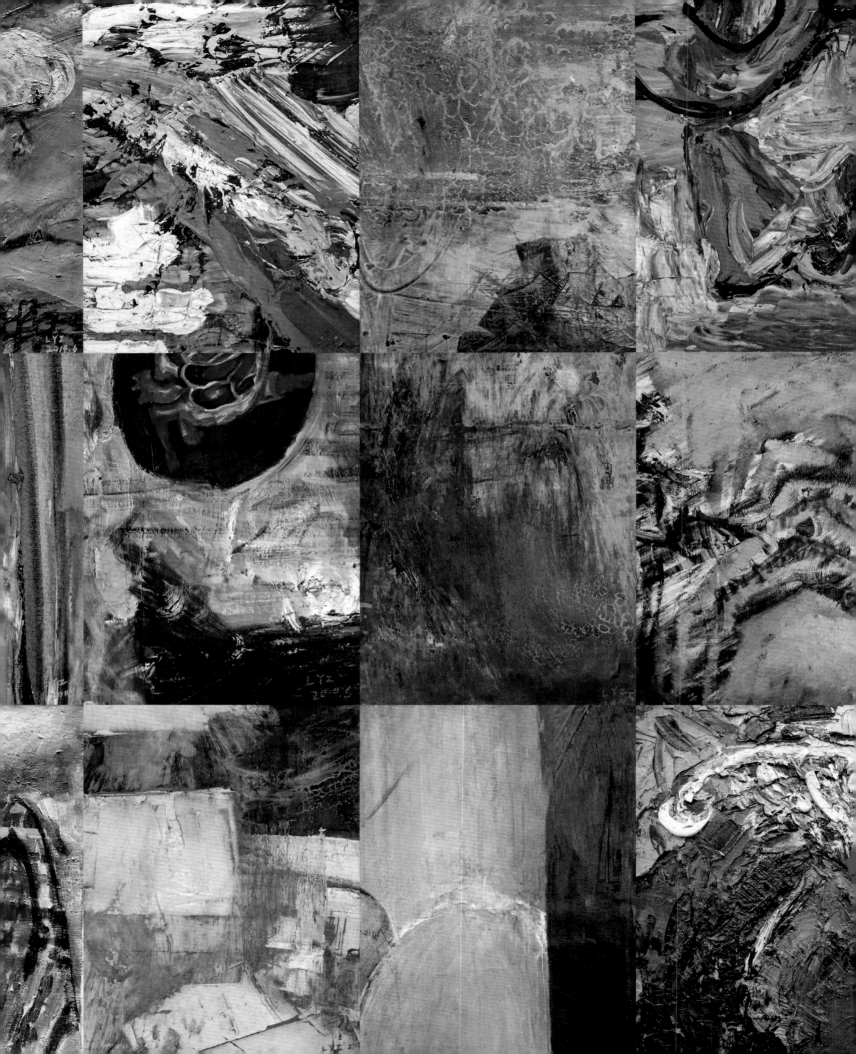

Secrets Exchange, 2014

她生活
得到的失
的，尽管
来、洗漱
班的那半

她也
想象的爱
是有美好
后便戛然
辑的片段，
时却也还

其实
无方向感
会出现的
在熟人与
何质的改
往复。她
责，但她

她其实
定期来扰
小一点，
微的她对
己：感知
之中的生

那个晚上
我
空间·过
过一下子
气场搁
过里仔
我的错
丽省白
今生过
阳界
你为

连她自己都无法描述自己的心境。有一种未曾
无法想象今天以后的任何一天会是怎么样
之后，她仍然重复着昨天的动作：准点醒
一样的早饭，然后上班。一天下来，走路上
得最有成就感的事。

有关的爱情，尽管一直以来她都与爱情无关。
得是那样的僵硬、不自然，更没有一段爱情
情总是结束在她的不自然相处的甜蜜中，然
她试图往下想，勉强得来的想象却是毫无逻
，她选择了放弃，她想一切都结束在美好之
。

的还不是这些，她觉得目前是不是的茫然、毫
辱的事情。她会跟随时代潮流，把这不定期
一种病，她一次次的宣扬"又发病了"，以
寻求一种精神上的赞同，可这丝毫起不到任
把这样的一种感受无限期的延后，然后循环
该对周围的事有所承担、对周围的人有所负

离奇、有趣的故事，这有这些循环往复的心绪
一个人的时候，她也会渐入人群，人群面积
到她是组成部分，人群面积大一点，微乎其
都无所谓组成部分了。在这时，唯有告诉自
，与组成无关，与你无关。这是生活在人群
母从来不知道她的这些心事，哥哥姐姐也不

秘密秘密.rtf

听过一个说法—如果你梦到了谁，那说明这个人正在想你。我选择相信这样
的怀疑我梦到的那个人根本没有喜欢着我。也许一切都是我自己幻想出来。因
住情节的大概5、6个梦，一次河边桥头分手，看着他走到灯火阑珊的对岸，怅
及我给他说的这个梦，我们和衣躺在一起，他从后面抱着我，没说的心里感受
梦之后。他仍然像以前一样跟我聊了一个多小时，然后忽然要走，我当时感觉
了，要不然你明天醒来就会后悔的，我希望你成为伟大的艺术家，也希望我给

想了一段，但不太开心，换段开心的写。大一结束的暑假，我受邀去高中同桌的大学所在城市秦皇岛玩，因为我想看大海。两个人都有些相互喜欢，但是当时都很单纯。走前一天来姨妈了，所以我安心去找他玩了。住的地方是他找的，海景房，景色特别好，去了就是晚上了，晚上的夜景更是尤其动人。

听着海风的声音闻着海的气息，更让我特别想看海，后来他带我去了海边。从没想过第一次看海会是在晚上。去的路上要过一条沟，然后他让我牵他的手过去。第一次跟他牵手，接触的那一刹那感觉俩个人都有颤抖，他的手很热也很有力量。　我们牵着手，光着脚在海边的沙滩上走了一段，感觉很美好又很羞涩，终于，实在不好意思了，假装要捡贝壳，松开了他的手。我们一起夸海有多漂亮，一起背高中学过的有关海的课文，一起讨论大学的生活……晚上时一起看电视，坐的很近，他一会儿坐着，一会儿躺着，都只最多拍着我的腿说我傻，没有再越界的举动。因为，我们原来讨论过异地恋太难了。他特别体贴温柔，给我买吃的，烧好水晾凉送给我，什么都先给我吃，一直抢着付钱，不让我出。

一起玩的时候也很开心。记得出发的时候头发是披着的，后来被风吹乱了，扎了起来。于是问他，我的头发披着好看还是扎着好看。

的解释。直到有一天，微信里一位多年半生不熟的诗人在我朋友圈发的信息评论：我昨晚梦到你啦。我开始对这种说法产生抵触，并真于做梦这个事，我跟他讲过。他当时的反映是发来惊讶的表情，沉默，然后回了句"日有所想"。其实，我梦到他何止一两次，能记得找他。一次他拿着放大镜检查我的胸部。一次他给我爸爸妈妈说了一大堆话。一次他打电话的声音好像所有人都听演讲一样听到了。以我觉得很安心，想跟他做爱。我们认识了好几年，单独见面5次，前四次手指都没碰一下，都是他主动约我的。第5次见面是我给他说了以后就再没见的理由了吧，于是挽留他，拥抱，亲吻，听到他说亲爱的，又说我们不能这样，你好好休息，不能这么廉价的把自己出卖
美

都在童年完美结束了。那
发呆或者浮想，它们不过
小伙伴，然后一起狂奔逃
蜓停在草尖上

童年。如梦。
秘密，换回一
是象征的。在
我的一个童话
爸爸妈妈哥
楼房前一棵三
花串在顶楼
我的童年花园
然醒了，房间

过来两个警察，二十来岁，
他们开始询问我跟她的关系，
是朋友，然后警察登记了我的
详细住址，问了些认识时间，
云云，我只好硬着头皮——

后，两个警察把我带到二楼她
门外，喊我等着，过了十来分
钟我才看到那个女孩很痛苦的
查室出来。没等我发言，警察
"你找的是不是他" 她神情

到了谁，那说明这个人正在想
没有喜欢着我。也许一切都是
次河边桥头分手，看着他走到
和衣躺在一起，他从后面抱着
跟我聊了一个多小时，然后忽
一天，微信里一位多年半生不熟的
我跟他讲过。他当时的反映是发来
着放大镜检查我的胸部。一次他给
想跟他做爱。我们认识了好几年，
理由了吧，于是挽留他，拥抱，亲昵会快乐

淫了
小小的我，有一
呻吟声。
我想说的是，3岁
记得7岁时，夏天
我，我已经开始
自己洗。
当我懂的害羞时

小小的我慢慢在
来，9岁时开始
生作文选，我就
再后来，作文选
渐的开始翻起了

日有
打电
一下，都不
能这样，

次深夜时听到了父母做爱时发

的我就性启蒙了。。。。

，有一次要洗澡，妈妈要过来
害羞，拒绝她的帮助，一定紧

就发现了摩擦自己身

大，字也慢慢的开始
了作文课，父亲就买
上了看书。
的情节已经满足不了我
亲的书刊 《小说日

Secrets Exchange, 2014

听着海风的声音闻着海的气
没想过第一次看海会是在晚
去。第一次跟他牵手，接触
有力量。 我们牵着手，光
涩，终于，实在不好意思了
多漂亮，一起背高中学过的
起看电视，坐的很近，他一
傻，没有再越界的举动。因
柔，给我买吃的，烧好水晾
我出。

一起玩的时候也很开心。记
了起来。于是问他，我的头

他看着我的眼睛 像孩子一

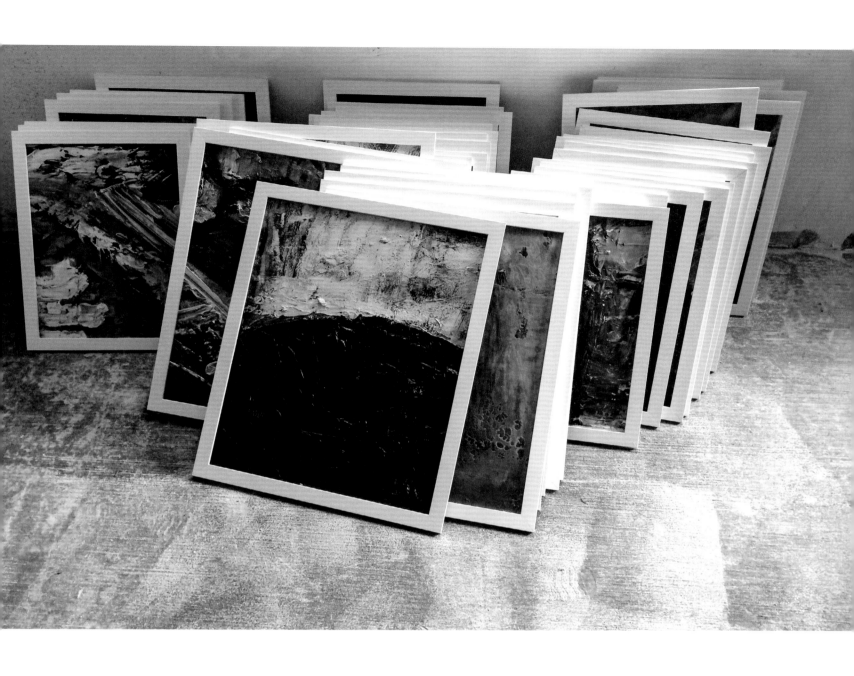

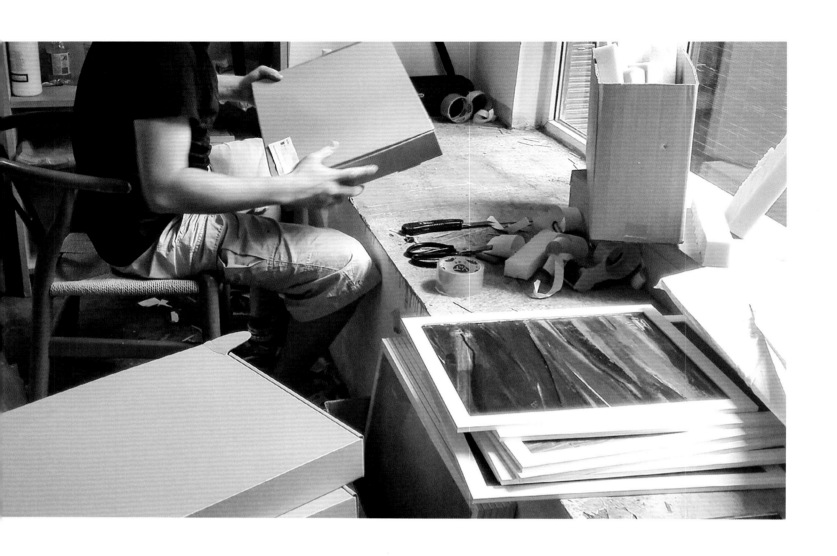

Secrets Exchange, 2014

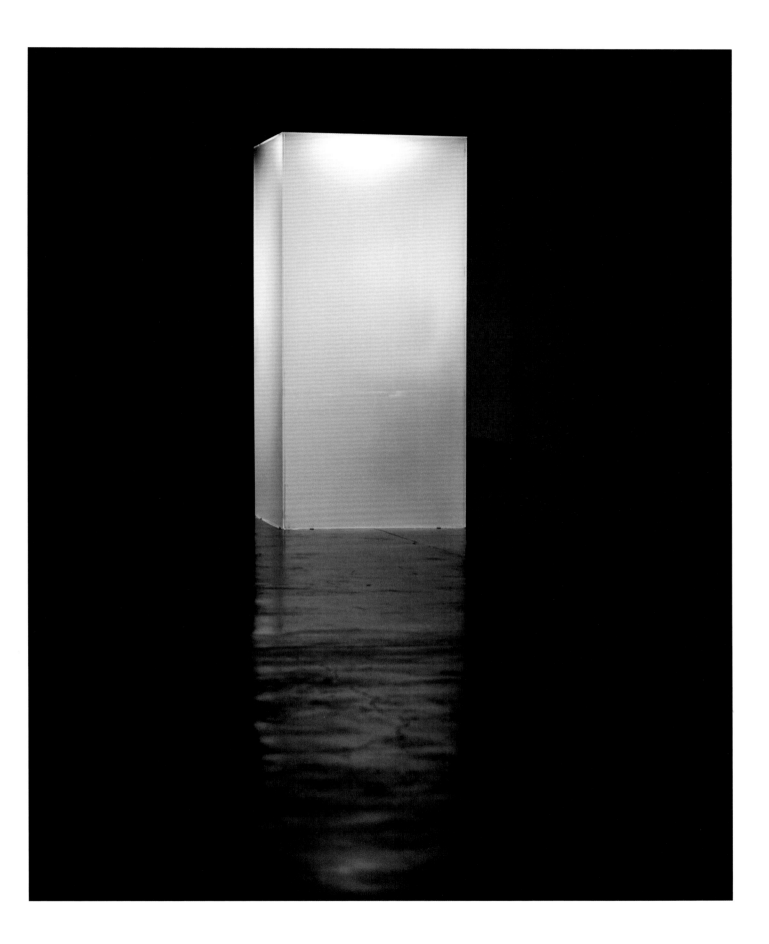

163

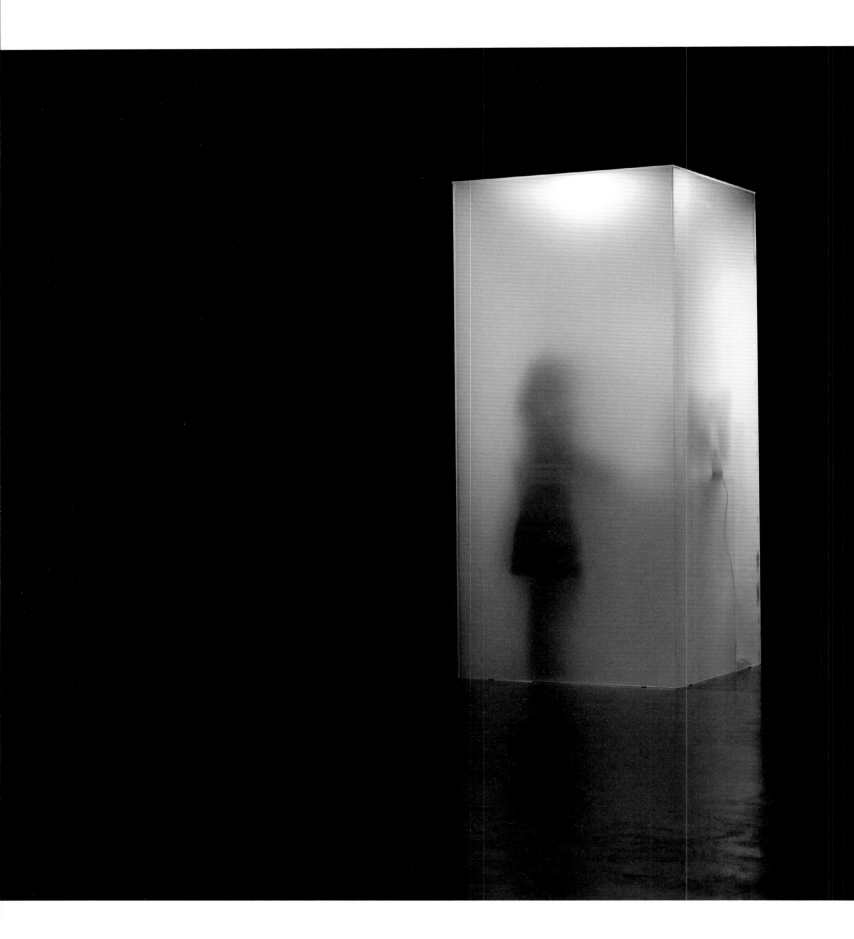

Secrets Exchange, 2014

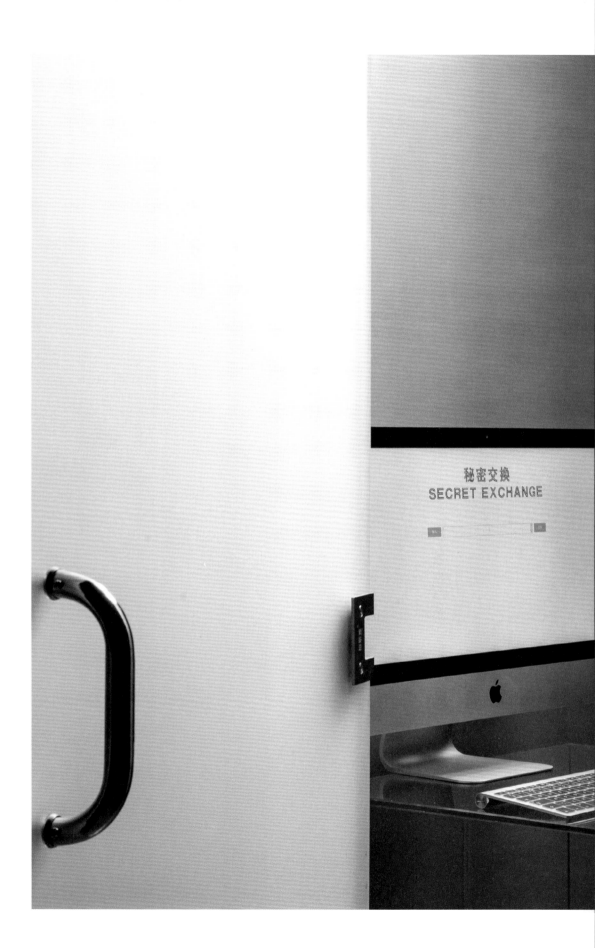

秘密交換
SECRET EXCHANGE

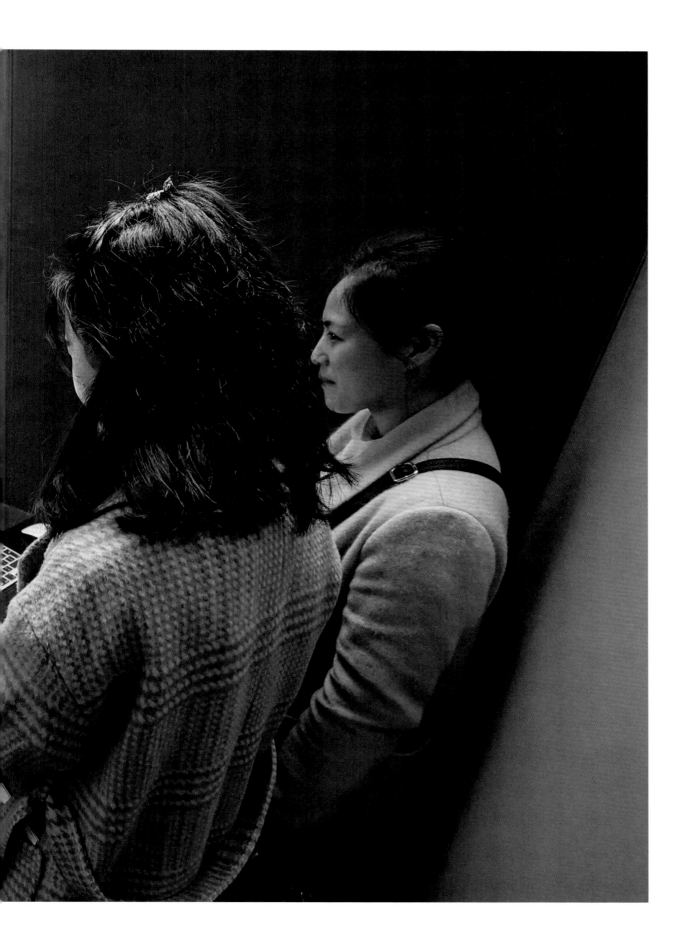

Consumed Salt at Gangren Boqi Mountain

Medium: Installation art, interactive performance art

Material: Himalayan rock salt

Description: Two thousand bricks of natural halite from
the Himalayas were composed to form the shape of Gangren
Boqi Mountain in the exhibition. During the exhibition,
the halite bricks were on sale for 100 RMB each.
Naturally, the overall shape of this work underwent changes
in pace with the constant reduction of the halite bricks
during the exhibition. A total of 1,323 salt bricks were sold
after one month of the exhibition.

Located in Tibet, Kangrinboqe (Gangren Boqi) is recognized as
a holy mountain by the whole world. It has been identified as
the center of the world by Hinduism, Tibetan Buddhism, Tibetan
Bon religion, and ancient Jainism.

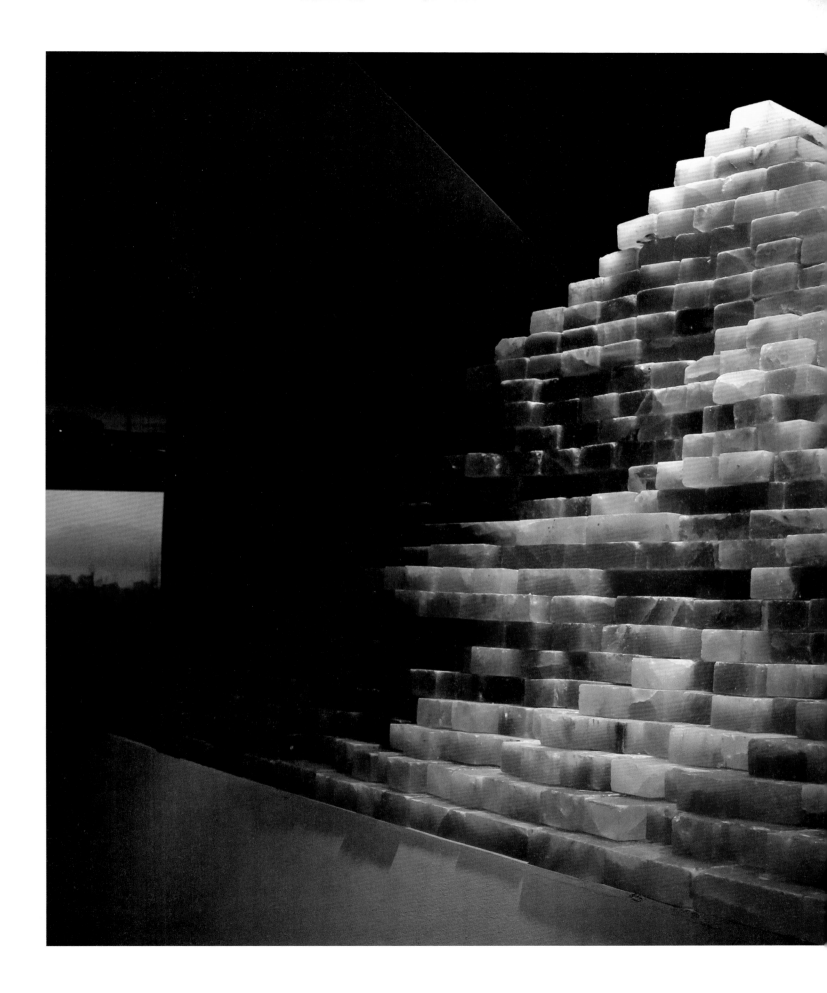

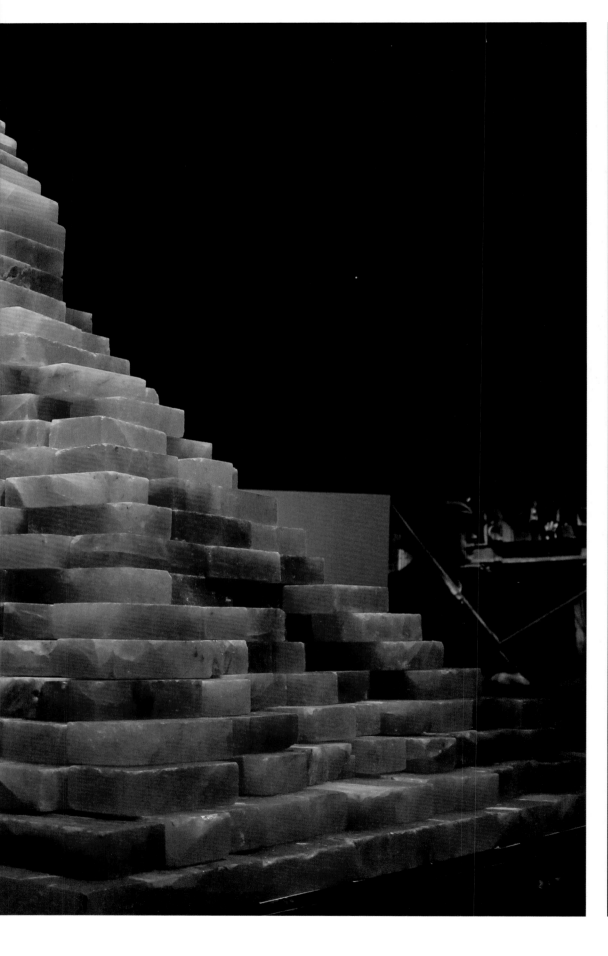

Consumed Salt at Gangren Boqi Mountain, 2014

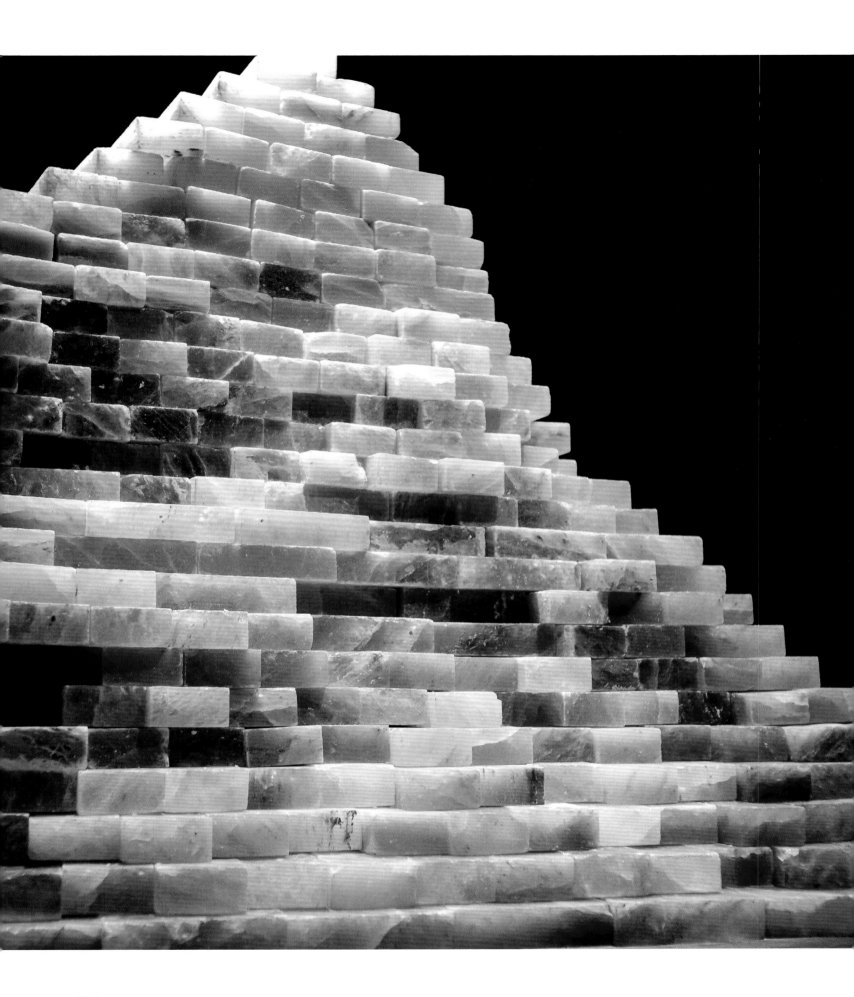

171

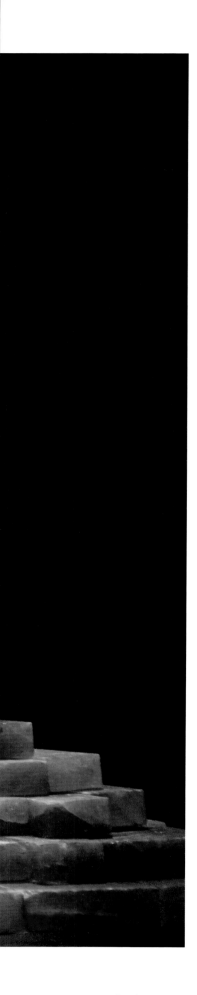
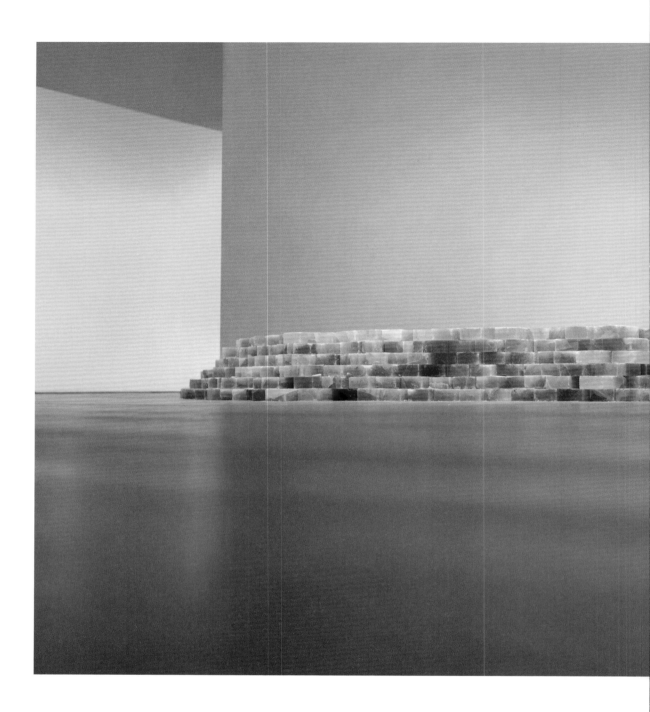

Consumed Salt at Gangren Boqi Mountain, 2014

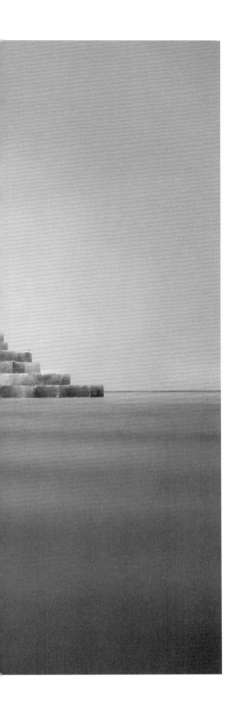
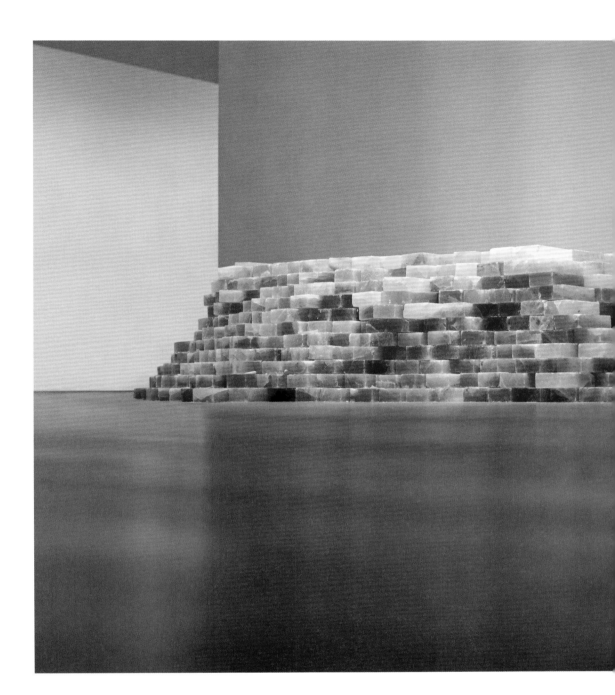

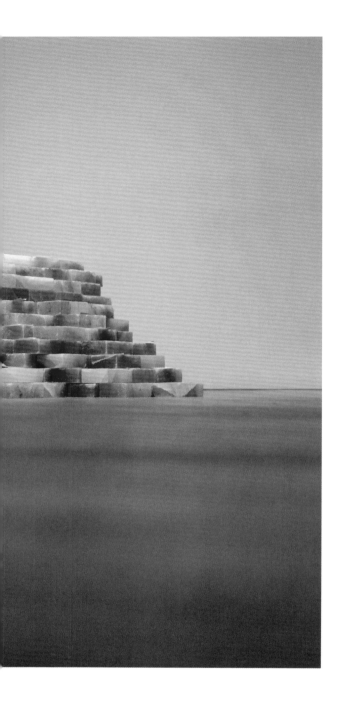
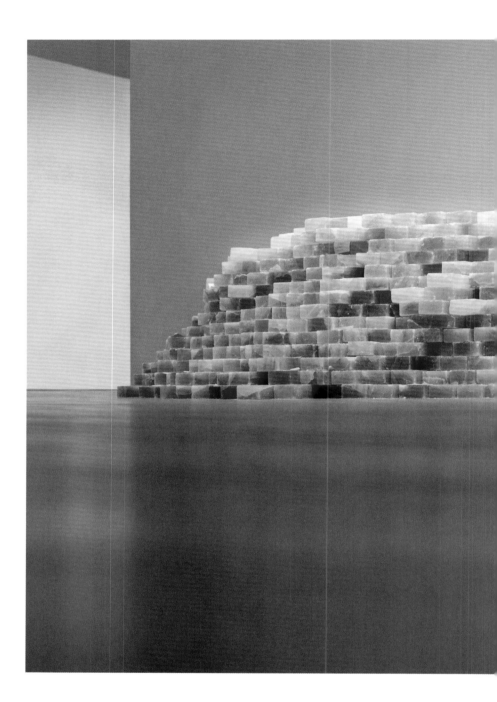

Consumed Salt at Gangren Boqi Mountain, 2014

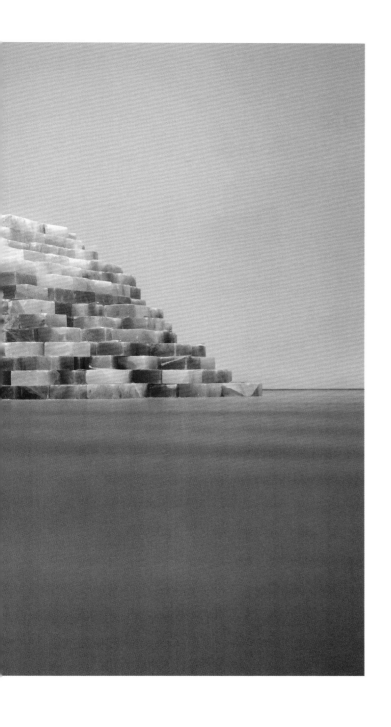

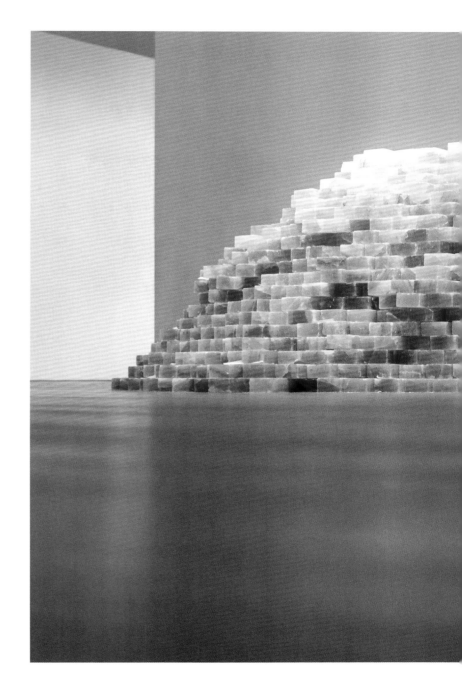

175

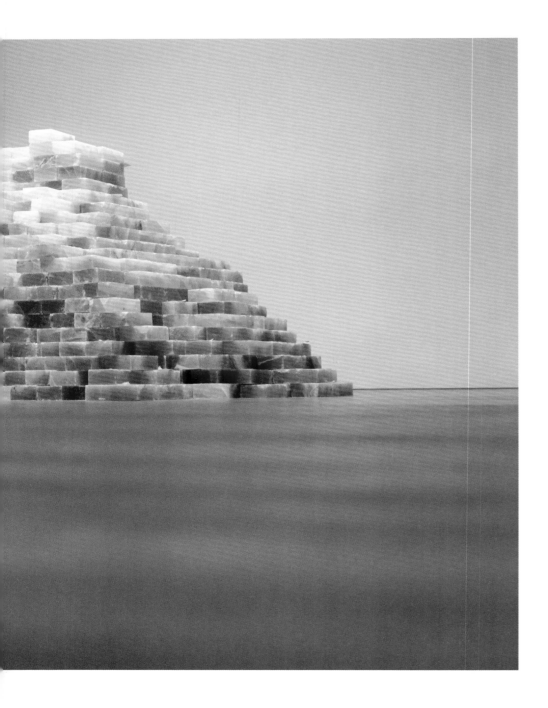
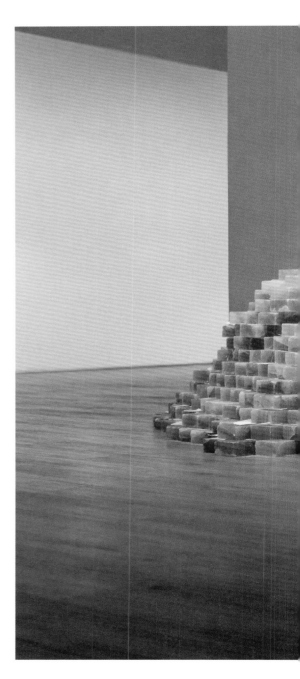

Consumed Salt at Gangren Boqi Mountain, 2014

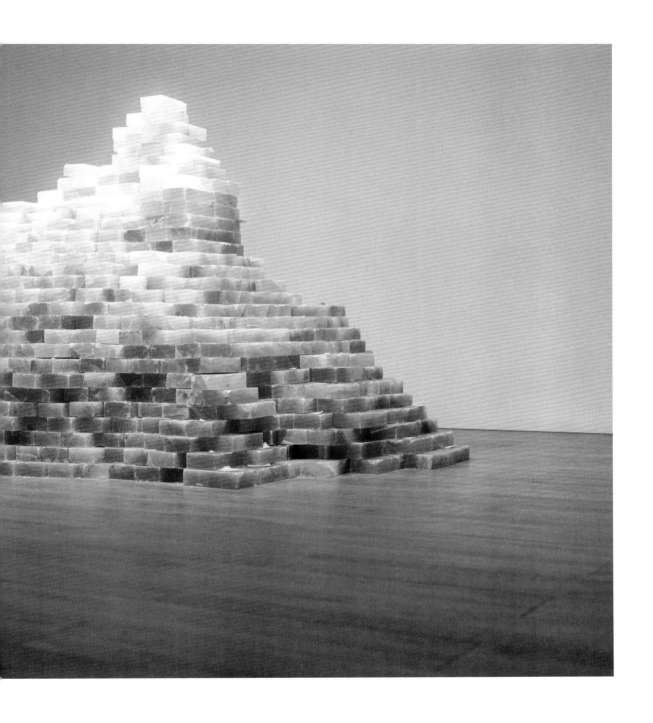

Death Has Been My Dream for a Long Time

Medium: Installation, event & performance artwork

Materials: Salt bricks, video

Description: According to a media report on June 9, 2015, four
 children (three sisters-the youngest age five-and one brother)
 committed suicide in Cizhu village, Qixingguan District,
 Bijie, Guangzhou. On June 12, the media revealed that the
 oldest sibling, the thirteen-year-old brother, Qi Gangliu, had
 left a suicide note. The letter said, "Thank you for your good
 will, I know you meant well by me, but I have to go. I once
 swore I would never live beyond 15 years of age. Death has
 been my dream for a long time. Today is a new beginning!"

The artist arrayed natural salt bricks from the Himalayas along
 the beach in Tanggu, near Tianjin. He arranged them so that
 they read, "Death has been my dream for a long time." The
 incoming tide quickly dissolved the bricks. The salt returned
 to sea.

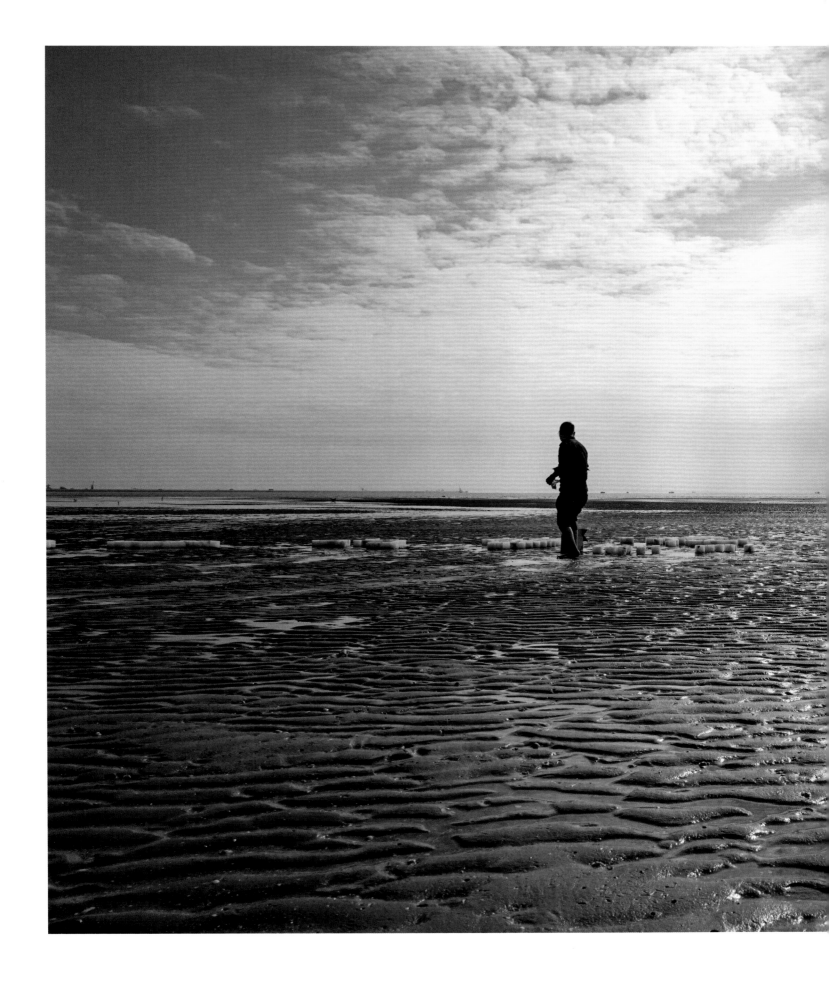

Death Has Been My Dream for a Long Time, 2015

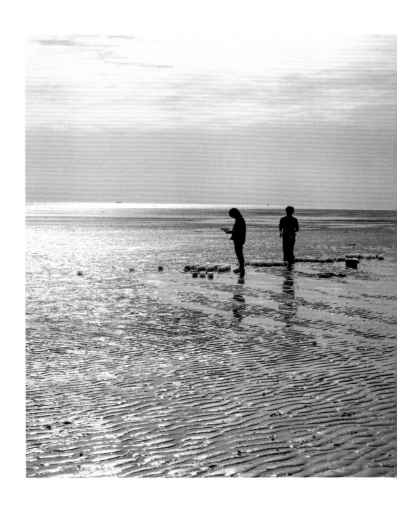

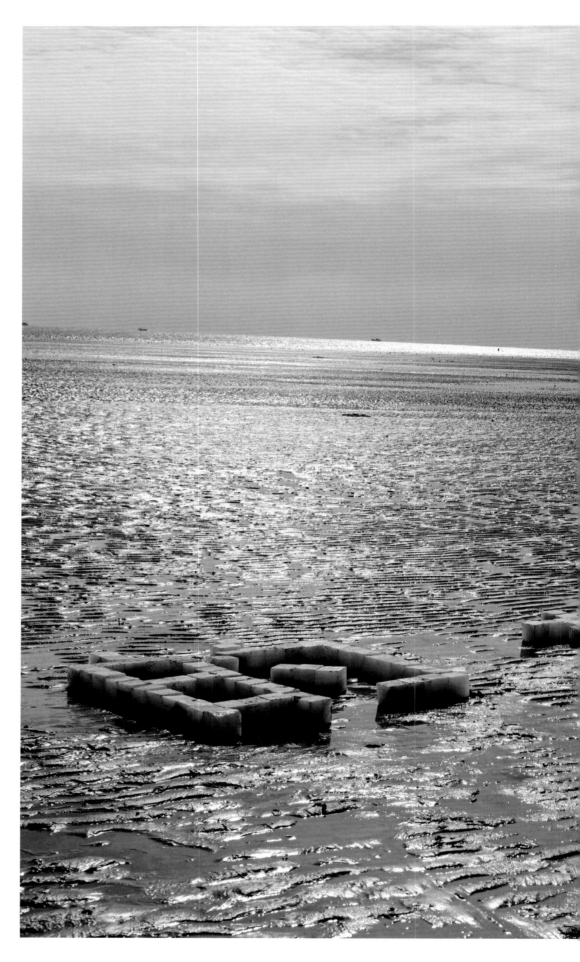

Death Has Been My Dream for a Long Time, 2015

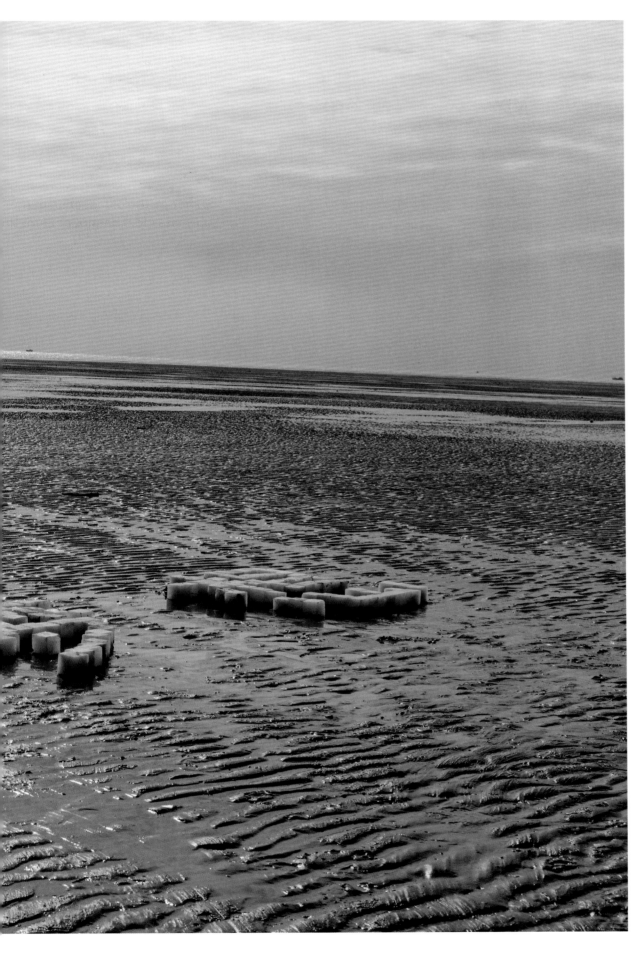

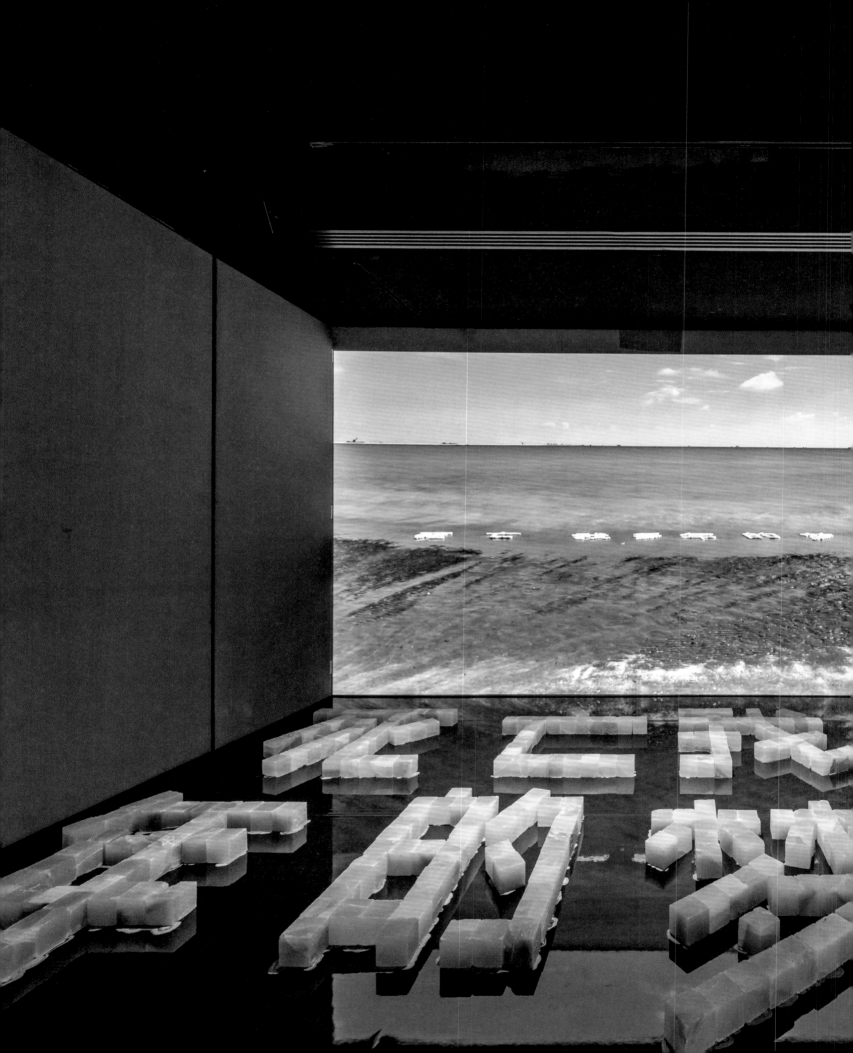

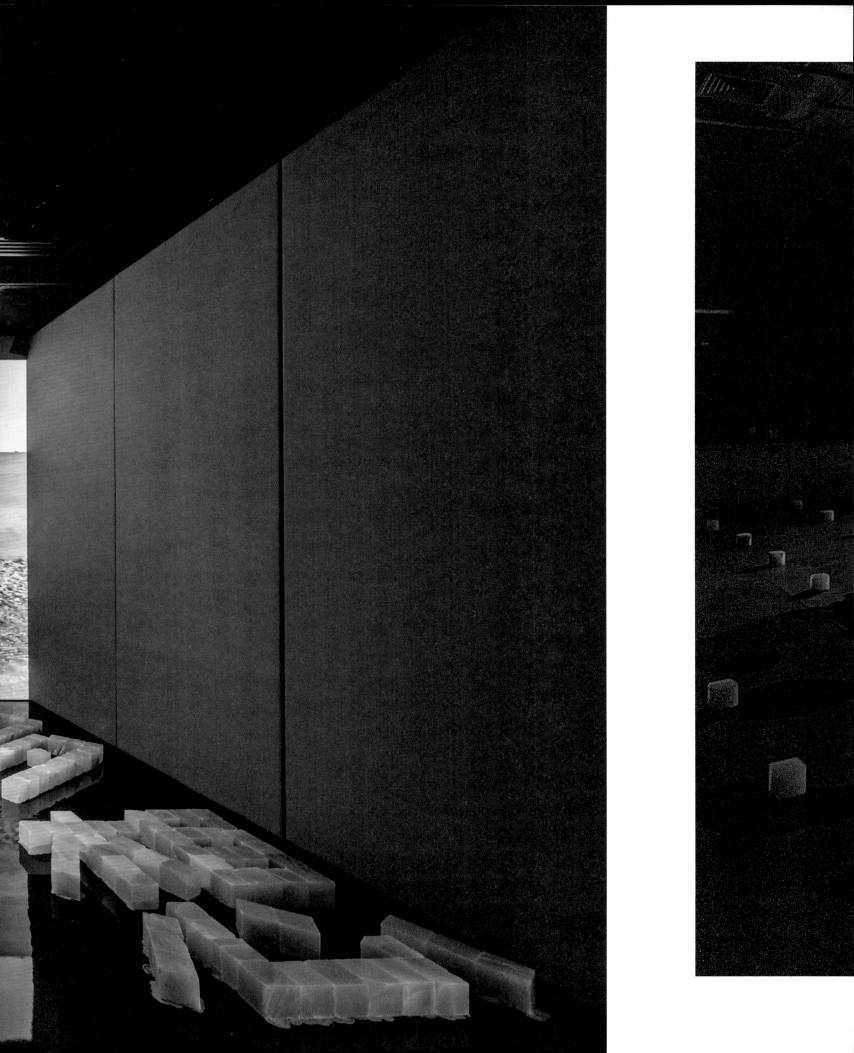

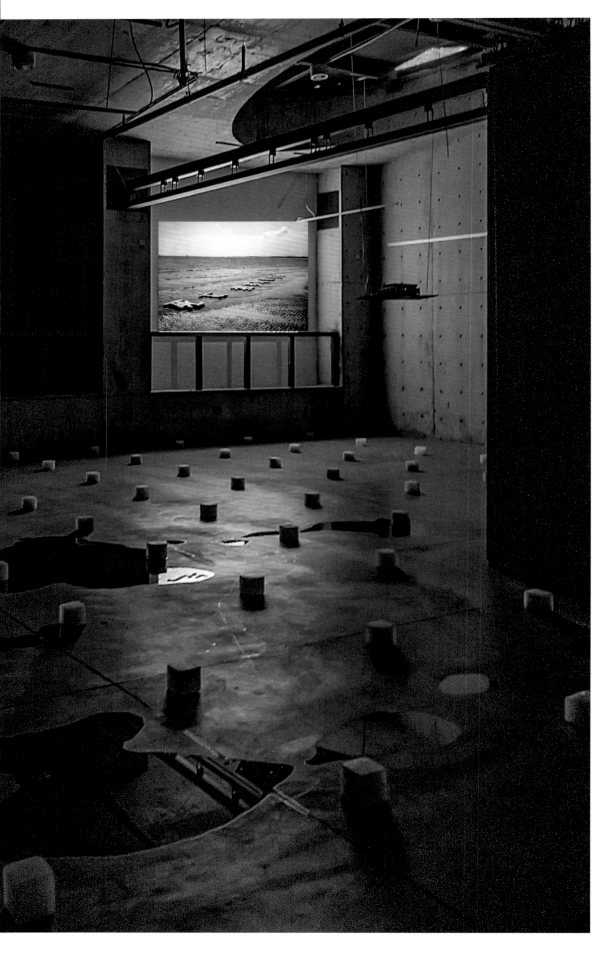

Death Has Been My Dream for a Long Time, 2015

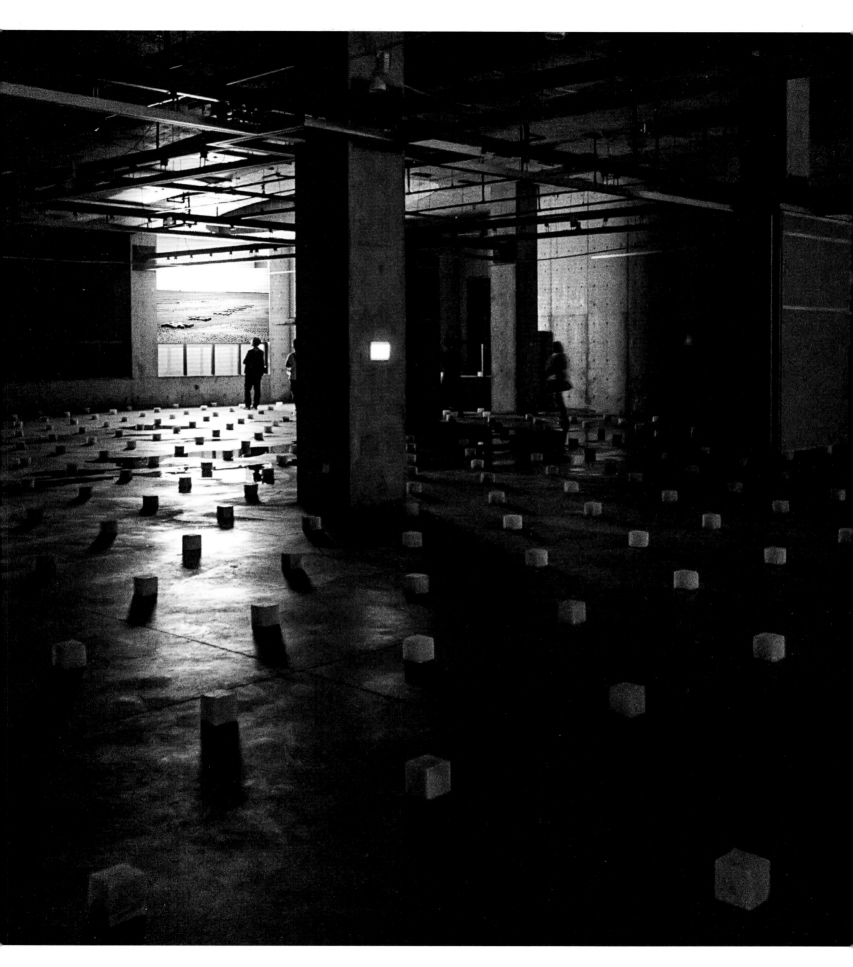

It Must Be Done: Regarding Death, a Dream of Mine for a Long Time

A conversation between Du Xiyun and Li Yongzheng

Du Xiyun: On June 9, 2015, four children (siblings) died by imbibing pesticide in Qixing district, Bijie city, Guizhou province. It was said that the sentence, "Death has been my dream for a long time" was written by one of the children in a suicide letter. Do you believe this sentence is true?

Li Yongzheng: The oldest child of the four was not yet fifteen years old. I cannot confirm the veracity of the suicide note on the internet. There were several versions of this sentence.

Du Xiyun: Why do you think the four children selected this method to end their lives?

Li Yongzheng: This world was a hellhole for them.

Du Xiyun: Were you moved by the sentence "Death has been my dream for a long time"?

Li Yongzheng: I was. I have dreamt that I was sinking into a black swamp, and that I would soon die. My body floated, warm and comfortable … I also thought that I would not live to see thirty, but I've now lived this long. While experiencing so many unbearable things, hope kept me on top. But reality could never give them that hope.

Du Xiyun: How do you see the relationship between death and the right to life?

Li Yongzheng: According to media reports, on November 16, 2012, on the same streets of Qixing district, Bijie city, five children were hiding in a dumpster to escape the winter cold. They started a fire and died of carbon monoxide inhalation. The average age was ten. What is heartbreaking is that such things are constantly happening and being forgotten. The definition of the right to life in the Universal Declaration of Human Rights reads, "Everyone has the right to a standard of living adequate for the health and well-being of himself and of his family, including food, clothing, housing and medical care and necessary social services." It not only contains safety and basic freedom from assault, but also forbids things like the plunder of wealth that humans need to survive. But there's a bookworm-like atmosphere becoming attached to these documents, and it can even lead to putting yourself in unexpected danger. In a broad land, how to live is more real than discussing rights.

Du Xiyun: Life ultimately ends, and death is an inevitable part of it. Whether filled with joy or sorrow, all of it must disappear. Before death, concerns such as fame, wealth, favors and grudges all seem empty. How do you see their relation to death?

Li Yongzheng: If death is the end, it certainly encourages life. If this is everything, why can't we be a bit more amazed, a bit more fearless, and live without restraints? Aren't the joy and sorrow you speak of evidence of life? Or rather, if death is "just a state of being from which one cannot return," an end to all questions, then don't joy and sorrow have a lingering significance? Aren't they the meaning of existence?

Du Xiyun: Nothing that living people say can affect those who choose to end their lives. When living in difficult circumstances, many people gradually lose their wisdom and imagination, and their willpower slowly disappears. Has this happened to you?

Li Yongzheng: If an adult person chooses to end their life, I would have nothing to say. I would even understand it as Baudrillard does, that choosing death can be a method of actualizing freedom. Humans are molded by reality, and choosing to die is a form of resistance to these mechanisms of control. This resistance possesses metaphysical symbolism. But in this case, I would say it seems false and pale. What kind of control? They were just beginning their lives!

Everything I have now, I attribute to fate. I'm no more insightful than anyone else and I don't have the courage to actualize my freedom, but I'm also not filled with fear or constrained. I just remain doubtful. When everyone else is bursting with joy, I desire to take a small step backward.

Du Xiyun: What do you think led these four children to lose their lives in this way?

Li Yongzheng: According to the papers, in China there are
sixty-one million children who stay in villages while their parents go to work in the cities. They are raised by their grandparents or other relatives. There are close to ten million children who don't see their par-

ents at all in a year, and there are around two million children with no one caring for them at all.

The four children who committed suicide, and the five children who died before, all number among these left-behind children. When they're left behind, what are they waiting for? This is a generation that has been abandoned. However much insane exaggeration there is about this era, this is a wound that can swallow all of the light.

Du Xiyun: Do you think similar events will occur in the same area?

Li Yongzheng Yes. In this society, we don't care much for the pain of others, and we're not good at learning from the past.

Du Xiyun: How can we prevent similar occurrences?

Li Yongzheng: I don't know. All I know is, it starts with personal action. For example, I worked with some non-

governmental relief organizations and did what I could. This kind of terrible thing left me unable to hide my emotions, and I had to make an artwork about it.

Du Xiyun: Two thousand blocks of rock salt placed on the beach spell out, "Death has been my dream for a long time." There is a metaphysical significance to your use of Himalayan rock salt. The salt is washed away by the sea. It melts and is transformed, indicating a return. Why were there two thousands blocks?

Li Yongzheng: To me, salt is a particular symbol, but this is unimportant because everyone has a different impression of the Himalayas, salt, and the ocean. There is no symbol with a universal meaning. Two thousand blocks is an arbitrary number. I found a suitable beach and each character was two meters high. It suited the environment, and I needed 1,170 blocks to spell out the eight characters. On-site, about 830 square meters were covered by the blocks, with one block on each square meter. You can do the math, and it adds up to two thousands blocks.

Du Xiyun: You take the specific societal causes of their death and transform them into a poetic art-

work. When expanding the laments and thoughts that humans have about their lives, are you negating the specific causes of death with these poetics?

Li Yongzheng: Misfortunes are constantly occurring, and they are numerous. No matter how you express them or what the expression is, you cannot preserve something for eternity. One incident will always be swallowed by the next, until even you yourself cannot return to your questioning state and cannot regain your tranquility. I just wanted to make something. Or rather, this event forced me to do this, even if it is already forgotten.

Du Xiyun: For you, what is the use of the artistic identity, artistic methods, and dissemination in the art system?

Li Yongzheng: I don't know. Perhaps using that kind of method inside that kind of system cannot produce a clear answer. But we have to do something. I hope it can produce a beautiful result and encourage action in this moment. In the end, we're still living well.

<u>Medium</u>: Interactive installation artwork

<u>Materials</u>: Ready-made objects, video

<u>Description</u>: In early 2015, the artist put out a call on a social networking app. The call invited people to place plastic figures of police along street and sidewalks, as well as in front of and behind buildings. The artist then invited these participants to send him photographic documentation. Within one year, participants from over twenty Chinese provinces had sent photographs.

<u>Interactive component</u>: Spectators were able to interact with the models and masks on display at the exhibition.

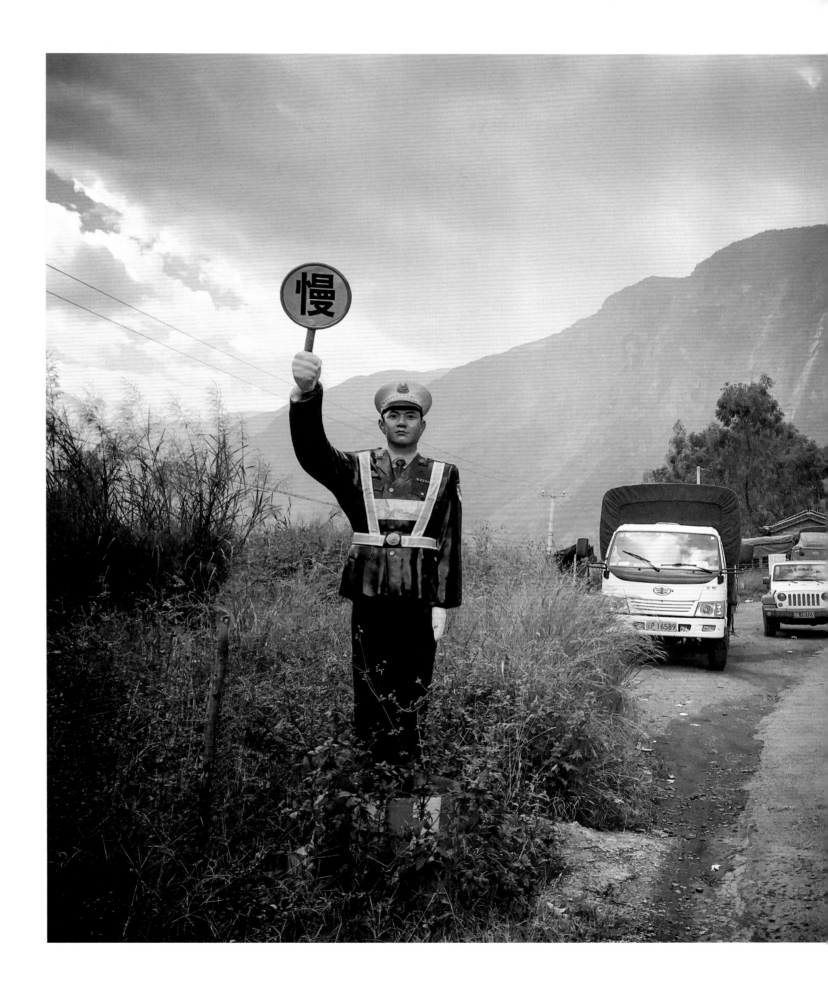

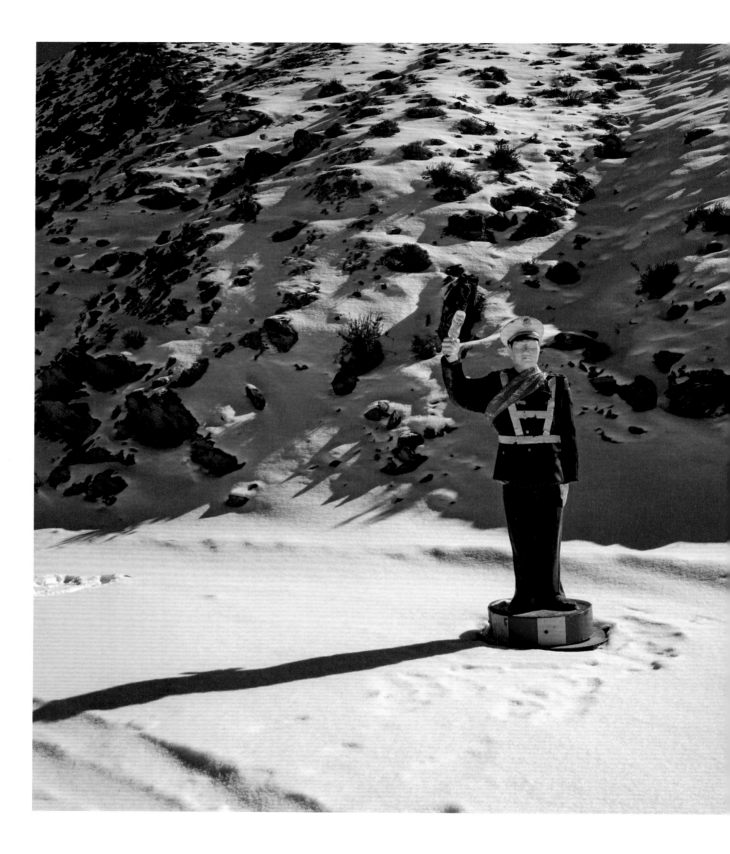

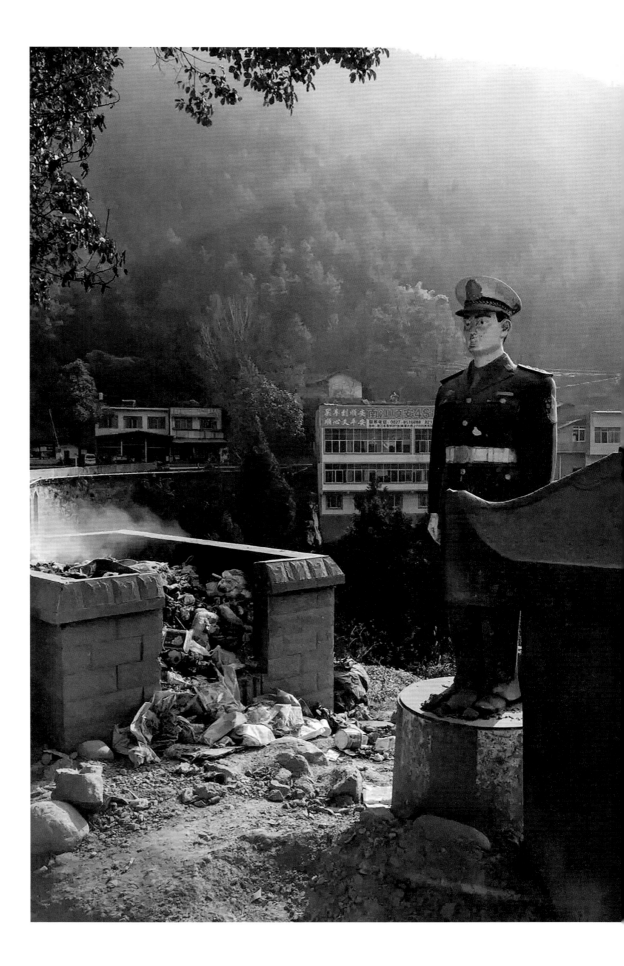

193

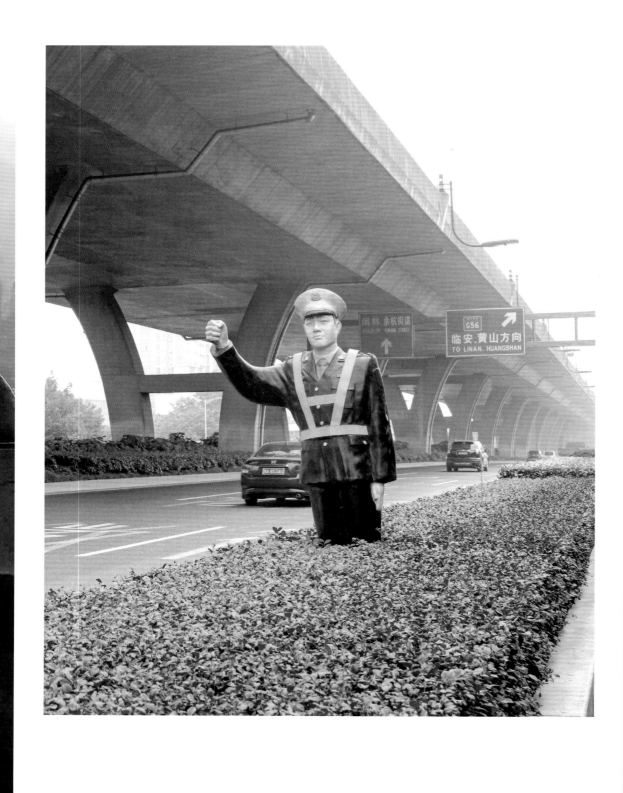

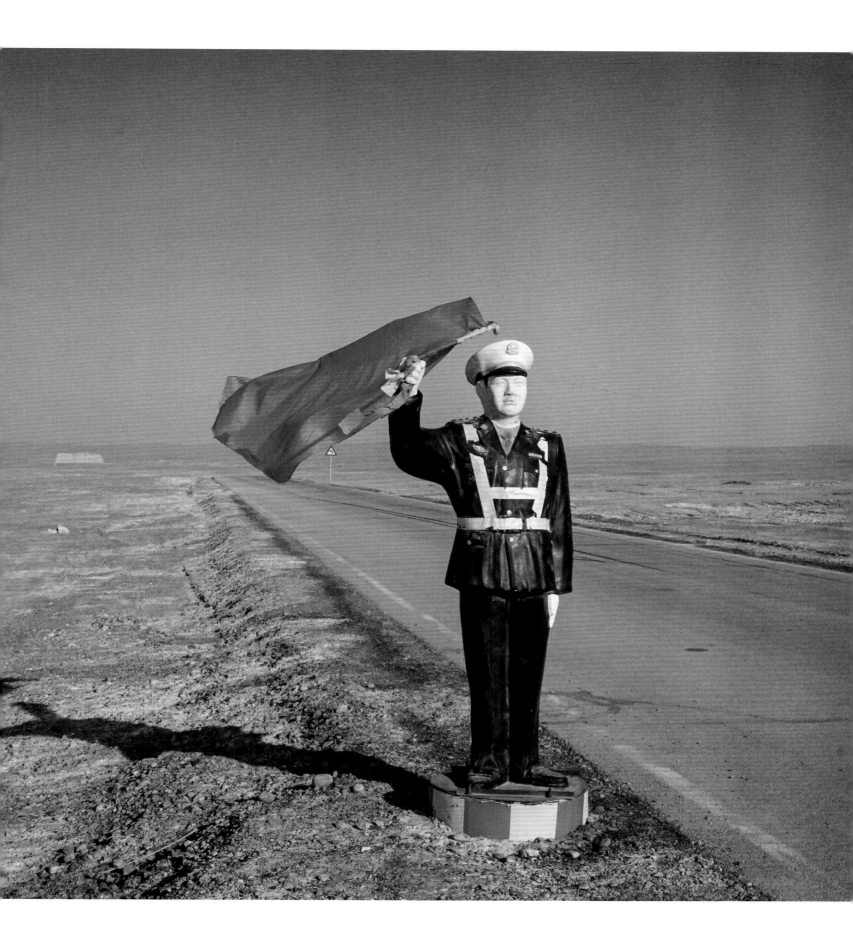

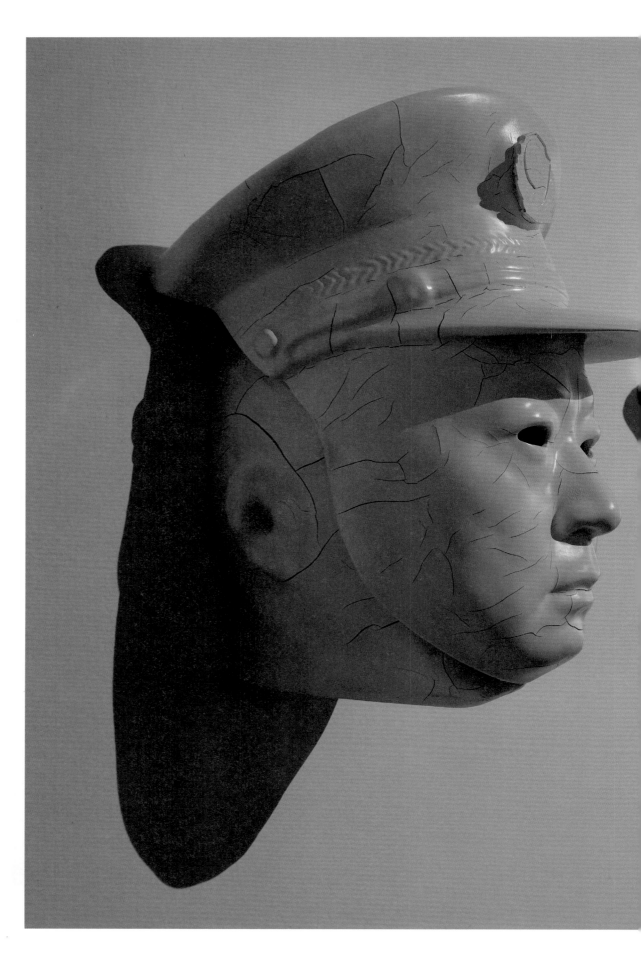

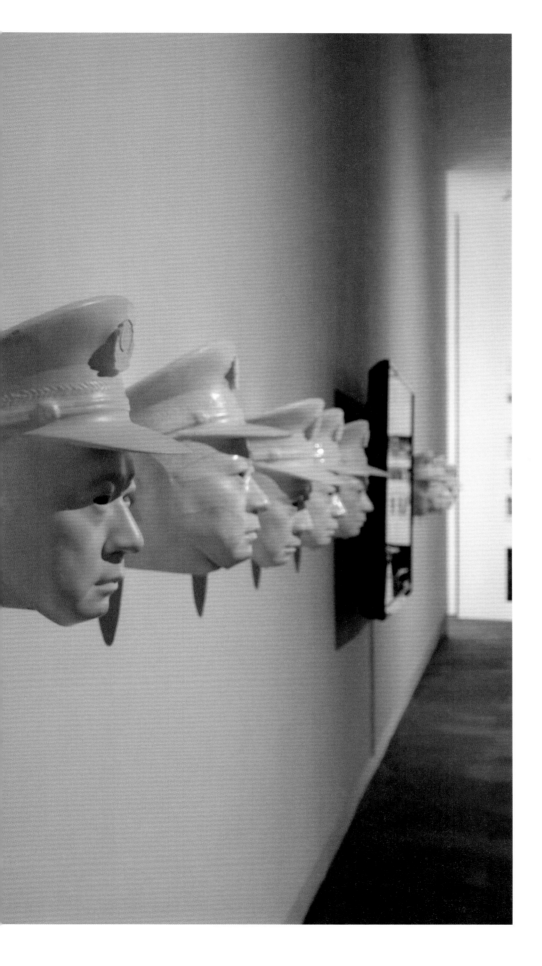

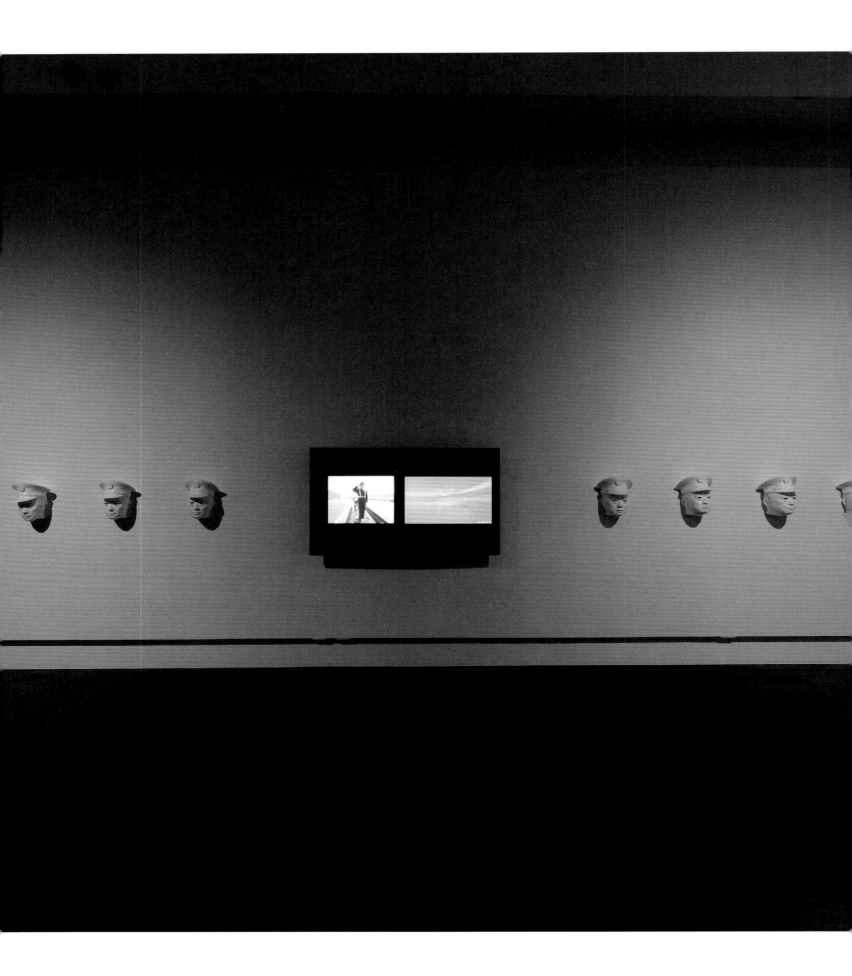

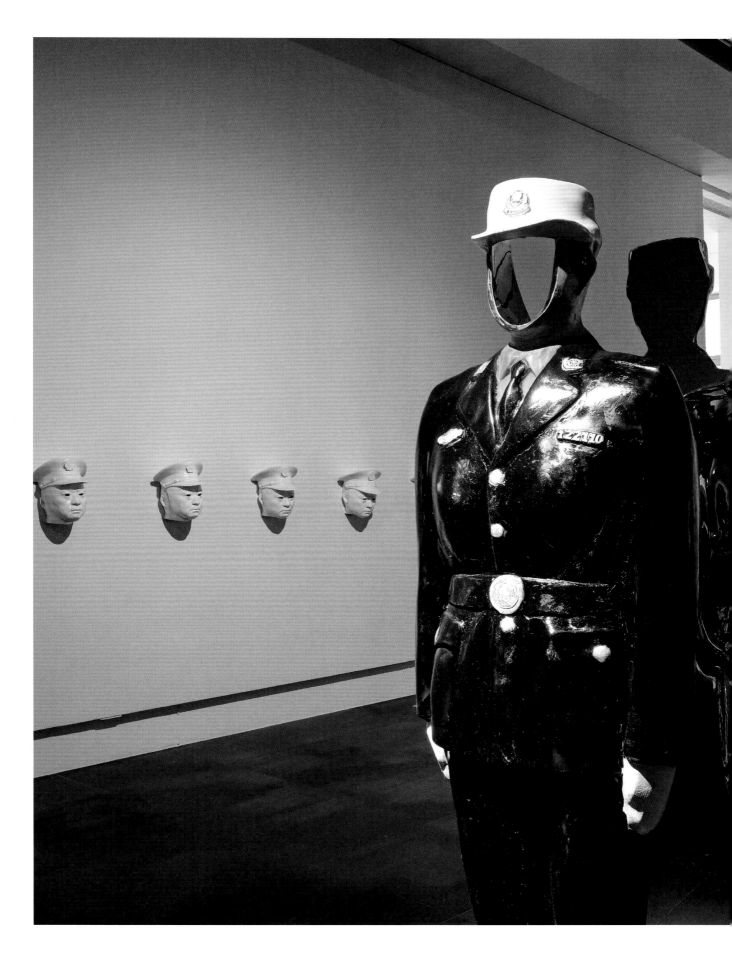

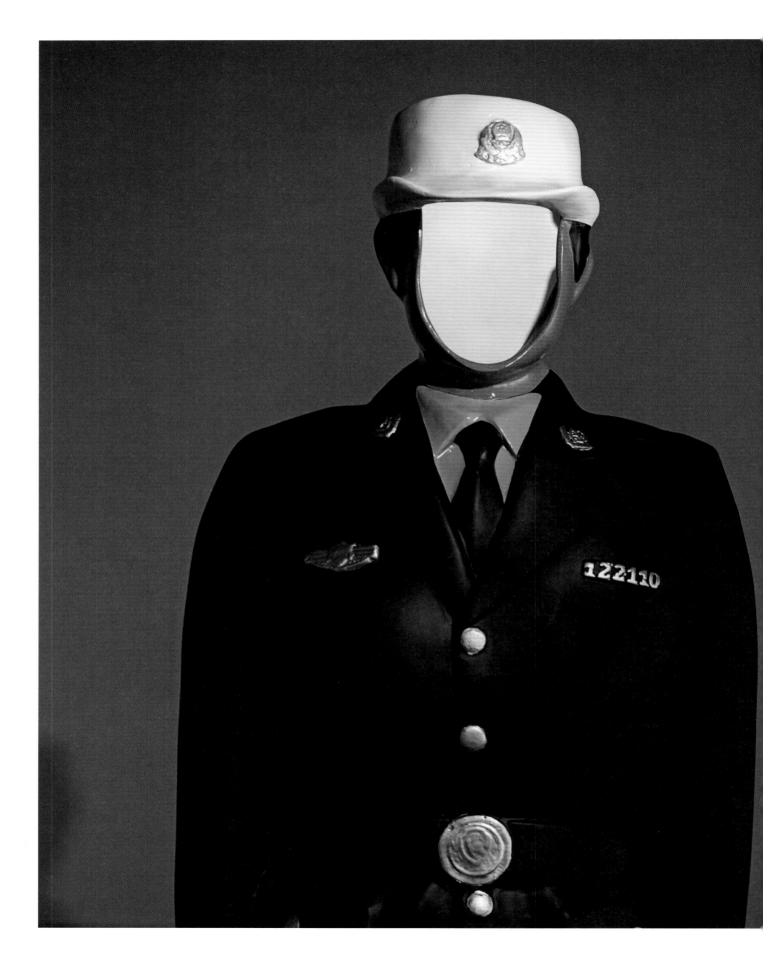

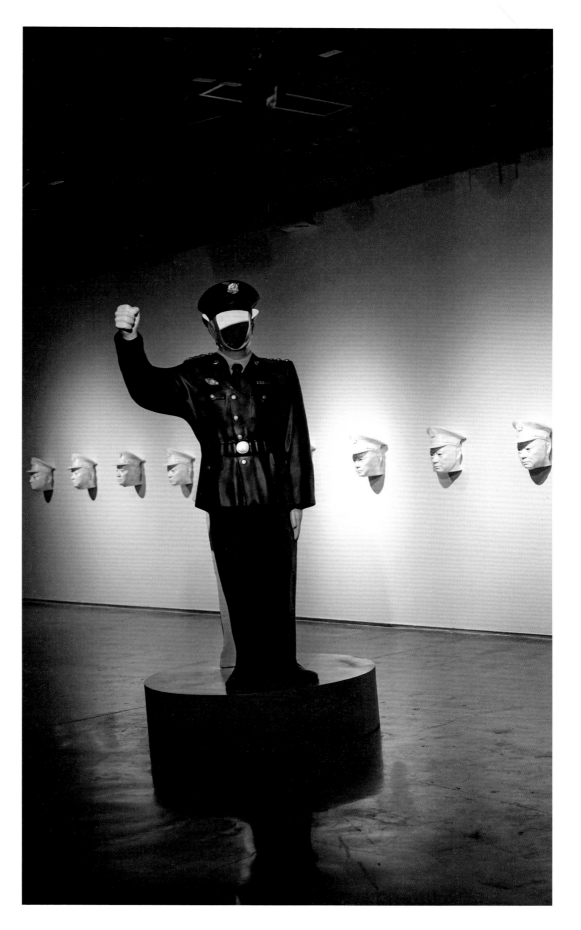

Gift

<u>Medium</u>: Interactive installation artwork

<u>Materials</u>: Fake rockets, railroad track, shopping cart, virtual-reality video

<u>Description</u>: The fake rockets on display at the exhibition were initially purchased online. These rockets are sold as auspicious amulets and village mascots. The VR video is an empty scene recorded in advance. The audience saw the same scene in VR and reality.

<u>Interactive component</u>: Spectators were invited to wear virtual-reality glasses while receiving help from a worker to push the shopping cart from one end of the railroad track to the other.

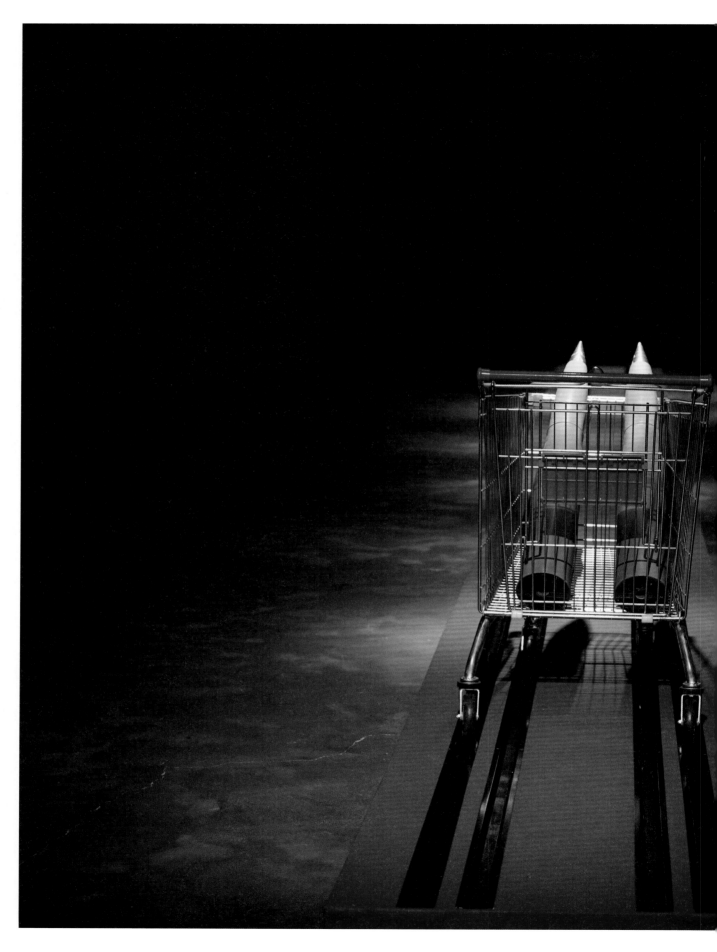

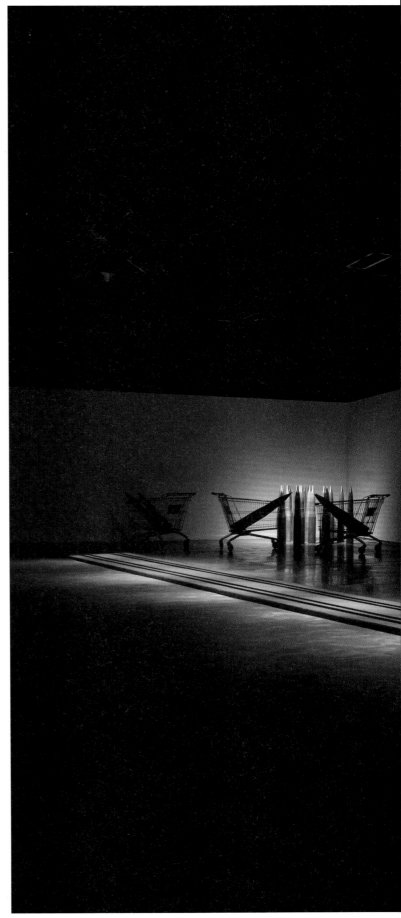

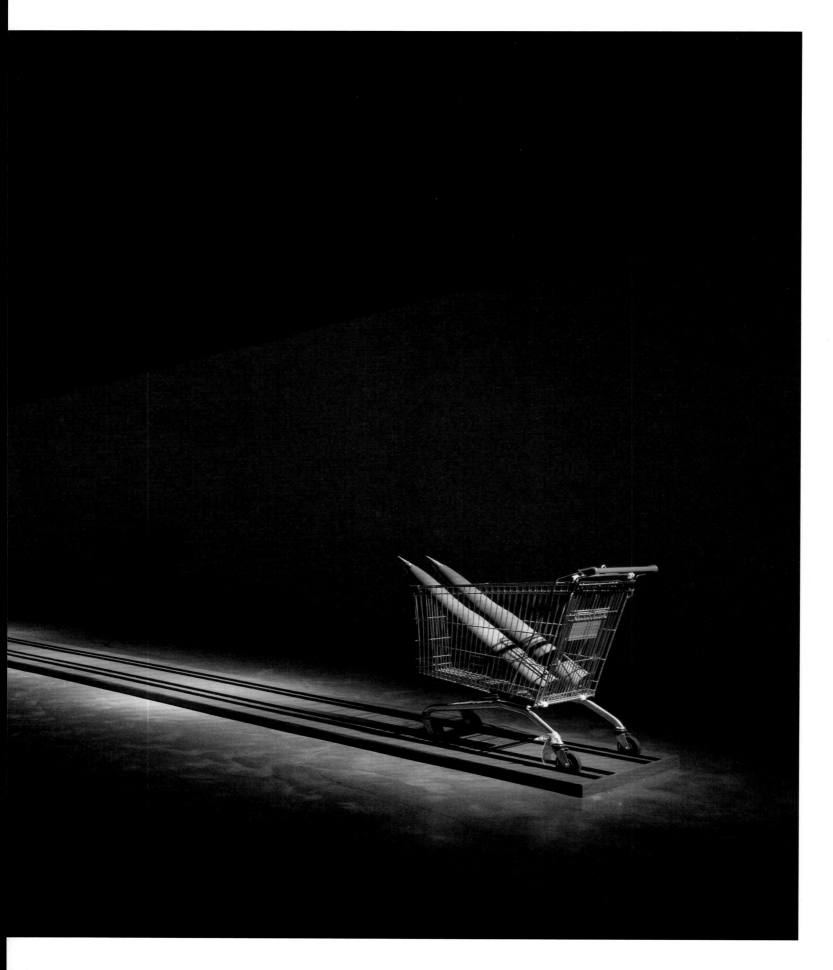

Gift, 2017

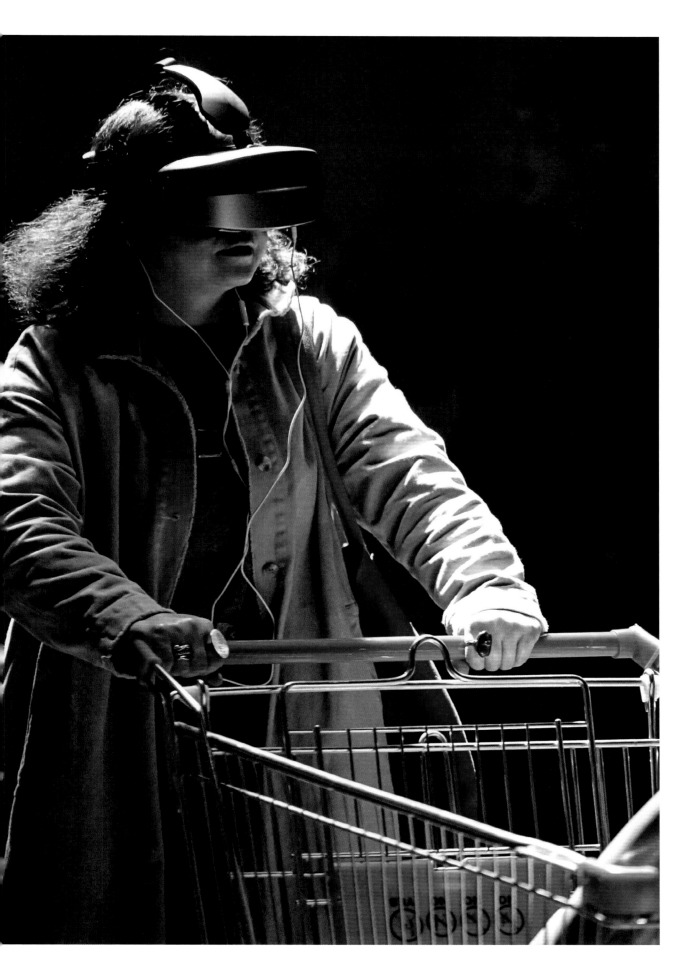

Installation

: Himalayan salt

ion: A map of the myriad mountain ranges of the
as was created. The map also indicated places where
ople had chosen to die. Visitors could walk on the map,
as paved with Himalayan salt, their footsteps mimicking
nd of crackling ice.

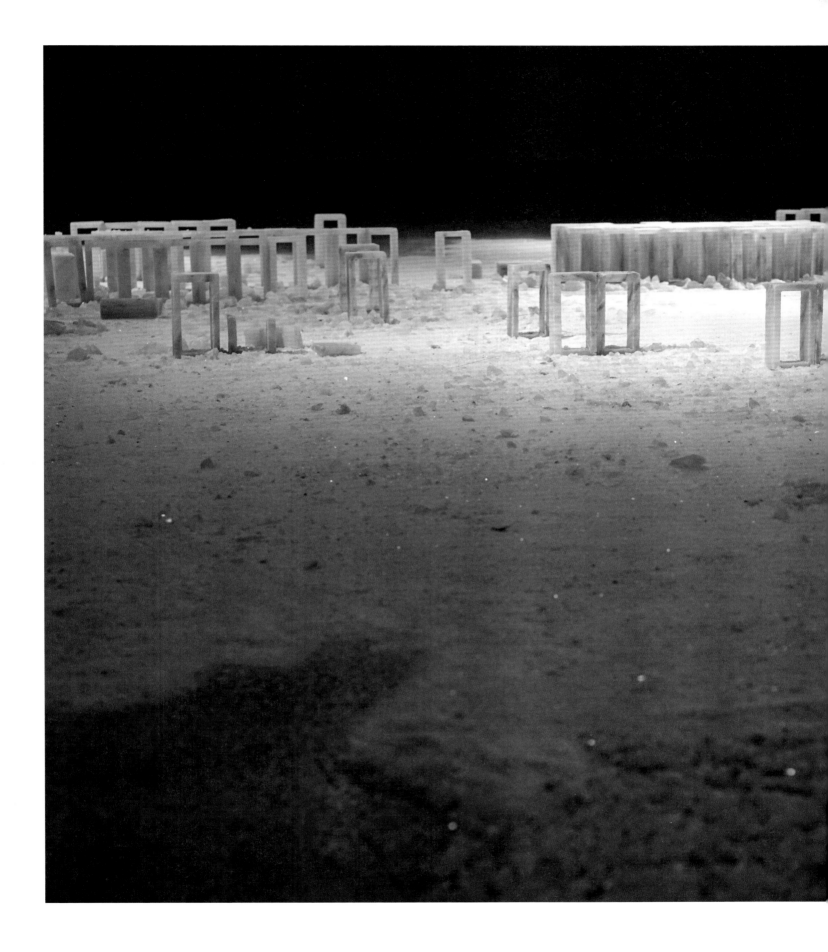

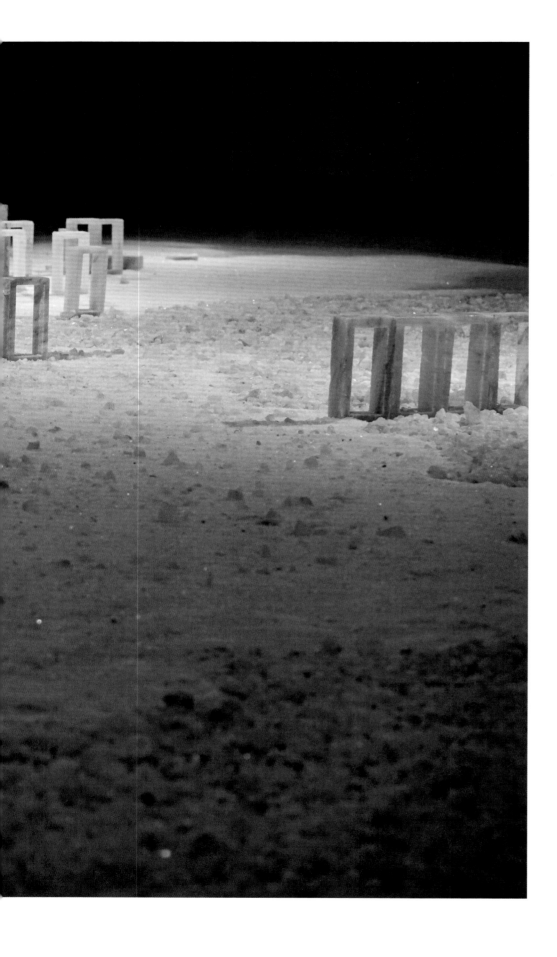

There Is Salt 1, 2017

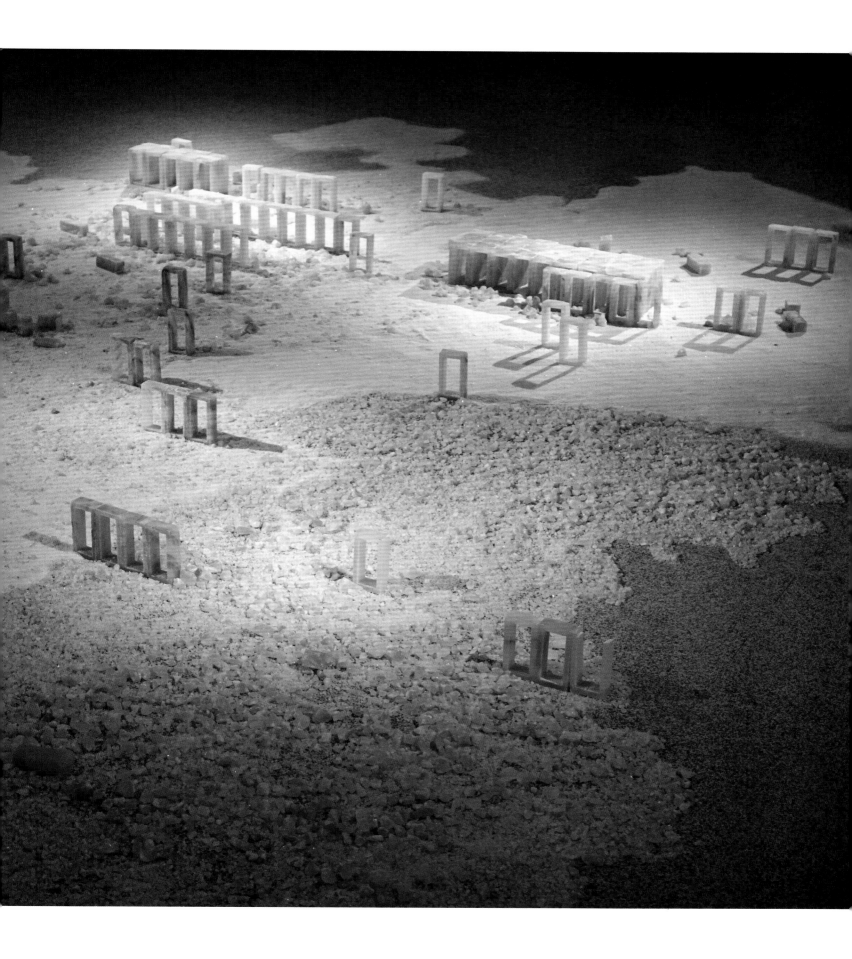

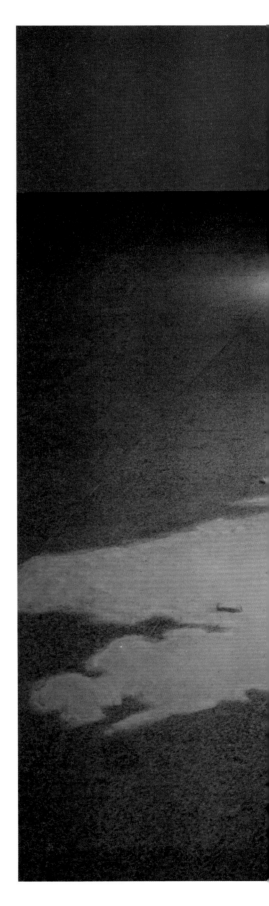

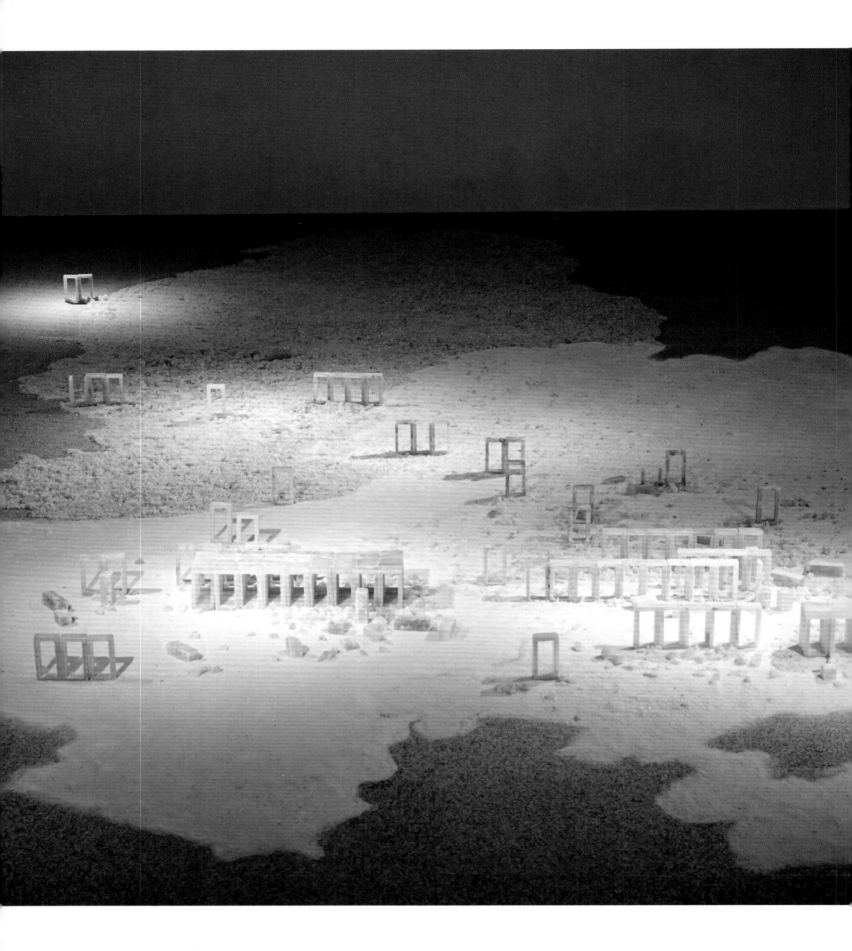

There Is Salt 1, 2017

t

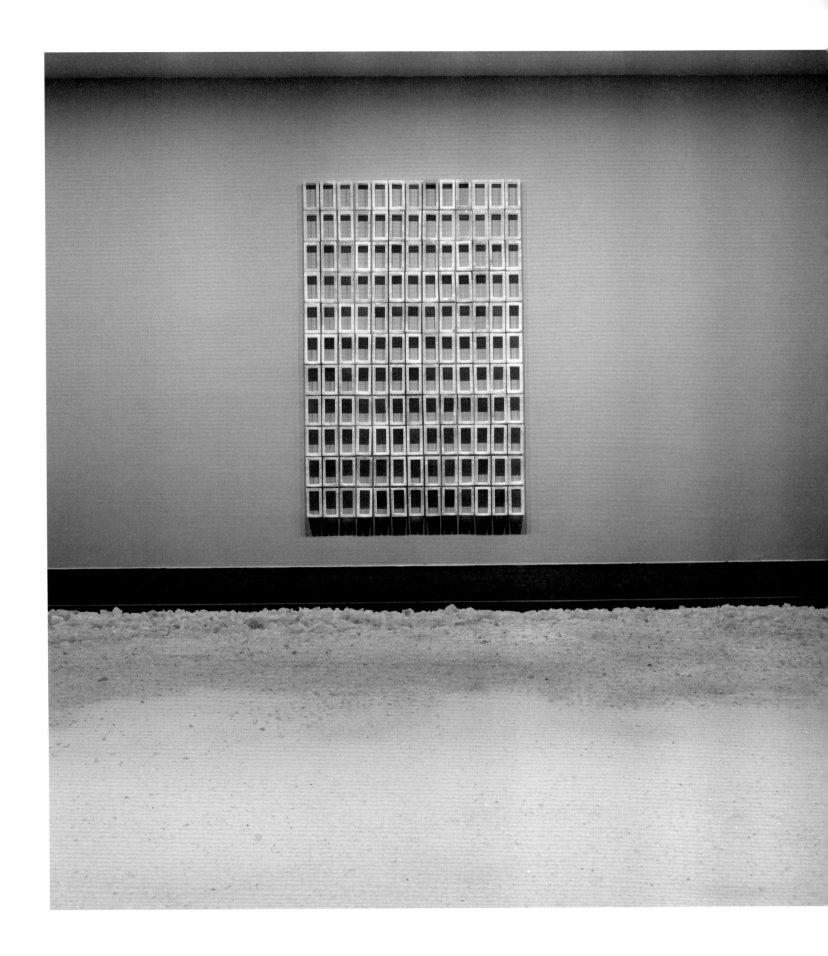

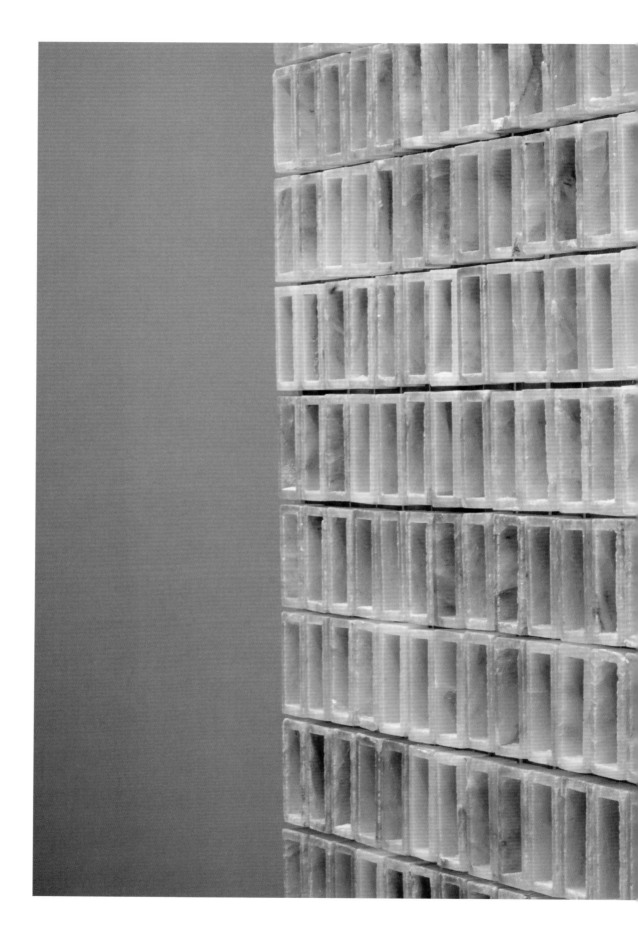

There Is Salt 2, 2021

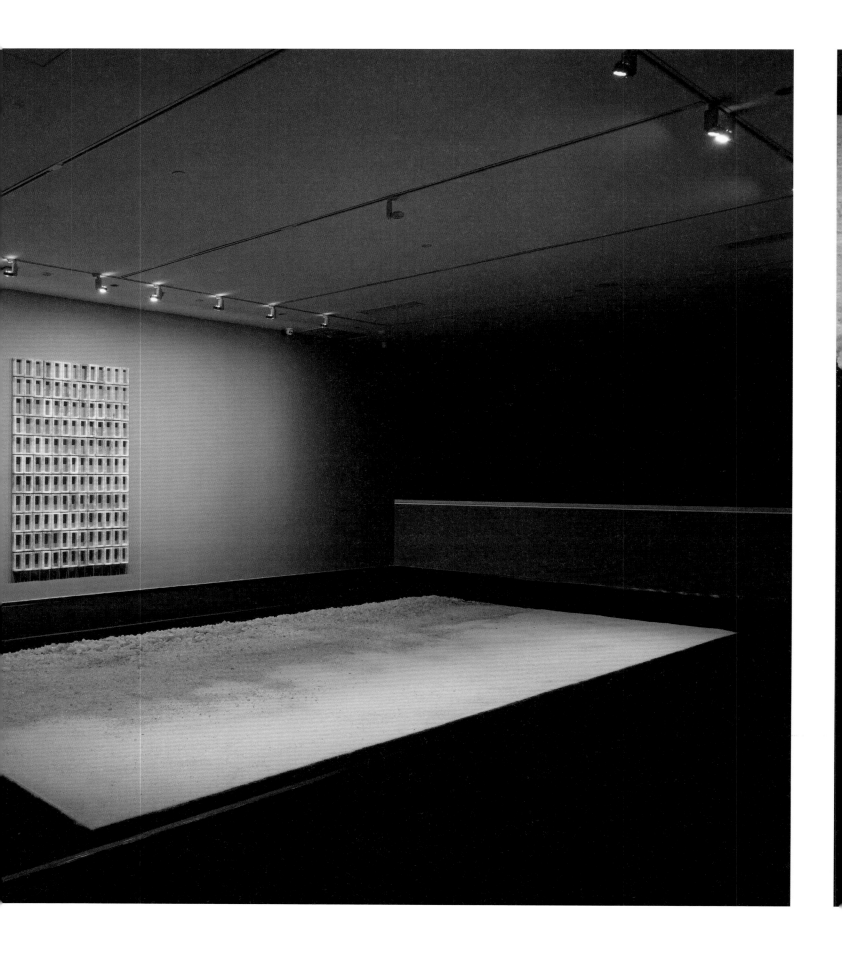

There Is Salt 2, 2021

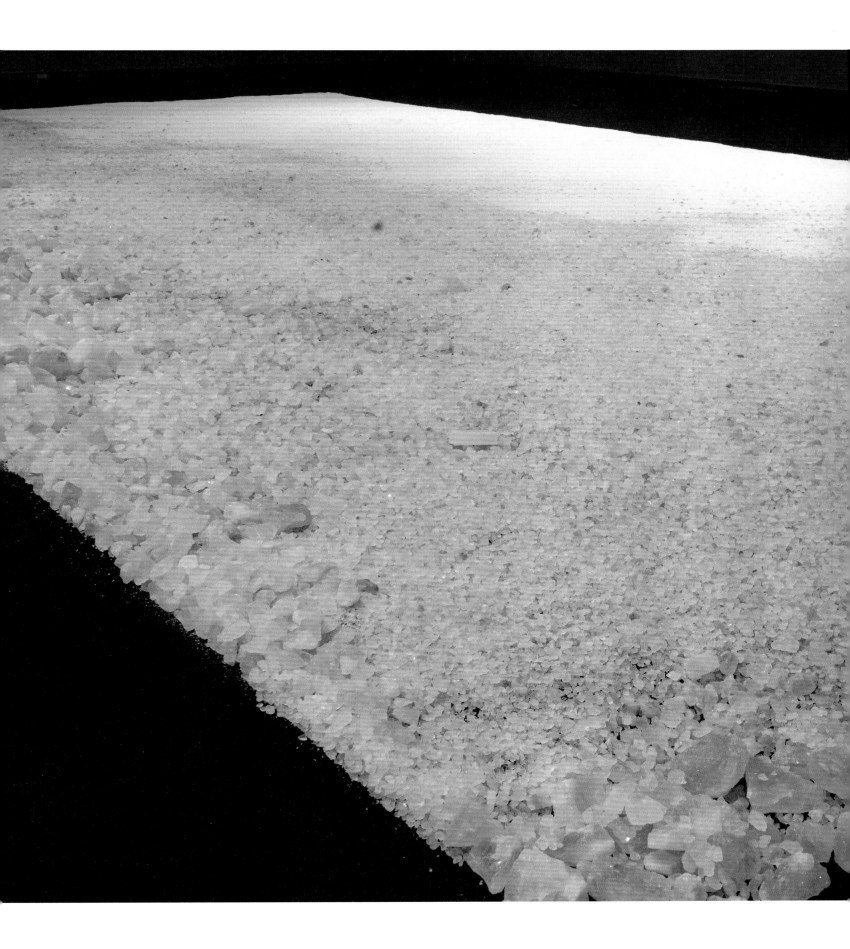

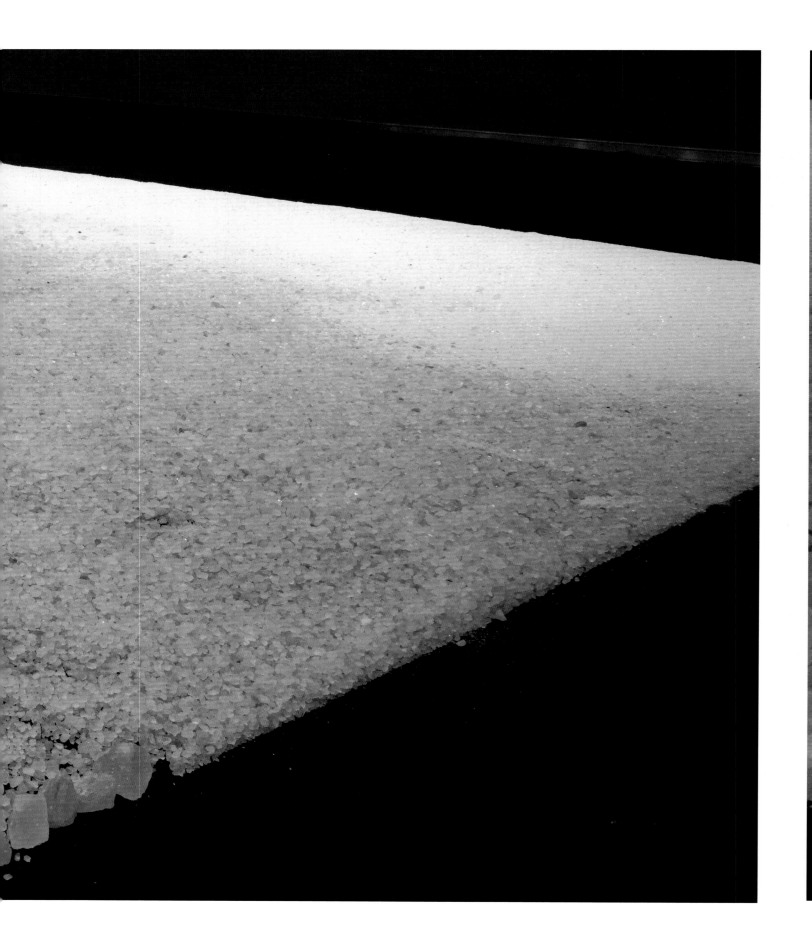

There Is Salt 2, 2021

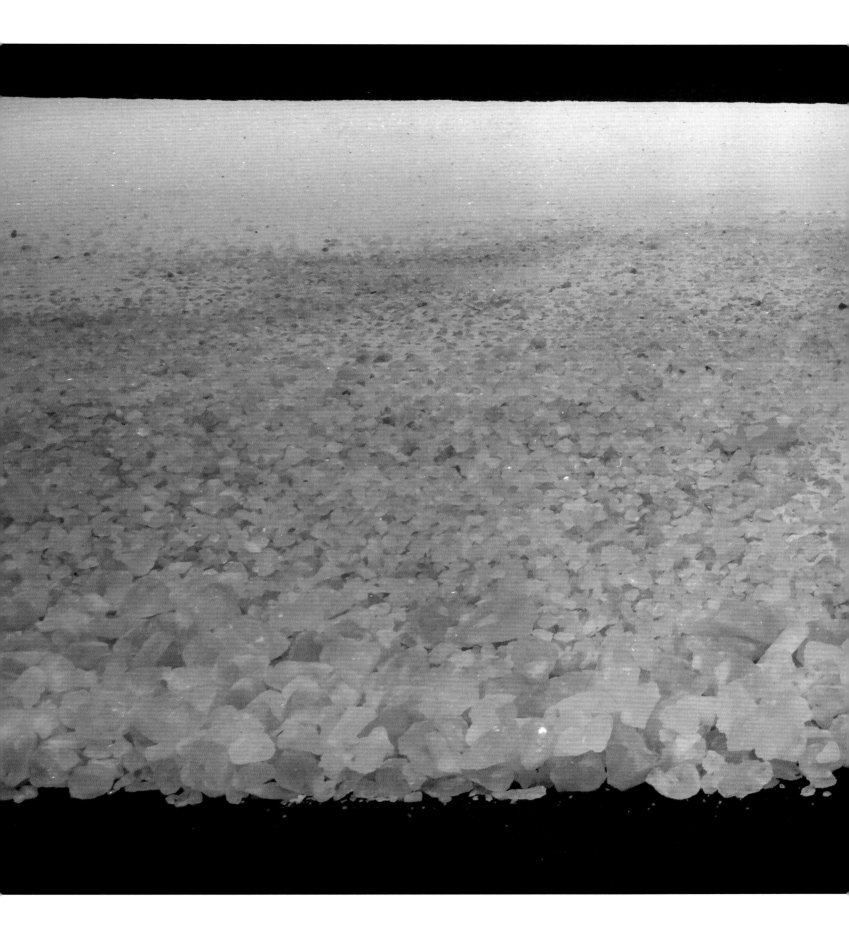

223

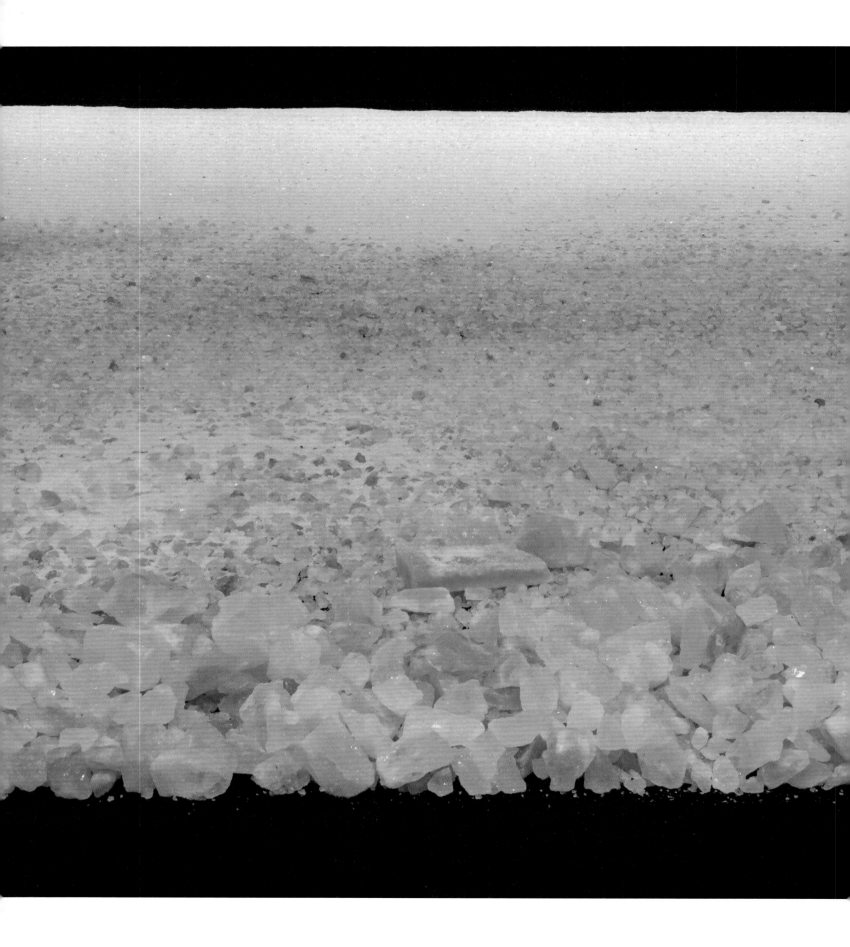

There Is Salt 2, 2021

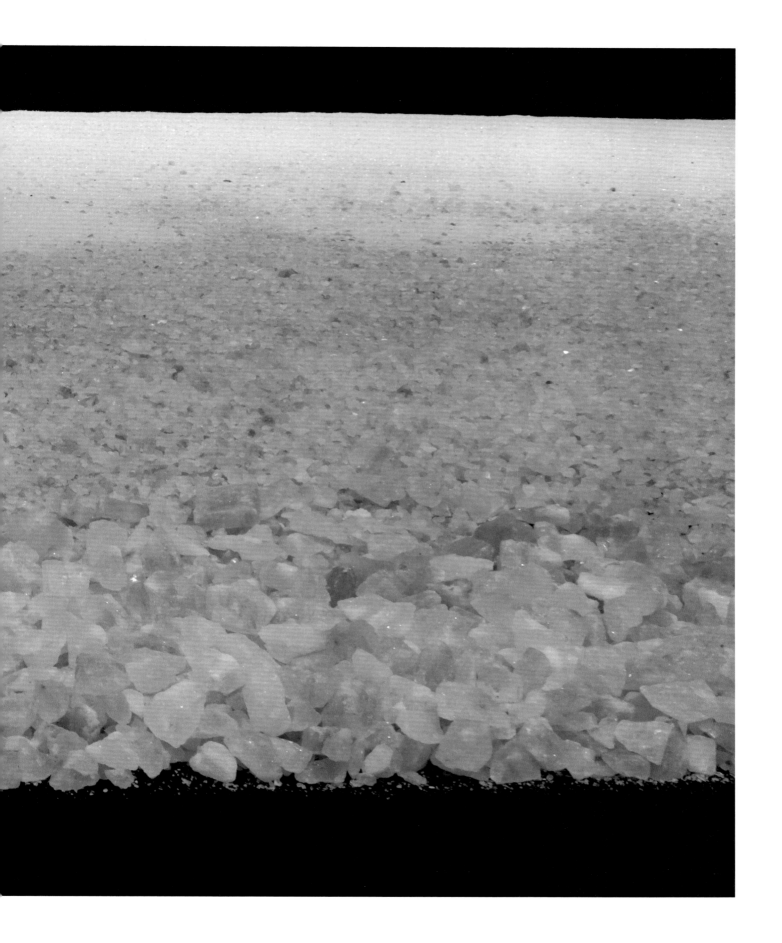

225

Yes, Today

Medium: Installation, video, live

Size: Unfixed dimensions

Description: The media has revealed that some young people from
 impoverished areas in Chengdu and other large cities across
 China have been learning martial arts in fight clubs. After
 local education departments became aware of these activities,
 these youths were sent back to their homes.
 Following this thread, the artist contacted them back in
 their hometowns and asked them to engage in a fighting
 performance, and to talk about their hopes and dreams. These
 scenes were displayed in video format in an exhibition
 hall. Simultaneously, recordings of ancient nursery rhymes
 regarding the pleasure of realities, pain and death, sung by
 elderly people from the youths' villages, were played in the
 exhibition. Based on the size of the exhibition hall, the
 installation included one or two 2m-long, 2m-wide, 0.5m-thick
 black mats. During the exhibition, several groups of young
 boxers performed at different times. When the performances
 were not underway, the audience could play freely or fight on
 these mats.

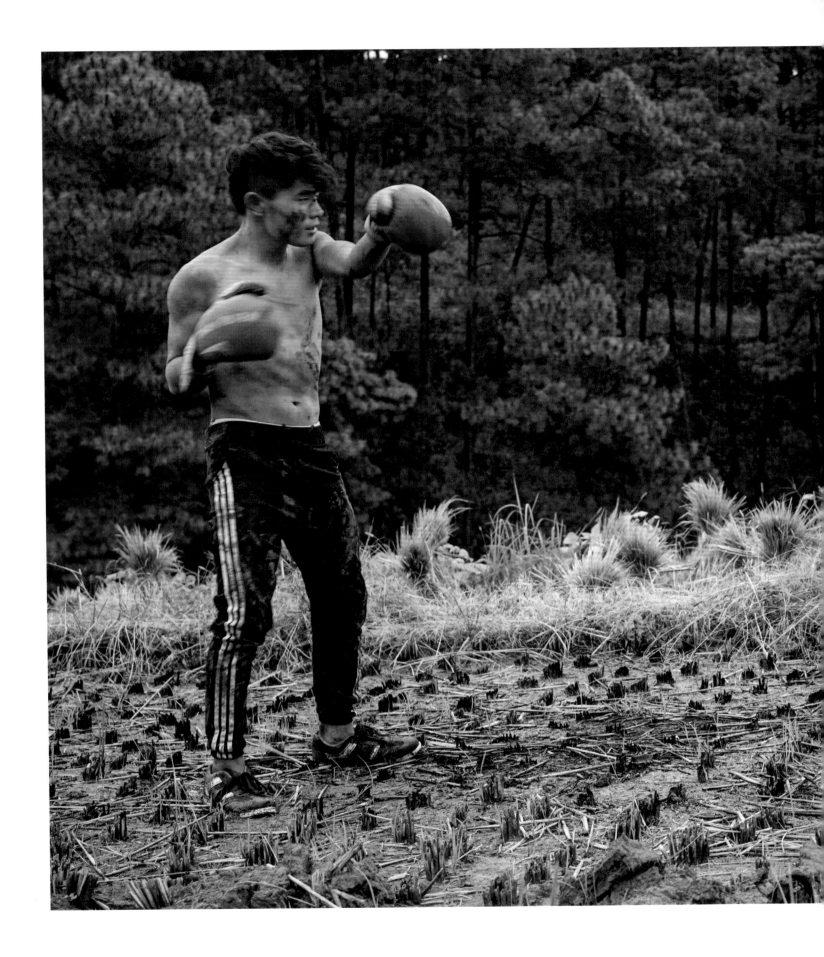

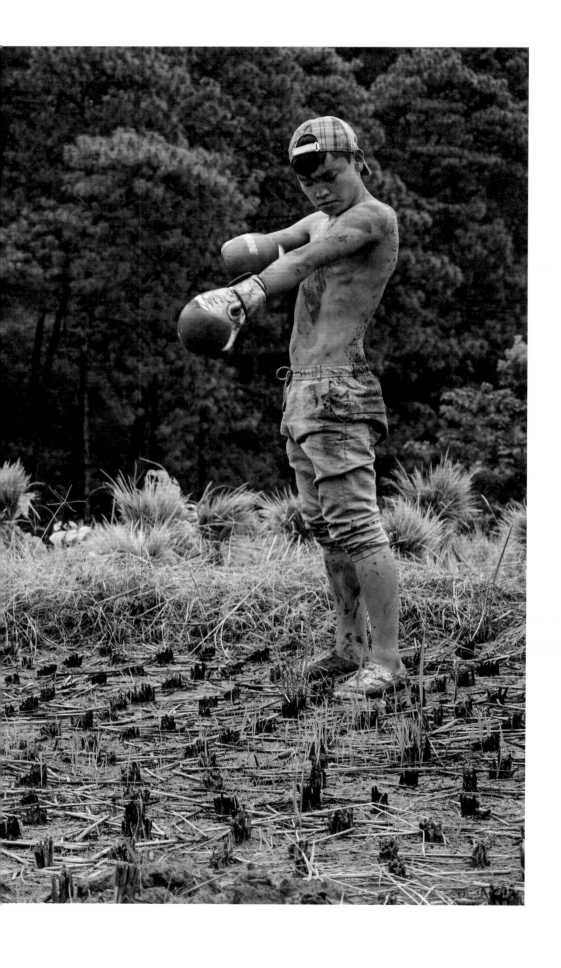

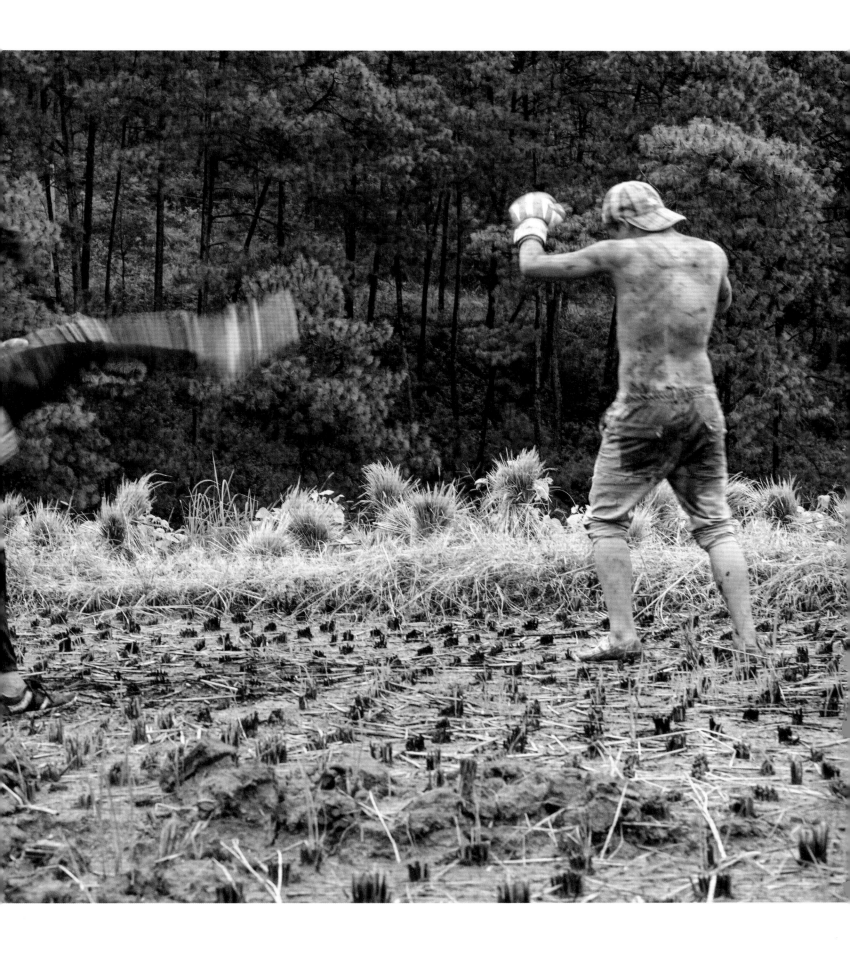

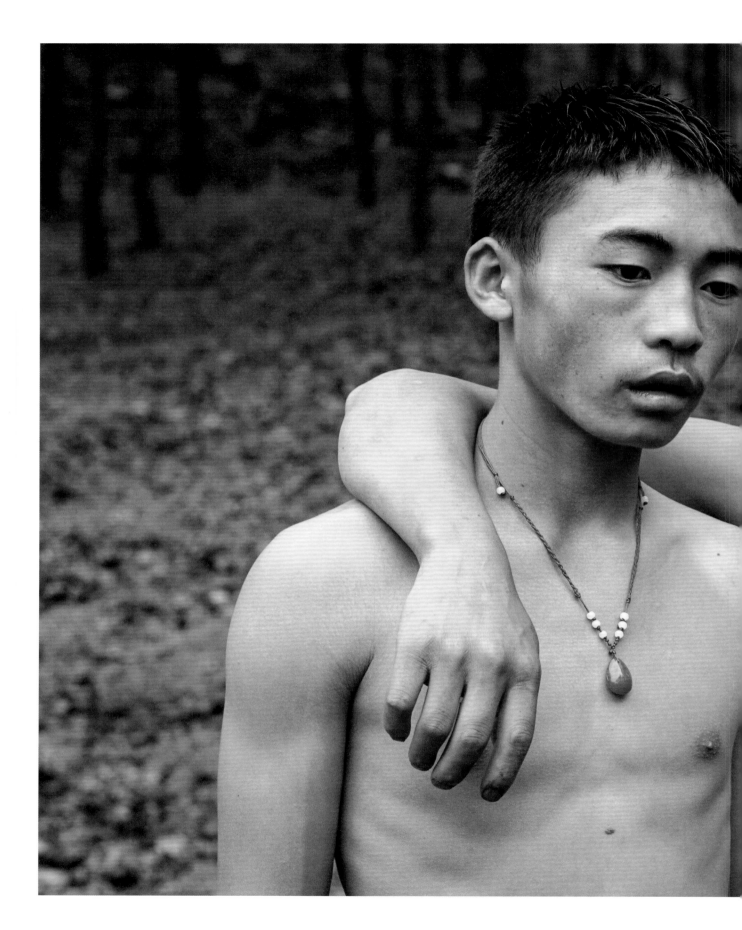

Yes, Today, 2017

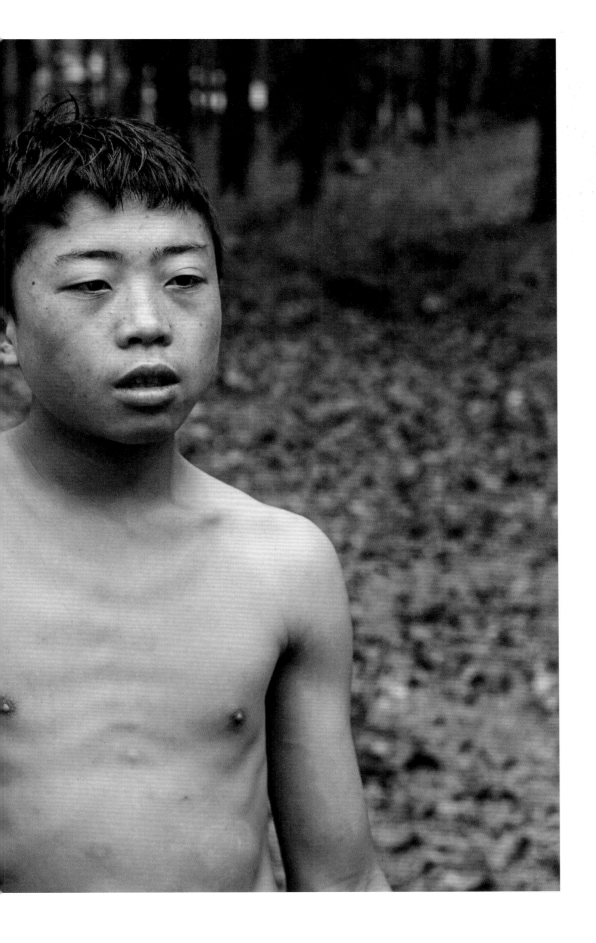
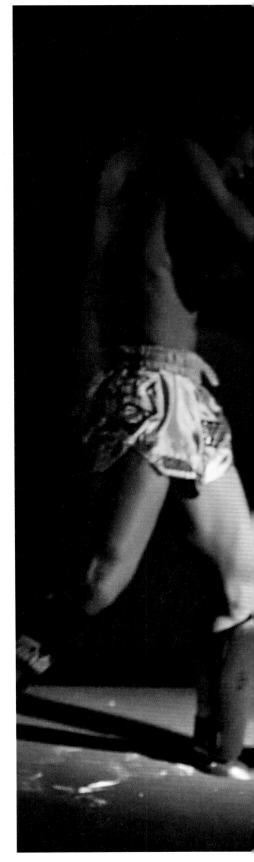

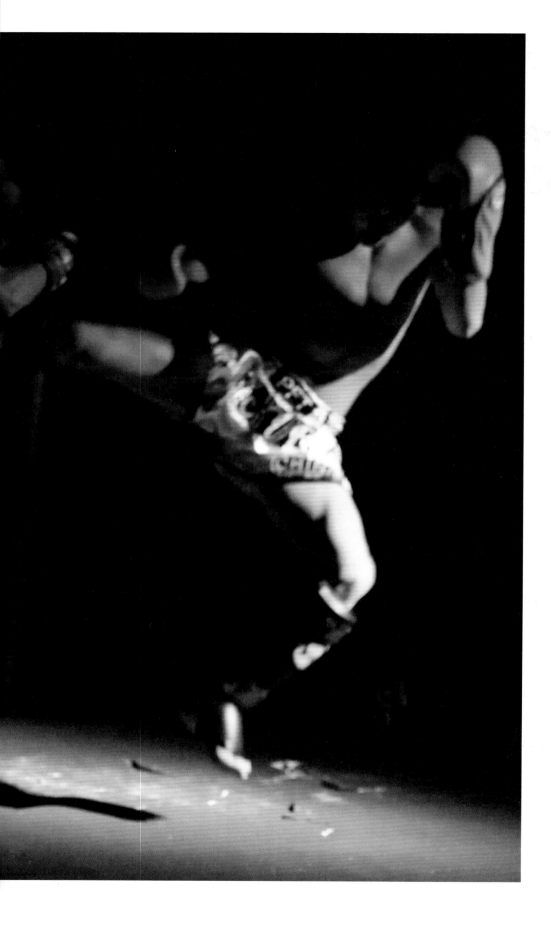

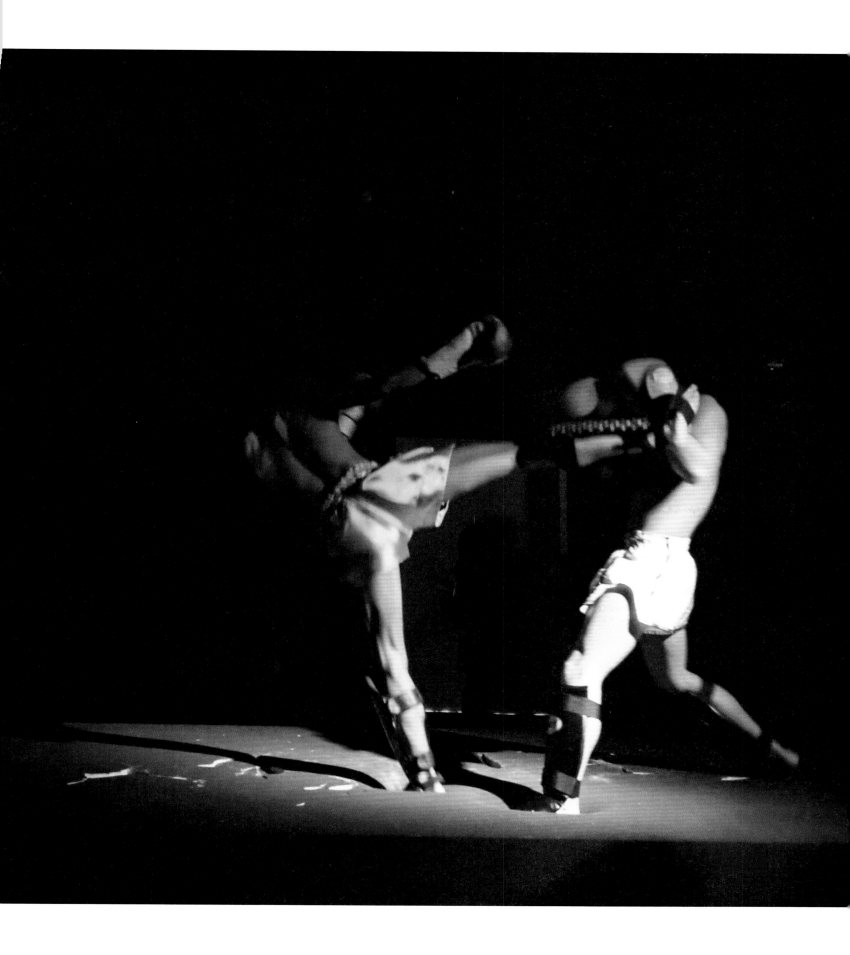

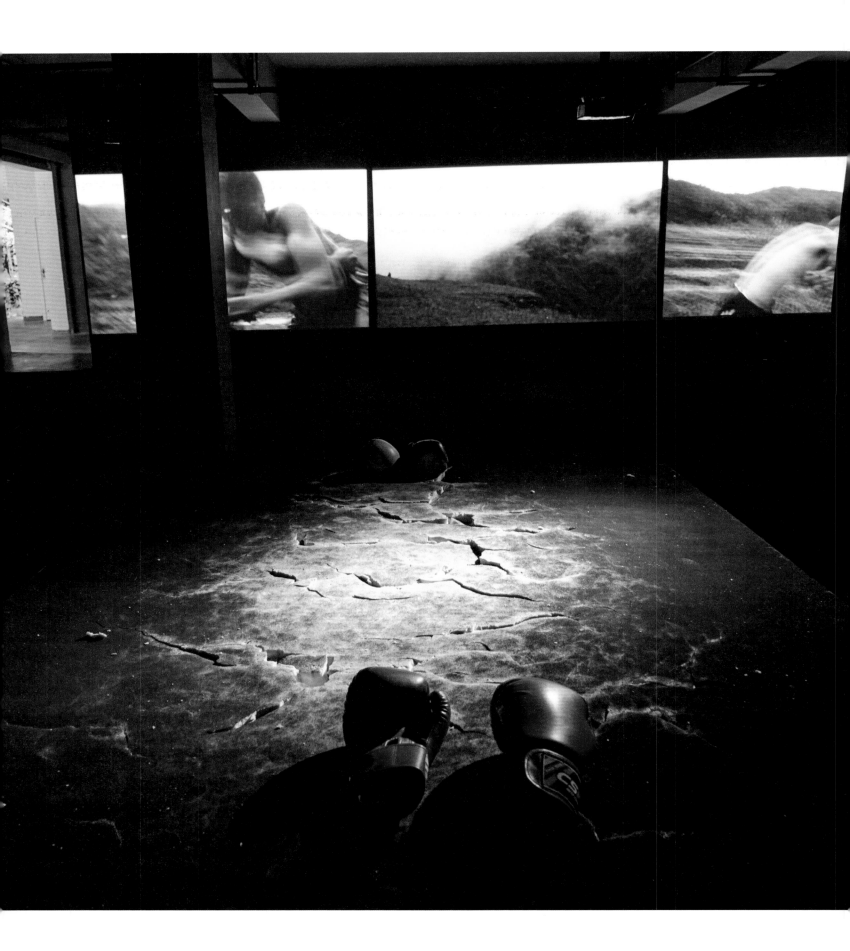

Yes, Today, 2017

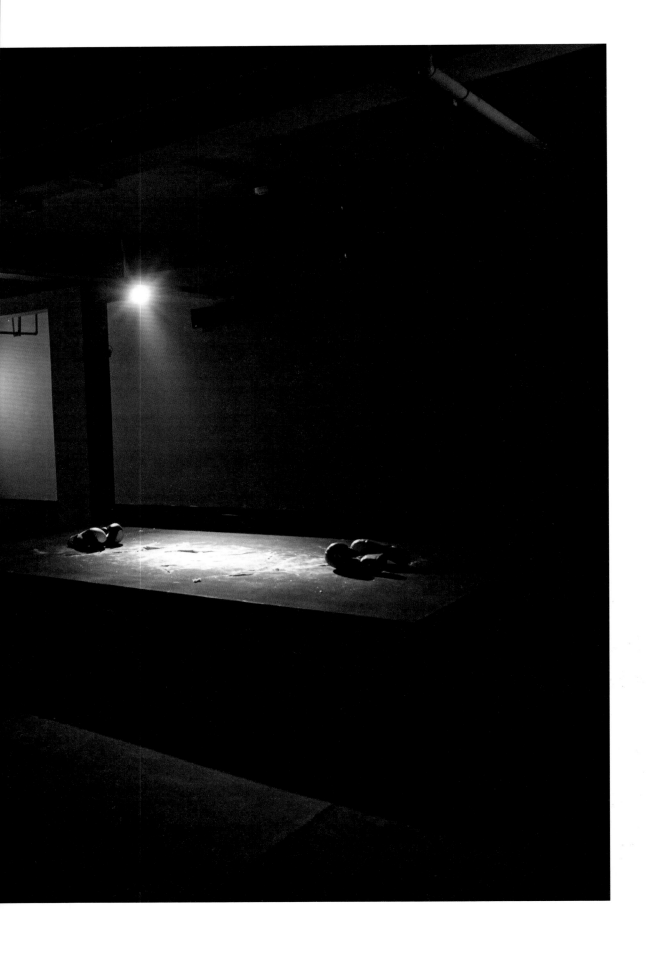

Yes, Today, 2017

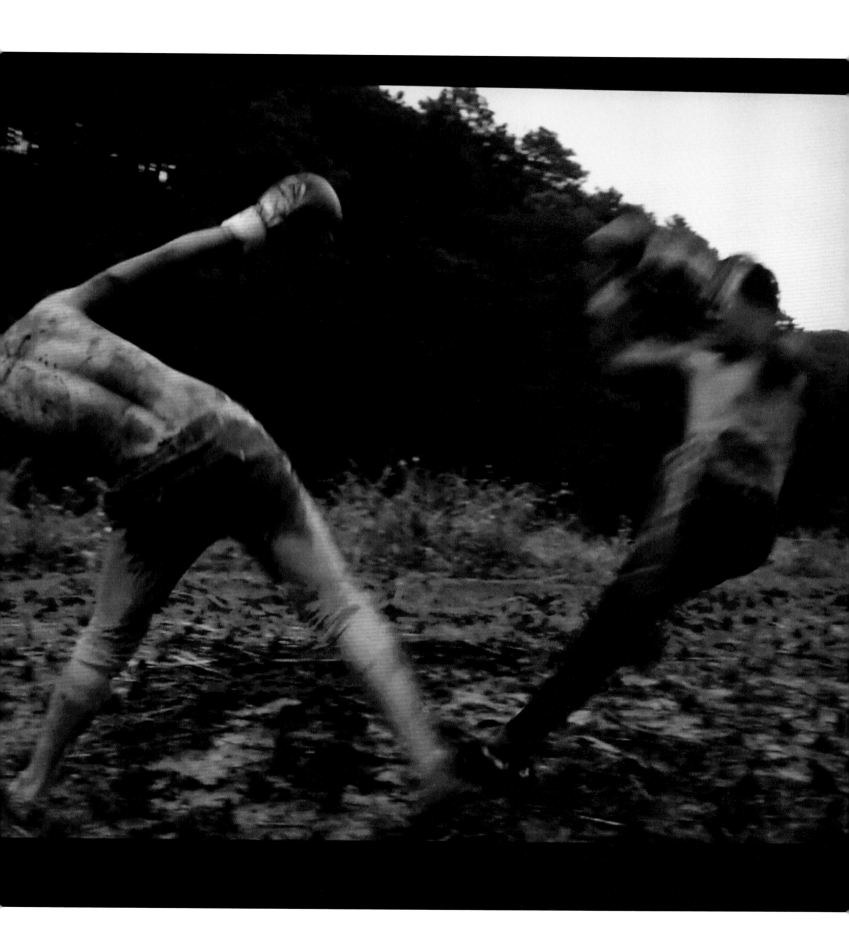

<u>Medium</u>: Sound installation

<u>Materials</u>: Variable

<u>Description</u>: In 2020, during the most severe period of the
 Coronavirus epidemic, many people were isolated at home.
 People living in different communities across China yelled
 or sang spontaneously. The artist collected some of this
 collective singing and sounds from the internet. Three
 doors are arranged in the exhibition hall, and the sound
 corresponding to the audio rhythm is transformed into an
 airflow through an induction device installed behind each
 door. The air flows through each door's mirror hole, blowing
 small flags of different colors that cover the door mirrors.
 The flags flutter according to the airflow: when the voice is
 high-pitched, the small flags wave in the air, and when the
 sound stops, they totally cover the mirrors.

AFTERWORDS

In the End, "the Border" Is a Matter of Human Perception

A conversation between Tian Meng and Li Yongzheng

Tian Meng: What kind of opportunity allowed you to start thinking about creating the work *Border*?

Li Yongzheng: The starting point of the *Border* series is the work I did in 2015, *Defend Our Nation*. At that time, I saw the four Chinese characters standing for the slogan: "Defend Our Nation," i.e. *Baowei zu guo*, abandoned in front of a military base in Lop Nur, Xinjiang. However, I hadn't yet fully developed a concept about works focusing on the border. Those two years were a period of strong anti-Japanese sentiment among the Chinese people, and later there was a wave of boycotting Korean Lotte products, one after another. This is also the reason I made this work at that time. In 2017, Donald Trump was going to build a wall between Mexico and the United States. It was going to be thousands of kilometers long, just like the Great Wall built years ago in China. This made me feel very strange; I was optimistic about the methods of resolving the differences between the countries after World War II, considering that since then the European Union has provided a good model. Therefore, from one European country to another, one cannot feel the existence of borders at all. This model has put some ideals into practice and created great hopes for reducing crises. However, in recent years, the originally optimistic situation has encountered great challenges. Then there was Brexit, and the rise of global populism. After 2000, the future of global democratization predicted by Francis Fukuyama became out of reach. A border that in the past had gradually become softer had now become harder again.

Tian Meng: Today we regard the Great Wall as a symbol of China and the Chinese nation. However, from a historical standpoint, our use of this symbol shows its absurdity. The Great Wall was historically a military fortress built against foreign enemies, and without doubts it is a border. Moreover, once the Great Wall was no more a defensive building between the enemies and us, those territories were included in the territory of today's China. This means that the border is continuously changing and not as clear and hard as the physical building of the Great Wall. Obviously, when we use the Great Wall as a national symbol, we don't consider the

areas outside the wall and their history. When you first thought about the "border," did you ever think about using the Great Wall as a border symbol?

Li Yongzheng: In the winter of 2019, I made the work *Border 1.* In *Border Post*, I removed an abandoned boundary post and re-erected it 1,000 kilometers away, at the Han dynasty's old fire beacon built in the 1st century AD, near the Great Wall. This work is the first of a series where I decided to focus on the theme of borders. The source of inspiration came from such a thought. Such a sacred and inviolable border is flexible in history, and its existence will be given new interpretations in different historical periods. In fact, any hard things will change greatly in time, although these geographical delimitations are related to many people's recognition of honor and happiness.

Tian Meng: The Great Wall provides us with the opportunity for reflection. The concept of nation we are shaping is to a large extent dehistoricized, or shaped by a selective use of history. Someone on the internet has recently produced a video that shows the changes in China's territory from the Shang and Zhou Dynasties over the following thousand years in just a few minutes. In a very intuitive way, this video shows that the border has always been changing. While watching this video, I was thinking: What is the legitimacy of establishing our territory or national sovereignty today? From such a perspective, we will find that different countries and nations have different understandings about the history and the present, and consequently, different understandings of borders.

Li Yongzheng: Of course, we can also say that borders are shaped by power. Just think about the source of the power legacy today: a subject of power must incorporate a mature and even consistent narrative into the consolidation of its power. Therefore, it is difficult for most people to look at the current border dilemma from a historical perspective. If you engage in some specific discussions with some people, you will discover that the standard answer is easily accepted by most people. Too many people have already lost the resources and the ability to understand the facts.

Tian Meng: In your works, you sometimes put the focus on a specific event or news, such as *Death Has Been My Dream for a Long Time*. In fact, in a certain sense, this work expands the problem and the concept of the border, extending the visible border to various social problems, and thus explores another invisible border of consciousness.

Li Yongzheng: Yes…in the end, the border is a problem of human perception. We are influenced by some big concepts, inspired by grand narratives that are irrelevant to urgent life situations. When we talk about borders, borders are a distant concept inspiring your glory or sorrow. But, in fact, the real frontier is the consequence of an individual's perception of the world and actions based on different values. A person who is easily glorified by distant concepts often lacks the enthusiasm for solving specific problems. And in concrete reality this has meant that there are borders everywhere.

Tian Meng: Actually, this is about daily life, and the concept of border is related to what the individual meets in his own life, rather than representing an abstract and unreachable border. During the epidemic last year, you also went to the Northwest Desert to complete the work *Feast*. This work also involves the daily relationship between people, but this happened during the epidemic and in an uninhabited desert.

Li Yongzheng: In September 2020, in the midst of the Covid-19 epidemic, we went to the desert on the north border. We invited the ethnic minorities living in the area to have dinner in the desert's valley. I wanted to reach out through some concrete actions, hoping to fill some gaps and show some hope. When the border is not so abrupt, there must be a period of relative harmony between people, and there is an opportunity to comfort one another with words and actions. When we lose these actions, the border becomes a high wall, rising higher and higher, and it will coerce many people or many families to gradually become cold in its shadow.

Tian Meng: Why did you choose Uighurs? Why did you choose a desert, that is a place where there are no people and where there is no breath of life?

Li Yongzheng: Those people live there, in this area that is part of the vast western border. I am also relatively familiar with that place since previous works on the border were also completed there. The Lop Nur area is called the "Dead Sea" because of the drought, but these canyons are formed by the melting of the snow and ice of the Altun Mountains. The canyon is full of life and is a paradise for many animals. The desert in the canyon and above the canyon are completely different scenes. However, the desert on the gorge was once very prosperous in history. It was the most important post and trading post on the Silk Road in the Western regions of China. It used to be a very glorious civilization, but it is silent today.

Tian Meng: Did you explain your thoughts to them when you invited them to the banquet?

Li Yongzheng: No, we commissioned local friends to be introducers. These people were their contacts. They told them that some Han friends wanted to invite them to kill sheep and cook in the desert canyon. They may have been curious, and just came. It is true that the scene made them feel something different from their daily life. In fact, it was a rare spectacle for them, and also for us. I remember a girl named Gu Li, she said, "Today is like a dream." Yes, after driving hard in the desert for a few hours, I came to such a place and set off fireworks. Everyone sang and danced together. To them, it was an unforgettable experience because that day was so different from their daily lives, also for us.

Tian Meng: During the performance, did they show their curiosity or ask you any questions?

Li Yongzheng: We were curious about each other, but we were not very good at communicating. Maybe because they don't speak Chinese very well, or maybe we both had concerns and couldn't open our hearts.

Tian Meng: "Not being very good at communicating" is actually the gap between people you talk about. In such an environment, there might be a certain amount of tension between you.

Li Yongzheng: The border is just ubiquitous. I remember that during a vacation in Lijiang in 2007, I wrote a short article, defining countries with traditional sovereignty that separate themselves from other political entities through physical media as "hard-border countries," and those using the internet to tie the community as the predecessor of the "soft-border countries." These "soft-border countries" will form a group of common values, and they may even have common actions at some point. Although they respect the actual rules of the "hard-border countries," other actions are guided by their community values. They even have their own currency. I think that in a few decades, the traditional concept of the country will encounter great challenges.

Tian Meng: The "soft-border countries" you describe have been forming in recent decades. From multinational corporations and globalization to the internet and Bitcoin in recent years, we have been continuously changing our understanding of the traditional concept of national borders. For example, in the internet world, some groups are transnational and have their own existence and organizational form. The social and organizational forms of these groups are just like the concept of "soft-border countries" you mentioned. This may be the form of the future state. However, there must be new problems here.

Li Yongzheng: Humans have problems, life just can't be perfect, and the society we build will never be. We hope that actions will change the future, but I am not an idealist, nor do I think that the future we build will be better than today. History always repeats itself, but this pessimism can't stop the current action. I can't stop hoping because of fear, we exist just because we constantly create hope.

Tian Meng: In a recent conversation with some friends, I suddenly realized that some of the consensus we once thought we had does not actually exist. When it comes to specific social phenomena and problems, there are huge differences in cognition between people. This gap in perception prompted me to think, what caused these serious divisions? This differentiation exists between different generations, as well as between people of the same generation. Sometimes, I feel that these differences only involve common sense.

Li Yongzheng: People have an instinct to seek advantages and avoid disadvantages. If you don't really

regard a certain value as an inevitable practice in life, then you will intentionally or unintentionally adjust your words and actions according to the pressure of reality, just like it happened to some friends of mine who in the past used to share some values. For many people, such an adjustment does not even represent a conflict of ideas, because when it comes to personal advantage it is easy to find the reason for one's consistency. We may be among those kinds of people, but the difference is that we are aware of this. So, I don't care about what others say or what changes have been made, I am more concerned about what I think and feel at the moment. When walking alone becomes a habit, I don't need to gain the power of action in the group.

Tian Meng: In your understanding of the "soft-border countries" and estrangement, an extremely important element involved is negotiability. This should be a characteristic of modern civilization. Contradictions and conflicts must exist in our real world. However, negotiability itself is a way to solve problems in real contradictions and conflicts. This will also soften the border to a certain extent and make it more flexible. Negotiability can, to a certain extent, place contradictions and conflicts on the level of diversity and difference and will not push contradictions and conflicts to violent disasters. This is a relatively ideal state. Of course, none of us are total idealists. I even feel a kind of fear among those who hold non-negotiable views. This fear is not because of their direct harm to us, but the non-negotiable argument reminds me of the thoughts and concepts that led to wars and massacres in history.

Li Yongzheng: Yes, this risk is always present, and I am not optimistic about the future either. That kind of active negotiation has never happened to the land under our feet. The advancement of technology makes what Habermas calls the "public domain" also appear to be diminished. We have never been unconsciously controlled by various information like we are today. People believe in everything they see more because of all this. It's all what they like to see. In the political field, showing off power has become a fashion, and power has reappeared on the

stage in many places without concealment. This is a dangerous signal. We have not gained experience from historical disasters. Benefits are still the most important thing in globalization, and the exchange of interests has become a weapon: it concealed many disagreements under the iceberg and suppressed the voice that we should have a possible beautiful world based on values. These results will eventually make the contradictions irreconcilable. The world is losing its foresight, and mankind can only wake up for a while after encountering a major crisis. Many times, when discussing these issues, I feel absurd, because even when talking about these topics that have nothing to do with our specific reality, I will be unconsciously cautious, so in this situation, I would prefer to talk about some kind of specific negotiations, like an illusion.

Tian Meng: Another phenomenon is that before we have completed our individual understanding of concepts, many people have retreated to a collective consciousness. They imagined collective unity to be merged with the individual. In the collective, the individual is abandoned, and the individual's decision often depends on the collective choice, and also on the discourse of authority as a symbol of the collective. As a result, this has brought more new barriers, more new divisions. Since the outbreak of the epidemic, we have not produced a consistent understanding of such a big event, which could bring people back to a basic common sense. On the contrary, we have seen more unprecedented differentiation. Some people consciously defend their imaginary collective and dignity, and even ignore the facts, while those who ask questions to seek the truth are regarded as heretics. In your work *2020*, you collect those singing voices in the epidemic and present them poetically through the form of a door. Have you paid attention to this phenomenon of division?

Li Yongzheng: Yes, because in the current reality, only those who appear to have correct voices can speak freely. We are used to a kind of voice that has been echoed many times in our minds during our youth, but today, when this voice suddenly becomes no longer correct to us and gradually disappears from

our conversations, this is when we feel the split. When this voice speaks about real or imagined danger, then the gap of the split is wider. Personally, the year 2020 will definitely have a great impact. Just like the 2008 Wenchuan earthquake: I haven't been able to get out of that shadow for many years. According to the method I used in the past, I would give voice to respond to such unforgettable things. The door is an interesting image that represents this, and I also like the word.

Tian Meng: When you made *Defend Our Nation* in 2015, did you structure your thinking about the "border," or did you gradually clarify your understanding of this subject in a later phase of the process?

Li Yongzheng: The idea of making a series of works about the border came into being between 2017 and 2018. Before this, it was very vague. Maybe this kind of concept has always been something I wanted to understand, but I couldn't find the answer.

Tian Meng: In fact, you discussed this topic in depth from the perspective of the symbols, involving a historical dimension, such as in *Different Kinds of Willpower* where you used the symbol of the swastika. This symbol makes people imagine the relationship between the swastika in Buddhism and the swastika in the Nazi party. Does this mean that your thinking on the "border" issue extends to the ideological and historical dimensions?

Li Yongzheng: This symbol appeared a long time ago, six or seven thousand years ago, both the Sumerians and Aryans used this symbol. This may be some kind of illustration of their interpretation of the universe, very similar to the Chinese Tai Chi. Later it was used more in Buddhism. In Buddhism, it symbolizes light and means endless reincarnation, and it is the same concept for most Buddhist schools. But this symbol is widely known to the world because the Nazis have used it. I don't know why they chose such a symbol. Perhaps they thought they inherited it from the ancient Aryans. The focus of my concern is not on the history of this symbol, but on the phenomenon it presents. It represents a very compassionate religion, and also reminds people of the Holocaust and concentration camps. What I am concerned about is

what kind of power the content of this symbol has. Just like a theory or a social phenomenon that suddenly one day is given a new interpretation, and then erected by power to become an example.

Tian Meng: Once knowledge becomes a tool for shaping power, then this kind of knowledge is worthy of vigilance. Power is sometimes used to cover up ill intentions in the name of knowledge or truth.

Li Yongzheng: Even under a very compassionate cultural system, once a certain kind of thought is established as an unshakable position, it is a source of danger. When a kind of thought engulfs everything, then it would definitely hurt the belief in freedom. Therefore, there is no real unshakable goodness, goodness exists only in the balance of power.

Tian Meng: In *A Family from Ding'er*, you used the carpet as the material of the work. Based on general experience, we would think about the relationship between carpets and Northwest China. In the work, you also pour wax on the carpet. Why in this work did you choose a carpet and wax as the materials to explore the subject of the border?

Li Yongzheng: On the border of western China, whether it is the Tibetan, Kazakh, Uighur, or Mongolian ethnicities, the most decorative objects you see in their homes are carpets. This is an item that is closely related to their lives and culture. It is a kind of "warm existence," loaded with emotion, and a symbol of a happy life. I use wax to cover the carpets and shape them into something that expresses my emotions. In my memory, wax represents a necessity for long-term preservation of some important things, allowing some things to persist. Wax can seal the warmth that is not easy to leave at the cold border, and it has some softness that can disappear at any time without leaving a trace.

Tian Meng: In these works, you did not make a very clear judgment, but through an easy-to-access way you let the audience understand and think, and you provided them with a space for thinking.

Li Yongzheng: I never write answers, maybe I don't even have any. I have a moral premise, but I don't want to expose it: I just present them emotionally. It is these people and things that made me feel emo-

tional. I just made a door, there are many things in here. How far the viewer can go is their business. In fact, it doesn't matter if you see it or not. If this door makes them feel some curiosity, it is already a good result.

Tian Meng: In *The Art of the Novel*, Milan Kundera said that novels are not someone's spokesperson, or even the author's own spokesperson. This is consistent with your idea of creating works.

Li Yongzheng: I like Milan Kundera's work and his mode of expression, because no matter who you are and what kind of thoughts you have, we are all within an independent survival system. If you always want to present your thoughts instead of building consensus, then your ideas are considered to be black words that can only be spoken to people who understand the code of these words, and besides, it may be more appropriate to explain them further. Another way of expressing ideas is art, which I think represents an exceptional approach, since it is the only way you can express yourself when words can't.

Tian Meng: Milan Kundera also tried to define the characteristics of the novel itself, so as not to make the novel become a vassal of a certain philosophy or thought. In his view, novels are the discovery of the possibility of human existence.

Li Yongzheng: Art rises where language stops. I don't like some extreme forms, or giving them too much interpretation, because no form is essential. These forms are just in the use of time, given a certain status by power, and are related to the change of power. I like to look for resources from different systems, as close as possible to the people and things related to survival, the so-called possibility of meaning will be revealed in specific people and things.

Tian Meng: You have repeatedly used salt and wax in many works. These two materials create a sense of strangeness to a certain extent, and the narrative also makes people wonder why the artist chose these materials. This may become a door that opens into your work. What is the special meaning of salt and wax to you?

Li Yongzheng: My use of salt and wax is related to childhood memories. For instance, salt was very precious during my childhood, and it was the most important provision in the family. Without salt, it would be difficult to survive. Each of us can only use our own experience as the first step to start action. I am not against creating realistic spectacles, I believe that the aesthetic, formal, and methodological strangeness is also a very interesting part of contemporary art.

Tian Meng: Since *Defend Our Nation* in 2015, the *Border* series has been an ongoing creation for six years. Are there any plans for further creations on this subject?

Li Yongzheng: Not at present. I am not the kind of person who pursues the same theme. I am always attracted by something new. Curiosity can ease my anxiety and fear about the future. Of course, I can't rule out that I will make similar works. But in the next steps I will not focus on this aspect. I will shoot some videos to reinterpret some religious stories, and I will create in a way that is less like contemporary art. It requires action to establish the method.

April 7, 2021. Tian Meng: Curator, Art Critic, Director of Lushan Art Museum

Biography

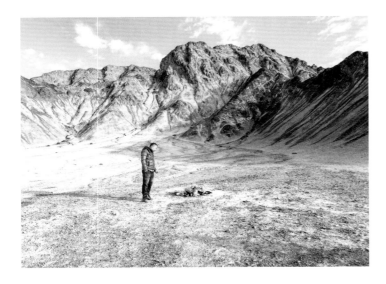

Born in Bazhong, Sichuan Province in 1971, Li Yongzheng pursued higher education at Sichuan Fine Arts Institute's Department of Technology and Department of Oil Painting from 1989 to 1991. In 1994, he graduated from the Department of Fine Arts of Southwest University (formerly Southwest Normal University). From 1998 to 2000 he attended workshops at the Department of Sociology of Sichuan University while living and working in Chengdu, Sichuan Province.

In Li Yongzheng's creations, whether it is performance art, installation, video, or long-term interactive artworks, there is always a clear intention to start from the bottom of experience. He often makes in-depth choices about the background and place in which the work is produced. In the forms of the installations, he repeatedly scrutinizes the history and even cultural sources of the "substance" of the installations. He is considered to be an important representative artist in the Chinese "post-internet" era.

Exhibitions

Selected Solo Exhibitions

2021
Borders, Lushan Art Museum, Chengdu, China
2018
Red Ruins, *Absurd Realities: Artworks by Li Yongzheng*, Kuandu Museum of Fine Arts—Taipei National University of the Arts, Taipei, Taiwan
2017
Hello, MOCA, Chengdu, China
2015
Death Has Been My Dream for a Long Time, TEDA Contemporary Art Museum, Tianjin, China

Selected Group Exhibitions

2021
A Stitch in Time, Fourth Edition of "Documenta Today Triennial," Chongqing Contemporary Art Museum, Chongqing, China
Lumen, White Rabbit Gallery, Sydney, Australia
2020
And Now: The Second Decade of White Rabbit, White Rabbit Gallery, Sydney, Australia
Reality and Ideal, Chengdu Blueroof Art Gallery, Chengdu, China
Ode to Great Beauty, Shanghai Powerlong Art Museum, Shanghai, China
Picture Magazine Cover Project, Art Museum of Nanjing University of Arts, Nanjing, China
2019
Ultimate Deal, Seoul Cultural Reserve Base T4, Seoul, South Korea
The Common Space, Beijing Times Art Museum, Beijing, China
A Confrontation of Ideals, The Second Anren Biennale, Anren,Chengdu, China
Vienna Parallel Exhibition, Vienna Bank Building, Vienna, Austria
New Art History – Chinese Contemporary Art since 2000, Yinchuan Museum of Contemporary Art, Yinchuan, China
Nothing to Ask, Cleveland State University Museum, Cleveland; Tennessee State University Museum, Nashville, USA

2018

Sailing Away on Land, Hyundai Motorstudio Global Art, Beijing, China

Capital@Art, Mercedes-Benz Center, Frankfurt, Germany

New Chinese Video, New Attitudes from 2010, Anren, Chengdu, China

Chinese Contemporary Art Yearbook 2017, Minsheng Modern Art Museum, Beijing, China

Bad Exhibition: Value in Art, Art City Gallery, Ventura, USA

2017

Today's Past, Anren International Biennale, Thematic Exhibition, Anren, Chengdu, China

Stress Field, Fourth Art Literature Exhibition, Hubei Museum of Art, Wuhan, China

Social Theatre, 5th Chongqing Youth Fine Art Biennale, Sichuan Institute of Fine Art Museum, Chongqing, China

Readjustment, Nanjing University of the Arts Fine Art Museum, Nanjing, China

Suspended and Still Unresolved, Sichuan University Art Museum, Chengdu, China

Blank Script, Tianjin Academy of Fine Arts, Tianjin, China

2016

Supply and Depression, Nanjing International Art Thematic Exhibition, Nanjing Baijiahu Museum, Nanjing, China

Motivate, Chun Art Museum, Shanghai, China

Confronting Anitya – Oriental Experience in Contemporary Art, Chengdu Museum of Contemporary Art, Chengdu, China

2015

Rock Bottom, Yinchuan Museum of Contemporary Art, Yinchuan, China

New States, Taiyuan International Sculpture Biennale, Taiyuan Museum of Art, Taiyuan, China

Songs of the Creatures of Dunhuang, Shanghai Himalayas Art Museum, Shanghai, China

Continue to Be Open CMNET Solo Art Exhibition, PIN Art, Beijing, China

2014

In the Name of Daily-ness, Blue Roof Art Festival Thematic Exhibition, Chengdu Blue Roof Gallery, Chengdu, China

Confronting Anitya – Oriental Experience in Contemporary Art, Bonn Centre for Contemporary Art, Bonn, Germany; Karl Shute Art Center, Germany; MAGI'900 Museum, Bologna, Italy

Brick Relay – Art on the Mobile Internet, Chinese Contemporary Art and Literature Exhibition, Shenzhen Circle Art Center, Shenzhen, China

2013

Formless Shape International Contemporary Art Exhibition, TEDA Contemporary Art Museum, Tianjin, China

Confronting Anitya – Oriental Experience in Contemporary Art, MAGI'900 Museum, Bologna, Italy

First Auction Biennale Exhibition, Shanghai World Expo Exhibition Hall, Shanghai, China

Extend—The Orientation of Contemporary Sculpture, Datong International Sculpture Biennale, Datong, China

Extend—The Texture of Civilization, China, Datong International Sculpture Biennale, Datong, China

The Awakening of Intuition, Pingyao, China

Send for You, Chengdu A4 Contemporary Art Center, Chengdu, China

Individual Growth—Momentum of Contemporary Art, Tianjin Art Museum, Shijiazhuang Museum of Art, Tianjin, China

Confronting Anitya – Oriental Experience in Contemporary Art, the 55th Venice Art Biennale, Venice, Italy

Voice of the Unseen, the 55th Venice Art Biennale, Venice, Italy

Contemporary Art and Social Process, Chinese Contemporary Art and Literature Exhibition, Shenzhen Circle Art Center, Shenzhen, China

Tomorrow, Contemporary Sculpture Exhibition, Sichuan Fine Arts Institute, Chongqing, China

Loose Sand, Chinese Contemporary Art, The Art Museum of Ball State University, Muncie, Indiana, USA

2012

Sanya Art Festival, Contemporary Art Exhibit, Sanya, China

SEE/SAW Contemporary Art and Collaboration, Beijing UCCA, Beijing, China

Li Yongzheng
Yes, Today

Project Management and Editorial Coordination:
Manuela Schiavano - WE World Expression

Translations from Chinese to English:
Ornella De Nigris, Sophia Kidd, R. Orion Martin

Translations from French to English:
Simon Barnard

English Revisions:
Andrea Baker

Book design:
Giulio Ferrarella

© 2021 Mondadori Libri S.p.A.
Distributed in English throughout the World
by Rizzoli International Publications Inc.
300 Park Avenue South
New York, NY 10010, USA

ISBN: 978-88-918322-3-8
2021 2022 2023 2024 / 10 9 8 7 6 5 4 3 2 1

First edition: November 2021

pp. 184–185 - Courtesy of White Rabbit Collection, Sydney.

This volume was printed at Errestampa S.r.l.
Via Portico 27, Orio al Serio, Bergamo
Printed in Italy

Visit us online:
Facebook.com/RizzoliNewYork
Twitter: @Rizzoli_Books
Instagram.com/RizzoliBooks
Pinterest.com/RizzoliBooks
Youtube.com/user/RizzoliNY
Issuu.com/Rizzoli

The realization of this book was made possible thanks to the wonderful writings of art critics Dr. Lü Peng and Mr. David Rosenberg, whose articles have built a bridge between the artist and the readers. Thanks to the team members who helped me create the *Border* series, Ma Zhandong, Zhong Ran, Gu Shi, Chen Jie, Yang Yi, etc. Without their selfless help, these works would be difficult to present. Special thanks to my wife, Ms. Xiong Yan, for her love and dedication to the family that has made me feel warmer in my creation for the past ten years. Finally, I would like to thank the excellent team at Rizzoli and Manuela Schiavano for their hard work. This book is dedicated to my daughters, Lacey and Aileen.